The art of
painting animals

PHalarope Books

PHalarope Books are designed specifically for the amateur naturalist. These volumes represent excellence in natural history publishing. Each book in the PHalarope series is based on a nature course or program at the college or adult education level or is sponsored by a museum or nature center. Each PHalarope Book reflects the author's teaching ability as well as writing ability. Among the books in the series:

The Amateur Naturalist's Handbook
VINSON BROWN

The Amateur Naturalist's Diary
VINSON BROWN

The Wildlife Observer's Guidebook
CHARLES E. ROTH, Massachusetts Audubon Society

*The Fossil Collector's Handbook:
A Paleontology Field Guide*
JAMES REID MACDONALD

*Nature in the Northwest: An Introduction to
the Natural History and Ecology
of the Northwestern United States
from the Rockies
to the Pacific*
SUSAN SCHWARTZ / Photographs by Bob and Ira Spring

*At the Sea's Edge: An Introduction to
Coastal Oceanography for the Amateur Naturalist*
WILLIAM T. FOX / Illustrated by Clare Walker Leslie

*Exploring Tropical Isles and Seas: An Introduction
for the Traveler and Amateur Naturalist*
FREDERIC MARTINI

*Suburban Wildlife: An Introduction
to the Common Animals of Your
Back Yard and Local Park*
RICHARD HEADSTROM

*Outdoor Education: A Manual for
Teaching in Nature's Classroom*
MICHAEL LINK, Director,
Northwoods Audubon Center, Minnesota

The Art & Design Series

For beginners, students, and working professionals in both fine and commercial arts, these books offer practical how-to introductions to a variety of ideas in contemporary art and design. Each illustrated volume is written by a working artist, a specialist in his or her field, and each concentrates on an individual area—from advertising layout or printmaking to interior design, painting, and cartooning, among others. Each contains information that artists will find useful in the studio, in the classroom, and in the marketplace. Among the books in the series:

Drawing: The Creative Process
SEYMOUR SIMMONS III and MARC S.A. WINER

Nature Drawing: A Tool for Learning
CLARE WALKER LESLIE

*Nature Photography: A Guide to
Better Outdoor Pictures*
STAN OSOLINSKI

Drawing with Pastels
RON LISTER

*Understanding Paintings:
The Elements of Composition*
FREDERICK MALINS

*Painting and Drawing: Discovering
Your Own Visual Language*
ANTHONY TONEY

A Practical Guide for Beginning Painters
THOMAS GRIFFITH

*Transparent Watercolor:
Painting Methods and Materials*
INESSA DERKATSCH

*The Art of Painting Animals:
A Beginning Artist's Guide to the Portrayal
of Domestic Animals, Wildlife, and Birds*
FREDRIC SWENEY

FREDRIC SWENEY has been a professional artist for the past 50 years with experience in painting and illustrating wildlife as well as teaching art. A recipient of several awards, Mr. Sweney has done illustrations for such magazines as *National Geographic, Outdoors, The Outdoorsman, Nature Magazine,* and *Sports Afield*. He is listed in *Who's Who in American Art* and lives in a beautiful part of the state of Washington, where he has ample opportunity to paint wildlife.

FREDRIC SWENEY

The art of
PAINTING
ANIMALS

*A beginning artist's guide
to the portrayal of domestic animals,
wildlife, and birds*

A SPECTRUM BOOK

PRENTICE-HALL, Inc., Englewood Cliffs, New Jersey 07632

Library of Congress Cataloging in Publication Data

Sweney, Fredric.
 The art of painting animals.

 (The Art & design series) (PHalarope books)
 "A Spectrum Book."
 Bibliography: p.
 Includes index.
 1. Painting—Technique. 2. Animals in art.
I. Title. II. Series.
ND1380.S9 1983 751.45'432 83-831
ISBN 0-13-047787-7
ISBN 0-13-047779-6 (pbk.)

This book is available at a special discount when ordered in
bulk quantities. Contact Prentice-Hall, Inc., General
Publishing Division, Special Sales, Englewood Cliffs, N.J. 07632.

THE ART & DESIGN SERIES.

10 9 8 7 6 5 4 3 2 1

ISBN 0-13-047787-7

ISBN 0-13-047779-6 {PBK.}

Editorial/production supervision by Eric Newman
Page layout by Gail Cocker
Cover illustration by the author; design by Hal Siegel
Manufacturing buyers: Christine Johnston and Edward J. Ellis

PRENTICE-HALL INTERNATIONAL, INC., *London*
PRENTICE-HALL OF AUSTRALIA PTY. LIMITED, *Sydney*
PRENTICE-HALL CANADA INC., *Toronto*
PRENTICE-HALL OF INDIA PRIVATE LIMITED, *New Delhi*
PRENTICE-HALL OF JAPAN, INC., *Tokyo*
PRENTICE-HALL OF SOUTHEAST ASIA PTE. LTD., *Singapore*
WHITEHALL BOOKS LIMITED, *Wellington, New Zealand*
EDITORA PRENTICE-HALL DO BRASIL LTDA., *Rio de Janeiro*

To Clair V. Fry

whose subtle guidance as an art director made it possible for me to follow my chosen field.

Contents

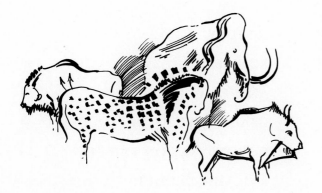

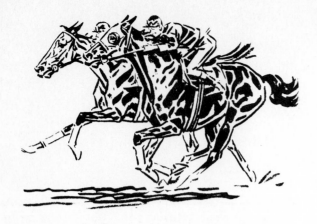

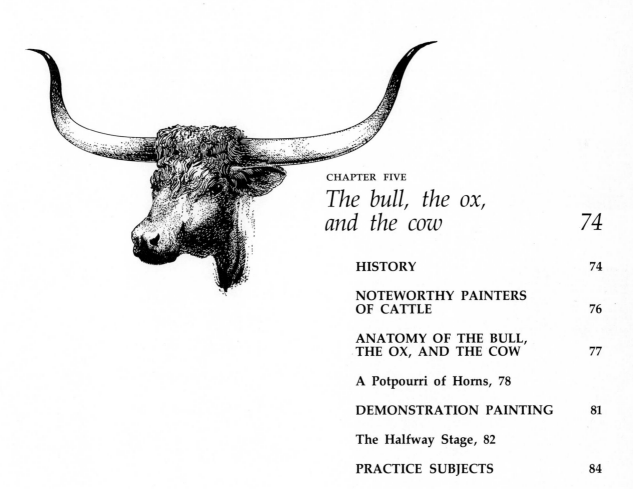

Acknowledgments

I would like to give special thanks to Mary E. Kennan for her editorial knowledge and guidance, and to her staff, who helped me throughout the three years it required to write the book and make the paintings and numerous illustrations necessary to complete it.

I also want to thank Eric Newman, whose competent attention to detail and to production matters guided this book to its completion.

My sincere appreciation goes to all museums and other artists for the use of their paintings and art, and also to Viktor Schreckengost and Bill Webster for their help.

Finally, a big thank you goes to my wife and my friends for their interest and understanding.

The art of
painting animals

INTRODUCTION

Painting animals and birds

THERE IS AN OLD SAYING, "A horse is beautiful to look at but terrible to draw," and this is quite true, particularly if you do not understand the physical structure and behavior of that animal. Whether you are drawing an elephant or the family pet, the same axiom holds true.

A very good example is the oil painting of "Saint Martin dividing his cloak with the beggar" by Jorge Manuel Theotocopuli, who was the son of El Greco. (See Figure 0.1.) He worked in a conspicuously distorted style like that of his father, but his horse and figures look right even though they are stylized to enhance the painting's emotional appeal.

In this book the horse will be used as the basis for understanding the physical structure of animals. The wild duck will serve as the model for the structure, wing construction, and flight characteristics of birds. If you understand the bone and superficial muscle structure of the horse, you should not have any trouble drawing other animals, whether they are large or small. Their anatomy is basically the same.

However, it is important for artists to understand that great animal art requires a knowledge of the subject that is to be painted. The success of the illustrations is dependent upon the artist's design, enthusiasm, and emotional interpretation.

This book is designed to assist the artist and the sculptor in approaching these problems. The comparative anatomical drawings and sketches of animals and humans, and the accompanying text, will be a guide to understanding their actions.

1

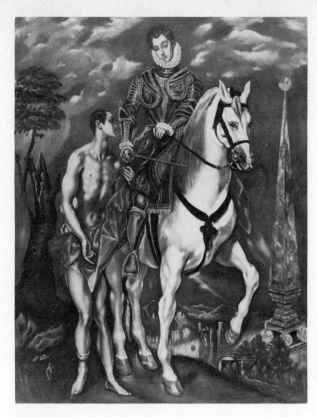

Figure 0.1
JORGE MANUEL THEOTOCOPULI
(Spanish, (1578–1631)
*Saint Martin Dividing His Cloak with
the Beggar.*
Courtesy of the John and Mable Ringling
Museum of Art, Sarasota, Florida.

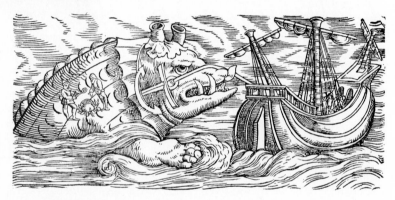

Figure 0.2
KONRAD GESNER (German, 1516–1565)
From *Curious Woodcuts of Fanciful and
Real Beasts.*
Courtesy of Dover Publications, Inc.

Figure 0.3
RIOGETSU (Japanese)
Duck (woodblock print on paper).
From the collection of the author,
courtesy of the Charles F. Tuttle Co., Inc.

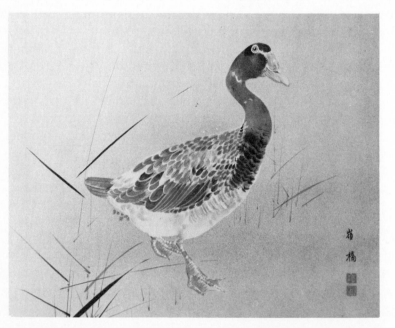

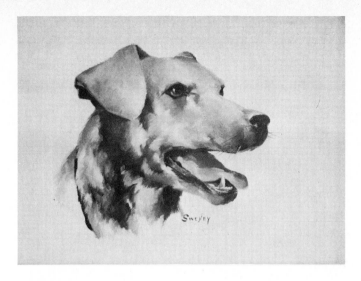

Figure 0.4

Figure 0.5
PAUL BROWN (American, 20th century)
From *The Horse in Sport.*
Courtesy of *Sports Afield* magazine.

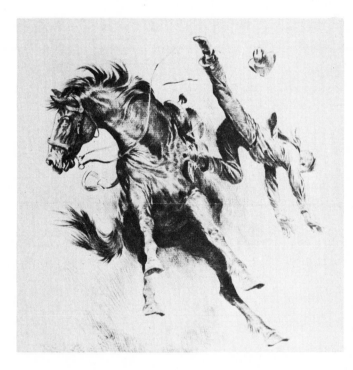

Figure 0.6
R.H. PALENSKE (American, 20th century)
And He Just Loves Horses (etching).
From the archives of and copyright
Brown and Bigelow, St. Paul, Minnesota.

Figure 0.7
PAUL BROWN (American, 20th Century)
From *The Horse in Sport.*
Courtesy of *Sports Afield* magazine.

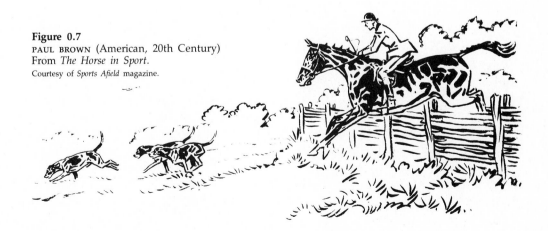

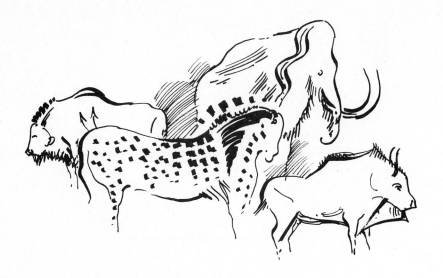

The first artist

FROM THE SLIMY, FOUL-SMELLING SWAMP of 250 million years ago, the amphibians, those sluggish creatures of the reptilian world, took their first tentative footsteps into the Paleozoic period. From this ancestral beginning the reptiles, birds, and animals had their birth. Humans did not appear until many millions of years later. The golden age of the dinosaurs lay ahead, but the first bird, Archaeopteryx, a magnificent, crow-sized, reptile-like creature with the beautiful feathers, already was here. (See Figure 1.1.)

During this era, when gigantic, cold-blooded, egg-laying vertebrates roamed the world, many warm-blooded creatures who bore their young alive and nursed them through infancy also inhabited this planet. The mammoth and the woolly rhi-

noceros searched for food, and they in turn were being hunted by the Neanderthal.

The sabre-toothed tiger (Figure 1.2) still prowled the land but, inexplicably, these giants—the mammoths, mastodons, and sabre-tooths—died quickly as the ice retreated toward the north, leaving the smaller animals, such as the rabbits, reindeer, and bison, to replenish and inhabit the earth.

The Cro-Magnon, who replaced the Neanderthal of the Stone Age 35,000 years ago, were successful in recording their impressions of the animals and birds of their time. Some of these illustrations are found on the walls and ceilings of the caves at Lascaux, Niaux, and Rouffignac in France, and at Spain's Altimira Cave.

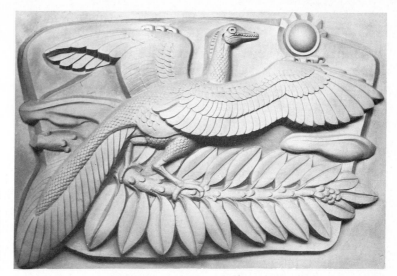

Figure 1.1
VIKTOR SCHRECKENGOST (American, 20th century)
Archaeopteryx (glazed colored terra cotta).
Courtesy of Viktor Schreckengost and the Cleveland Zoo, Cleveland, Ohio.

Culturally superior and intelligent, the Cro-Magnon set the pattern for contemporary families. Although they hunted most of the day in order to live, they still found time to produce beautiful art.

They endured extreme hardship and privation in a primitive and hostile land and environment. It is not surprising, then, that they would paint and sketch animals and birds that they hunted each day. Interestingly, very few human figures appeared in their art. The animals and birds were more important to them because they faced them daily when hunting for food.

The Cro-Magnon were very versatile in their art. In addition to the drawings, they made sculptures in the round and cut engravings into cave walls.

The sculptures give insight into Cro-Magnon life. These early humans are to be admired for the spark of intelligence that guided them into leaving their artistic mark on the walls of caves for posterity to learn from and enjoy.

The caves that served as homes were practically devoid of decoration. The great cave art that we know of today is restricted to the caves that had labyrinths of deep underground galleries and passages, and subterranean pools and rivers with colorful parades of stalactites and stalagmites. Since these caves were dark and mysterious, people had to carry torches or

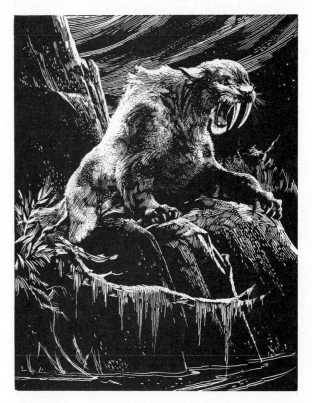

Figure 1.2
Sabre-toothed Tiger.

A large carnivore with long, cutting canine teeth; became extinct during the Pleistocene period.

fat-filled stone lamps in order to enter them.

Cave art depicting animals and wild game are at present the oldest graphic representation of form in the history of the human race.

5

Cave art does not exhibit any abstract, expressive forms of symbolic subjects, but these sketches and paintings are the masterpieces of Cro-Magnon, considering their limitations in terms of tools, equipment, and cramped working areas.

Lascaux was the most recent cave to be discovered, and it is without doubt the most interesting. A dog fell into a crack, and this accident led to the discovery of Lascaux. No one knows when the next cave might be found by a picnicker or a wandering animal seeking shelter. The cracking of a thin wall might also reveal the existence of additional caves. Some of the paintings are located in the worst possible places for viewing, behind rocks and in narrow niches.

What could have been the purpose of these out-of-the-way paintings? According to experts, this art provided a means of employing magic before a hunt.

Cro-Magnons were well equipped with all of the necessary weapons for a successful hunt, but in spite of all their powers and equipment they knew that they would face extremely dangerous animals that could cost them their lives. They also felt that if they painted pictures of the animals they wished to kill, this would forestall a tragic ending to a hunt.

Quite often primitive people would fabricate an enemy, an animal, or other game into a wall painting or clay sculpture in order to attack it physically in the hope that the real object itself would be injured or killed. To kill the game by throwing a spear toward the painted image would assure them of success in the forthcoming hunt.

Performing magic and religious rituals before the hunt was believed to magnify the power of the "wish picture." The fact that more than one painting occupies the same space suggests that a new painting was not for display but was used for new magic for the next hunt.

This brings up the question: Were these paintings made by a single person within a community or were they made by more than one artist? After a study of these cave paintings the viewer is not aware of any obvious differences in technique or style.

Apparently, good wall space was at a premium since concentrations of paintings occupy certain favored areas, possibly because these spots were thought to have stronger magic.

Cave magic required magicians. There are more than fifty known pictures of dancing shamans that look like human figures dressed in animal skins, sometimes even with animal heads and antlers.

Increasing numbers of families and hunters, as well as seasonal migrations, resulted in a scarcity of game that caused Cro-Magnon to resort to additional hunting magic.

It is also conceivable that, in this language-less culture, the cave paintings served as technical illustrations used to instruct new hunters.

Since the cave art was not located near an entrance, these paintings were obviously not made for decorative purposes, and they were not thought of as "fine art" by their creators. Instead, they were magical weapons to ensure a successful hunt.

CHAPTER TWO

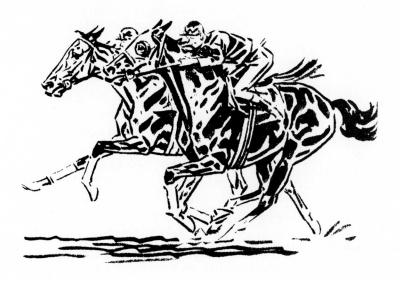

The horse

Portrayals of the horse date back 35,000 years to the time when they were sketched on the walls of caves in France and Spain. The horse, with its magnificent grace, strength, and beauty, always has been a challenge for the artist.

HISTORY

If we trace the lineage of the horse back to its ancestral beginnings, we go back in time 55 million years to a twelve-inch-tall creature named Eohippus ("the dawn horse"). This small, four-legged, horse-like mammal with splayed four-toed forefeet and three-toed hindfeet wandered the forest floor of the Eocene epoch.

As the urge to run on the developing grasslands and savannas increased, the horse's evolution raised it up onto its central toes. The side toes or digits slowly disappeared, leaving only vestigial evidence that they ever existed. The central toe evolved into the hoof.

The advent of the Ice Age had important effects on the development of the horse. Probably the most important phase of this chilling of the North American continent was the lowering of the level of global sea water caused by freezing. When the water level had been lowered by several hundred feet, a land bridge was formed between North America and Eurasia. This bridge made it possible for the primitive horses, which had developed in North America, to migrate to Eu-

rasia. Eventually, with the drift of the continental land masses and the melting of the ice, the Bering Strait filled with water, and the horses that had completed the long journey gradually spread over all of Europe. The North American horse then became extinct during the Ice Age.

Historians are not certain where or when the first horse was domesticated, but apparently the nomadic tribes that wandered over the steppes about 2,000 years ago were instrumental in capturing, taming, and breeding horses from one corner of Europe to another.

The Assyrian artists were among the earliest to leave graphic evidence that the horse had been tamed and was being ridden.

Historians also have credited Columbus with being the first to bring cattle and good Spanish horses to Santo Domingo on his second voyage to America in A.D. 1493, thereby completing the circle—from North America to Eurasia and back again.

This animal still manages to survive in our modern, mechanized world, and there are today more than 100 breeds of horses and ponies. They come in all sizes, large and small, the heavyweights and the lightweights, the working horses and the domestics, along with the innumerable types of riding horses, the wild horses, the horses that are caught up in the social world of polo, the sportsmen's matched bays, and the race horses with their brilliantly clad jockeys, just to name a few.

Dictionaries generally describe this beautiful animal with just a few brief words: *Horse*—A large, strong, herbivorous mammal (*Equus caballus*) with a solid hoof and a long mane and tail, that is used in the domestic state as a draft or a pack animal, or one that is used for riding.

As children we were all introduced to the horse and the pony early in life, along with all the assorted cute pictures of kittens, rabbits, and puppy dogs. We probably do not remember all of the glorious hours we spent riding rocking horses in our wonderful world of make-believe.

KNOWING YOUR SUBJECT

One of the most important rules for drawing and painting animals is that you should understand your subject before you start, especially with the horse because it is so variable in its character, size, and moods.

Knowledge of the anatomy of the horse will enable an artist to paint all types of animals, whether they are horses, dogs, cats, or exotic animals from faraway lands.

Precise attention to anatomy should not, however, inhibit the style or manner in which the artist executes the painting or drawing. The artist may use a realistic style, such as in the outstanding oil painting "Saddling the Blue Roan" by Melvin C. Warren (Figure 2.9), or a more stylized interpretation, as in the stylized woodcut by Albrecht Dürer (Figure 2.1) or the interesting ink drawings by Paul Brown (Figures 2.2, 2.8, and 2.14). Whether a painting is realistic, stylized, or distorted, the basic fundamentals of anatomy still hold true for the subject matter.

It is helpful to understand the bone and muscle structure of animals, but certainly not to the degree that is required of a veterinarian. It is more important to be aware of the moods, actions, and attitudes of animals since they are as individual as people. No two animals are the same. An understanding of the bone and muscle structure will certainly help you when you are sketching animals, especially short-haired animals like the horse, dog, deer, and antelope.

PHOTOGRAPHS

The camera should be considered as a tool for gathering information. Photographs should not be copied slavishly. You will have a better drawing or painting if you draw from what you know exists and not necessarily just what you see.

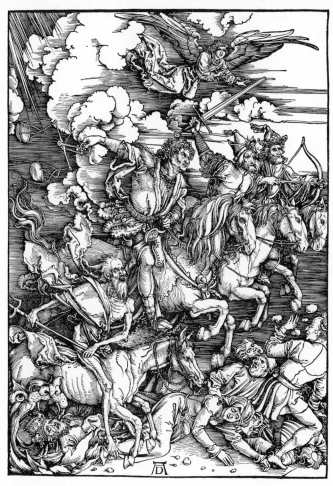

Figure 2.1
ALBRECHT DÜRER (German, 1471–1528)
The Four Riders of the Apocalypse (woodcut).
Courtesy of Dover Publications.

Figure 2.3
FREDRIC SWENEY (American, 20th century)
Frisky (scratchboard).

Figure 2.2
PAUL BROWN (American, 20th century)
From *The Horse in Sport*.
Courtesy of *Sports Afield* magazine.

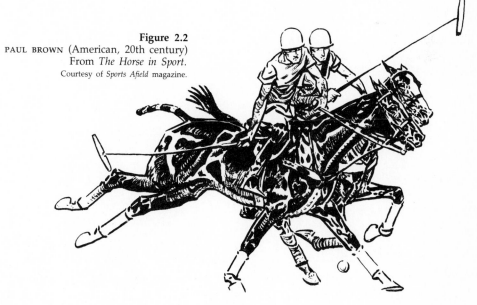

SCULPTURES

Sculptures make ideal models for the beginning painter of animals. It is very frustrating for the artist to be all prepared to make some sketches of a horse and then have the model walk away. Sculptures do hold still, and all of the preliminary studies—the pose and sketches—have been made for you. However, be sure that the sculpture you are drawing is the work of a master. None can be better than the dramatic, realistic "The Fighting Stallions," by Anna Hyatt Huntington, who was acclaimed for over half a century in Europe and America for her portrayal of animals and birds. (See Figure 2.4.) Her sculptures are found in more than 250 museums, parks, and public gardens. One of her most famous pieces is the equestrian statue of Joan of Arc, which can be seen on Riverside Drive in New York City, in Gloucester, Massachusetts, and in Blois, France.

The painting of "The Appaloosa" (Figure 2.5) is one of the few that I have made for myself, just for the joy of drawing and painting a horse in action. The model for this painting was a small plaster cast. Sketches were made first, and then,

as the idea evolved, the action was gradually changed. A Southwestern background was introduced, and the back lighting of a blazing white sun with a yellowish sky and clouds completed the painting.

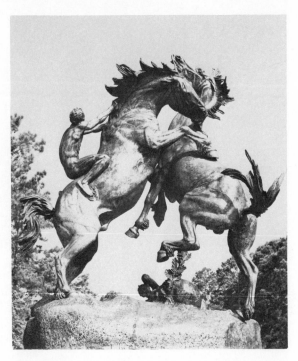

Figure 2.4
ANNA HYATT HUNTINGTON (American, 1876–1973)
The Fighting Stallions (sculpture).
Courtesy of Brookgreen Gardens, Murrell's Inlet,
South Carolina.

Figure 2.5
FREDRIC SWENEY (American, 20th century)
The Appaloosa (oil).
Courtesy of Mrs. Fredric Sweney.

ANIMALS IN MOTION

All artists are illusionists, actors, or magicians in that they give the feeling of motion to animals and their attitudes according to the situation they wish to portray.

Artists use every device possible in order to create action. Rhythm and sweep in your drawing or painting will create a feeling of motion. The background also plays an important part in creating this motion. The sweep of clouds or a storm across the sky, grass being whipped by an angry wind, clouds of dust raised by a bucking bronco, the rider being tossed from his saddle, or a horse leaping over a fence all give the illusion of motion. The first aspect of animal motion that we must understand are the gaits of animals.

All artists interested in painting and drawing animals will treasure *Animals in Motion* by Eadweard Muybridge, originally published in 1899 and now available from Dover Publications. This monumental photographic work illustrates, step by step, the various gaits of animals. It exposes some of the inaccuracies in some of the early paintings of fox hunts and the fact that horses do not always run as depicted.

Figure 2.6

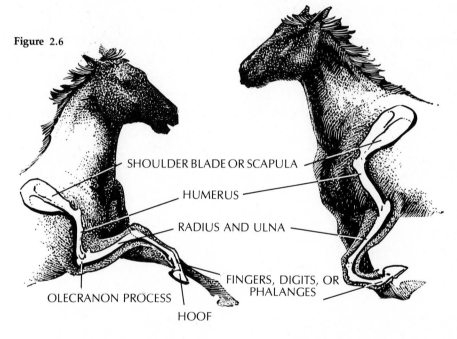

SHOULDER BLADE OR SCAPULA

HUMERUS

RADIUS AND ULNA

OLECRANON PROCESS

FINGERS, DIGITS, OR PHALANGES

HOOF

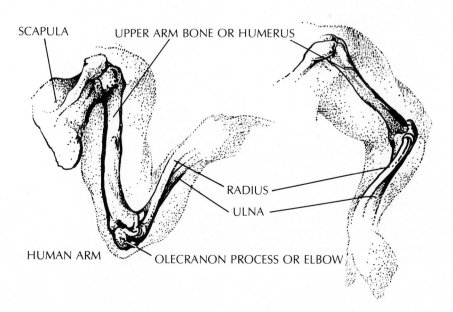

SCAPULA

UPPER ARM BONE OR HUMERUS

RADIUS

ULNA

HUMAN ARM

OLECRANON PROCESS OR ELBOW

The camera has demonstrated that quadrupeds use eight different systems of forward motion on the ground: the walk, the amble, the trot, the rack or pace, the canter, the transverse gallop, the rotary gallop, and the ricochet. Leaping or jumping are variations of the normal gaits.

An important factor in the movement of animals is the change of *lead*. If a horse is turning to the left, it will "lead" with its left front leg, just as a boxer will "lead" with a left jab before delivering a powerful right. When the horse leads with the left leg it is keeping itself balanced on that side. "A horse leads on the side that needs support." It is highly recommended that this important book by Muybridge be added to your library. This is a study within itself and cannot be covered in this book.

The drawings in Figure 2.6 illustrate bone actions of the horse and the human.

The weight of an animal is also very important. A gazelle should be drawn with nimbleness, so as to illustrate quick movement, while the drawing of a horse coming over a high hurdle should show the impact when its hoofs touch the ground. Be careful not to freeze the action and make the horse look as if it is standing on its two front hoofs. A horse landing from a high jump will touch the

ground and push off with its front legs before the hind legs touch the ground. This is similar to showing the spring of a rabbit.

SCHRECKENGOST, BROWN, AND WARREN

Viktor Schreckengost's accomplishments reach into many fields: painting, sculpture, ceramics, stage design, graphics, watercolor, and the many aspects of design for industry. The sculptor is shown at work on the "O'Neil Memorial," with the many sketches necessary to clarify forms for the stylized head of the horse readily displayed on the panel for reference. (See Figure 2.7.) This photograph is worthy of study. It is an excellent example of the use of basics. Viktor Schreckengost is a sculptor with an inherent sense of design, an understanding of structure, and the necessary craftsman's skill for its completion.

Whether you are sculpting, drawing, or painting the horse's head, you have to think "in the round." A painter, through the use of perspective, values, color, and knowledge of the animal's physical forms, gives the illusion of a third dimension on a two-dimensional surface. The same principles apply to the sculptor's studies,

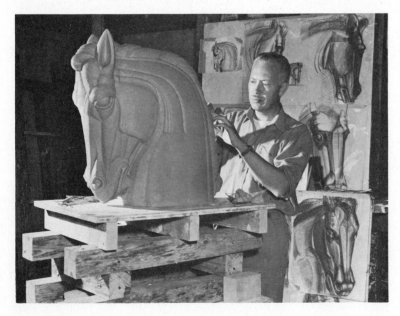

Figure 2.7
VIKTOR SCHRECKENGOST (American, 20th century)
O'Neil Memorial.
Courtesy of Viktor Schreckengost and the Cleveland Mounted Police, Cleveland Ohio.

Brown's placement of the darks to emphasize the turning of the forms shows a deep understanding of the location of the bones and the joints. He obviously knew the anatomy of a horse well and thoroughly understood the many gaits and actions of his subjects. Most of his illustrations dealt with the sophisticated sports that use the horse, such as polo, timber racing, steeplechase, and horse racing.

Brown's black and white drawings were very direct and accurate. (See Figure 2.8.) Many were executed in ink and others were handled in pencil, and he used the vignette to great advantage. His technique was copied by other illustrators. When artists draw or paint with a vignette background, it requires a very accurate foundation with good drawing, design, values, and color. A study of Paul Brown will be a real education in drawing.

"Saddling the Blue Roan" is a painting to be greatly admired. It is a typical, authentic Western scene painted by a real Western artist, Melvin C. Warren. (See Figure 2.9.) It is obvious that he knows horses well.

with the final piece modeled in the round and the color applied with ceramic glazes.

Paul Brown was one of the great American horse artists during the "Golden Era of the Illustrators" (the 1930s). His drawings and paintings graced the pages of numerous national magazines, and he wrote and illustrated many books. His style is unique in its simplicity of design, so outstanding that it became easily recognized as his trademark.

Figure 2.9
MELVIN C. WARREN (American, 20th century)
Saddling the Blue Roan.
Courtesy of Melvin C. Warren.

Melvin Warren paints peaceful pictures, not the violent, hard-riding ones with the dramatic climaxes that pervade many Western paintings. This is a well-designed painting. The dark shed with the weathered boards and posts provides an interesting background for the light-colored roan. The other horses and the cowboy bracket the roan, which forces the viewer's eye to the main subject. This is a realistic, well-painted picture with a lot of feeling.

ANATOMY OF THE HORSE

It is important to learn the anatomy and parts of a horse in order to sensibly and intelligently discuss and locate certain areas, and in order to understand the horse's bone and muscular structure, its actions, moods, and attitudes, and the effect of the various planes and the expressions as we draw and paint them.

I have chosen the American quarter horse as the model we will study, since that is our nation's most popular horse. (See Figure 2.10.) The quarter horse outnumbers its nearest rival, the thoroughbred, by four to one in annual registration (American Quarter Horse Registry—annual registrations average more than 60,000).

Let us take a close look at this horse. It is good-looking, strong but also gentle, yet rugged when working. The stance of the quarter horse is one of its outstanding features. Standing perfectly at ease with the legs well under the body gives the animal the ability to move quickly in any direction, especially when working cattle.

Figure 2.10
Parts of a horse.

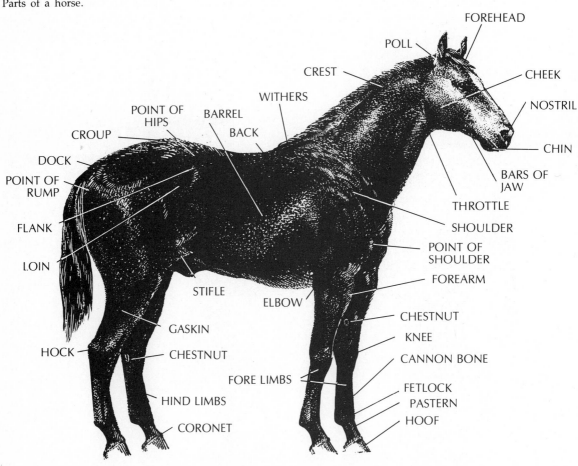

The remarkable qualities of this horse may be divided into three categories. First, ranchers will tell you that this is without doubt the world's finest cutting horse, a great all-around working and roping horse. Second, the quarter horse is a great riding horse and show horse; and, third, it has no peer in sprint racing up to 440 yards—a quarter-mile—the distance for which it is named.

Proportions

The starting point for measuring a horse is a square. (See Figure 2.11.) This is to be considered as an average since some horses will project above the perpendicular or the horizontal of the square, as shown in the "point of the rump" area. A line from point A, the withers, to a line under the heart, point B, is considered a good yardstick to use. Line AB equals line BC. Point C is at the middle of the pastern. In measuring the horizontal, the point of the shoulder D to line E should equal line AC plus one hand. A man's hand measures four inches across the palm. This is the unit used in measuring the height of a horse. A quarter horse may extend beyond line E because of its broad, deep, and heavy rear quarters.

Line AB will equal the distance from the point of the shoulder D to point F, which will be in line with the tip of the nose. It must be remembered that these units of measure are to be considered only as an average. Some horses may be oversized and some undersized.

The height of the American quarter horse will vary between 14.3 to 15.1 hands. (See Figures 2.11 and 2.12.) The height is measured from the ground to the withers. A thoroughbred will usually be sixteen hands. Figure 2.12 shows the height of a quarter horse in relation to a human figure.

Figure 2.11

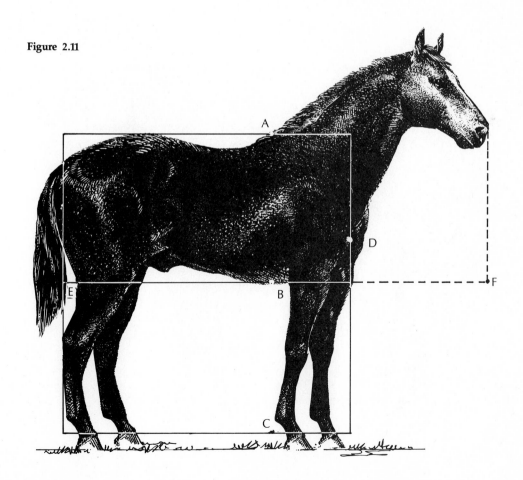

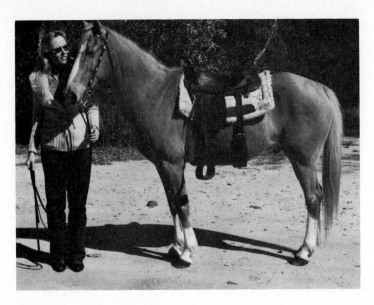

Figure 2.12
Photograph courtesy of Mrs. Mickey Sloat.

Planes of the Horse

Figure 2.13 is a study of the light that would fall upon a horse from an overhead source such as the twelve o'clock sun. In order to have a solid form, your drawing or painting should contain the *light* and a band of *middle-tone*, which is the area that indicates the true color and texture of the subject. The middle-tone may have a wider or narrower band depending upon whether the plane has a gradual or more acute curve. Next in importance is the *core*. This is the darkness that carries the form of the object. In sketching, this is the darkness that the artist will create to show

Figure 2.13

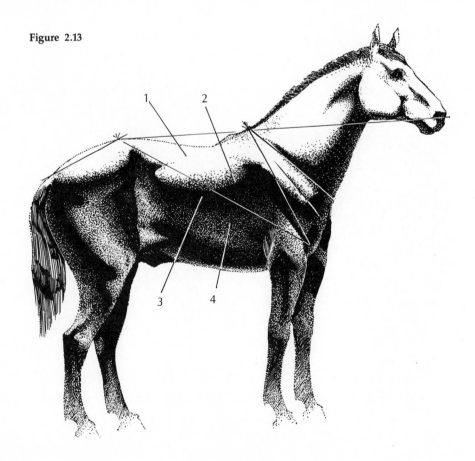

the location of the shadow area. Last, show the *reflected lights*, which are the low lights indicated in the shadows.

1. *The light*—This is dependent on the direction that the light is coming from, whether it is a top light, a side light, a morning sun, or an evening sun casting its long shadows.
2. *The middle-tone*—True color and texture belong to the middle-tone values and only to the middle-tones. An excess of light weakens color and texture while a weak light darkens true color and also weakens the texture by an absence of light.
3. *The core*—This indicates the direction of the forms and is the darkest area on the painting.
4. *The reflected light*—This is the light within the shadow that lets you see into the shadow. If this is not present, your drawing or painting will be flat.

Nomenclature

The following short glossary will make our discussion easier and will assist in locating areas that are being discussed.

Abduct: To pull a form away from the midline. To pull the leg outward.

Adduct: To pull or draw a form or leg of an animal inward.

Anterior: Pertaining to the front, such as the anterior part of an animal, nearer to the head.

Aponeurosis: A broad sheath of tendon or ligament, especially for a flat muscle, such as the aponeurosis that covers the rectus abdominus muscle of the stomach.

Articulation: The connection between bones that form a joint.

Belly: Anatomically, pertaining to the fleshy portion of a muscle.

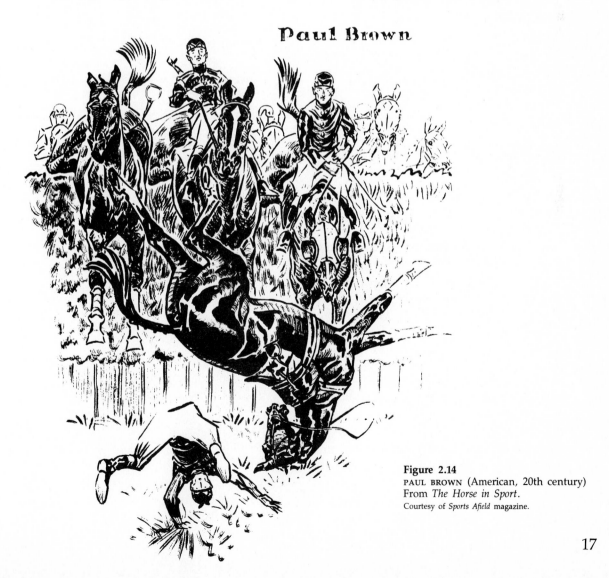

Paul Brown

Figure 2.14
PAUL BROWN (American, 20th century)
From *The Horse in Sport*.
Courtesy of *Sports Afield* magazine.

Bone: A hard, dense, porous but rigid material that collectively composes the skeleton.

Cartilage: A tough, elastic form of connective tissue from which bone ossifies, also known as *gristle*.

Concave: Curving inward. The inside curve of a bowl. The inside curvature of a sphere.

Condyle: The large, rounded, polished projection on the end of a bone that articulates within the cavity of another bone, such as the lateral condyle of the femur (upper leg bone) with the patella (knee cap).

Convex: Curving outward, such as the surface of the earth or the convex form of an egg.

Crest: The ridge on the bone structure of an animal, such as the iliac crest on the pelvis.

Deep: Farthest from the surface, such as a deep-set muscle or form that does not affect the exterior form.

Depressor: The muscle that lowers the leg. The depressor neck muscle of an animal pulls the head downward so that the animal can eat or drink.

Digitate: Muscles arranged like the fingers of a hand; fingerlike process or projection.

Extensor: The extensor muscles straighten out the foreleg of a horse. They also straighten out an arm.

External: The exterior of a form; the external planes of a shoulder.

Fascia: A fibrous, flat connective tissue that envelops muscular structures.

Flexor: A muscle that bends part of a body. The contraction of the flexor muscles causes an arm or leg to bend.

Fossa: A shallow depression for the articulation of one bone with another, such as the glenoid fossa of the scapula (the shoulder blade), which permits the movement of the humerus (arm bone) with the scapula.

Head: The enlarged, rounded end of a long bone such as the humerus (arm bone) or the femur (leg bone) that inserts into the pelvis (hip bone).

Horizontal: At right angles to a vertical or upright axis.

Inferior: The weaker part or area farthest from the head or the lowest form.

Insertion: The section where a muscle, through its connective tissue (tendon), attaches to a part or bone that moves.

Internal: Refers to the inside of a form or cavity, such as the lungs which are inside the ribs.

Interstices: The area between bones or objects, such as the interstices between ribs, particularly membranes and muscles.

Joint: A connection between two separate bones.

Lateral: Pertaining to the side or sides, such as the lateral section of the pelvis or the rib cage.

Levator: The muscle that causes a leg to be raised.

Ligament: The tendon that connects a muscle to a bone or a broad band that wraps around a group of bones, such as at the wrist joint. A very strong fibrous material.

Longitudinal: Running lengthwise or extending from head to tail.

Midline: Divides forms into right and left sides, such as the midline of the chest or body.

Muscle: Bundles of elongated fibers that are capable of contractions that produce bodily movements.

Oblique: Running at an angle to the vertical axis, such as the external oblique muscle on the side of the chest.

Origin: The primary source; the beginning of a muscle.

Posterior: The rear or back section of an animal, the hindquarters.

Process: An accessory prominence or projection on a bone, usually for movement, such as the elbow (olecranon process of the ulna).

Prone: The hand turned inward or the palm facing downward.

Ramus: A platelike division of a forked structure, such as the ramus of the mandibula, also called the mandible (the lower jaw).

Rotate: To turn or cause to turn.

Serrations: The sawlike edge formed where two muscles interdigitate, forming a woven appearance.

Shaft: The main portion of a long bone.

Sphincter: A ring-shaped muscle that circles an opening or tube in the body and closes it.

Spine: The spinal column of a vertebrate; the backbone of a human; also any sharp ridge or projection, such as the spine of the scapula (the shoulder blade).

Superficial: Refers to a muscle, form, or part nearer to the surface or skin.

Superior: Higher grade, nearer the head, or the stronger area.

Supine: The supine position of the hand has the palm turned upward.

Suture: The interlocking of two bones at their edges, particularly in the skull.

Symphysis: The joining of the right and left sides, such as a joint, usually by a cartilage, at the anterior or front section of the pelvis (the pubic symphysis).

Tendon: A strong connective ligament that forms the origin or termination of a muscle to the bone; a sinew.

Tensor: The muscle that tightens up a muscular form.

Transverse: Pertaining to forms across the long axis or from side to side across the long axis.

Trochlea: A smooth, pulleylike surface or spool that permits a smooth, effortless motion of one part over another, such as in the elbow joint.

Tuberosity: A large, rough eminence or bump on a bone for the insertion or attachment of a tendon or a muscle.

Vertical: Extending up and down or perpendicular to a horizontal plane.

Skeleton

From an animal artist's point of view, the most important part of the anatomy is the skeleton. Knowledge of bone structure, particularly the construction of joints and their movements and limitations, is paramount.

General knowledge of the shapes of muscles, their origins and terminations, and their actions is also needed. An artist equipped with this background should not run into any serious problems while drawing and painting wildlife. This knowledge will help the artist to "see" the hidden skeleton of the animal that is being sketched, particularly at a zoo, since zoo animals usually are on the move. Sketching animals in the wild is a lot more difficult and can be very frustrating for the beginner, because they will not pose for you.

The simplified drawing of the skeleton of the quarter horse in Figure 2.15 will help you to see that it can be separated into just a few units.

Vertebral skeleton. It is not important to draw every vertebra, but it is important to simplify it into a workable, continuous form. Attached to the spine (which includes the neck area) is the skull, the thorax (the chest), the lumbar (the small of the back between the chest and pelvis), the croup (the pelvis or hip bone), and the tail (the sacrum or tailbone). These units are known as the *vertebral skeleton,* and this is what we will study first. Also attached to the vertebral skeleton are the forelegs and the hindquarters, which we will study later in this book.

The skeleton of the quarter horse in Figure 2.15 was purposely simplified, since there are excellent books available and most artists do not want to get too involved with details here. I would suggest *An Atlas of Animal Anatomy for Artists* and *Atlas of Human Anatomy for the Artist* as references, as listed in the Bibliography.

Referring to the drawing of the bone structure, Figure 2.16, see the dotted line that defines the area of the vertebral skeleton. Starting from the skull, which we will study later in detail, we come to a very important part, the neck, which consists of seven vertebrae. Interestingly, all animals, including the giraffe, have seven vertebrae. The difference is in their size. Of these seven, the first vertebra, the *atlas* (which supports the skull), and the *axis* upon which the atlas rotates, are the most important.

The next section of importance is the *dorsal vertebrae,* which consists of eighteen

Figure 2.15

Figure 2.16

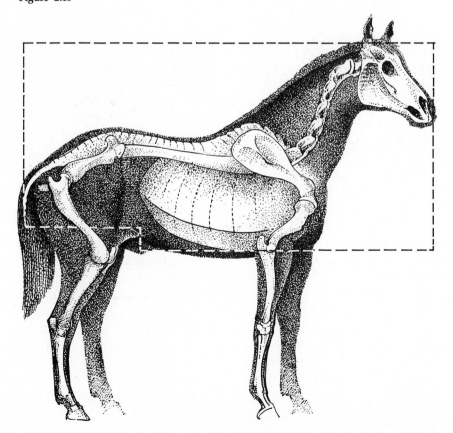

vertebrae. In other animals the number of vertebrae varies. For example, it ranges from eighteen in the horse to twelve in the camel. (The human body also has twelve.) These vertebrae support the ribs and also the *sternum* (breastbone), which encloses the lungs and heart. The *lumbar*, also known as the small of the back, consists of six vertebrae, although the Arabian horse sometimes has only five. The camel has seven. Notice that the spinous processes have two peaks, one in the shoulder blade area and the other between the lumbar and the pelvis. These processes are important because they help to define the contour of the back.

The next and last section is the *croup*, also known as the *haunch*. This also includes the tail vertebrae, which in the horse number eighteen. These areas will be studied individually.

Bones of the rib cage. The rib cage, also known as the *thorax*, is constructed of bones and cartilage. It consists of three parts, the dorsal or thoracic vertebrae, the ribs and their cartilages, and the sternum. It is designed to protect the heart and lungs and is also elastic and yielding, which is necessary for breathing. (See Figures 2.17 and 2.18.)

The human thorax (Figure 2.18) contains twelve pairs of ribs, while the horse (Figure 2.17) has eighteen pairs of ribs. In the human rib cage there are seven pairs of true ribs that connect directly to the sternum, while the remaining five are called false ribs since they do not connect directly to the sternum. Ribs eight, nine, and ten are attached to the sternum by a common, cartilaginous strap, while the last two, called "floating ribs," do not attach to the sternum.

Figure 2.17

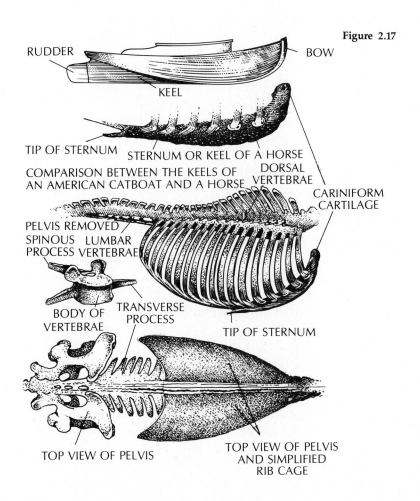

RUDDER

BOW

KEEL

TIP OF STERNUM STERNUM OR KEEL OF A HORSE

COMPARISON BETWEEN THE KEELS OF AN AMERICAN CATBOAT AND A HORSE

DORSAL VERTEBRAE

CARINIFORM CARTILAGE

PELVIS REMOVED
SPINOUS LUMBAR
PROCESS VERTEBRAE

BODY OF VERTEBRAE

TRANSVERSE PROCESS

TIP OF STERNUM

TOP VIEW OF PELVIS

TOP VIEW OF PELVIS AND SIMPLIFIED RIB CAGE

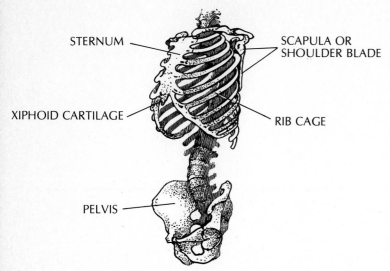

STERNUM

SCAPULA OR
SHOULDER BLADE

XIPHOID CARTILAGE

RIB CAGE

PELVIS

Figure 2.18

The first eight ribs in the horse are true ribs while the last ten attach to the sternum by a continuous cartilage. There are no floating ribs in the horse.

Also note that the spinous processes of the horse are very large, particularly those near the shoulder blades. The tip of the fourth vertebra is the junction point where the neck line terminates as it enters the trunk line.

There is a decided variation in the construction of the sternum of the horse. It is called the *cariniform cartilage.* This cartilage is an extension of the keel of the sternum that continues forward and upward, terminating roughly near the height of the point of the shoulder when a horse is in the standing position. This point is important in drawing because it is the termination of the neck.

Bones of the head and neck. An important part of the vertebral skeleton is the head and neck. (See Figure 2.19.)

It is important for the artist to understand the construction of the neck because it plays an important role in the movements and actions of an animal. However, it is not necessary for the artist to draw the details of every vertebra because they should be considered as a simplified single unit, commonly called the "stalk of the neck." This stalk consists of seven cervical vertebrae.

The giraffe has the same number of vertebrae as the human, the only differences being that those of the giraffe are longer. The ox, camel, deer, dog, cat, pig, and sheep all have the same number of cervical vertebrae. The greatest difference in the number of vertebrae in the animal world will be found in the thorax, lumbar, and pelvic areas.

The two most important cervical vertebrae are the *atlas* and *axis.* The atlas is attached directly to the skull and moves with the head as it turns. It does not conform with the general shape of a vertebra (Figure 2.17), as it consists only of a ring with two, large, rounded, winglike transverse processes. (See Figure 2.20.) These two processes are just below the surface and are a landmark in drawing, particularly for short-haired animals such as the dog, deer, horse, and cattle.

The axis, whose position is not visible on the surface, is also very important to the artist, for it is the vertebra upon which the atlas rotates. The atlas and the axis turn with the head, but the greatest movement will be between the second and third vertebrae. (See Figure 2.20.) As you will notice in the photograph, there is a slight curve to the whole neck but the greatest rotation is near the head. This action must be understood in order to be able to draw or paint a convincing picture that will not look awkward to the viewer.

The skull. In order to draw or paint the head of a horse, a thorough understanding of the bone structure is an absolute necessity. Copying a photograph is not always the answer, as you will have to cope with such things as camera distortion and unsatisfactory lighting. To the artist, the photograph is considered only a means of gathering information. The photograph of the horse's head (see Figure 2.21) will help you locate the planes, the mouth, eye structure, and the ears, but most damaging to the artist who copies a photograph exactly is the fact that the artist is not really expressing himself.

There are a set of photographs at the end of each chapter that are to be used

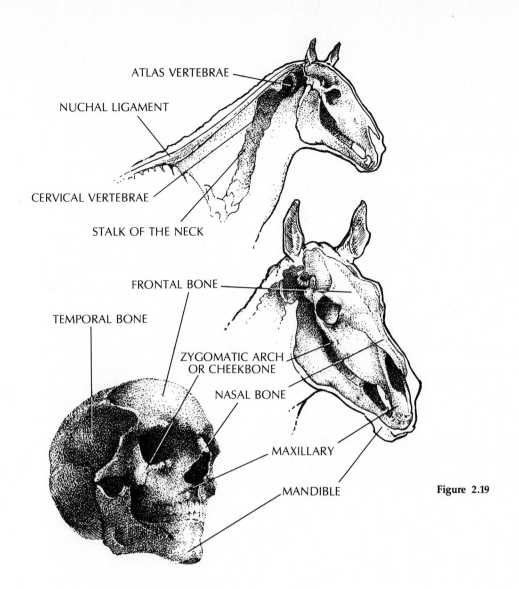

ATLAS VERTEBRAE

NUCHAL LIGAMENT

CERVICAL VERTEBRAE

STALK OF THE NECK

FRONTAL BONE

TEMPORAL BONE

ZYGOMATIC ARCH
OR CHEEKBONE

NASAL BONE

MAXILLARY

MANDIBLE

Figure 2.19

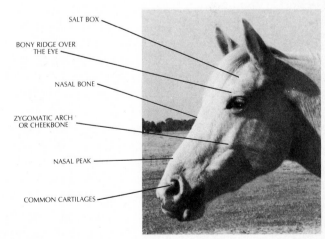

SALT BOX

BONY RIDGE OVER
THE EYE

NASAL BONE

ZYGOMATIC ARCH
OR CHEEKBONE

NASAL PEAK

COMMON CARTILAGES

Figure 2.21
Photograph courtesy of Mrs. Richard Kuchcicki.

Figure 2.20
Photograph courtesy of Mrs. Richard Kuchcicki.

23

only as reference material. Photographs such as these will help you get started, but you should make your own studies from them, and these should include the landscape or background as well. Assemble them into a pleasing composition and then paint your picture. You will be a lot happier with the result and you can then call it your own.

You will notice that the skulls of the horse and the human have the same bones. (See Figure 2.19.) The only differences are that in the horse the facial bones are extended and the brain case is smaller. There are also minor variations in bone structure, depending on the breed.

The skull of the horse consists of six sides, as does the human skull. (See Figures 2.19 and 2.21.) The top of the horse's skull is the *parietal* bone and its ridge. The bottom is the *occipital* bone, the base of the skull, which is very evident on the human but not on the horse since it is deep within the neck structure. The two sides are formed by the *temporal bones* that encase the brain cavity, the *zygomatic arches* that form the cheeks, the *maxillary* and *mandible bones* that make up the sides of the mouth, and the *frontal* and *nasal bones* that form the front of the face.

In the lower left-hand corner of Figure 2.22 there is a small sketch of a kite. This is the beginning framework for drawing the horse's head. Line AB serves as a center line and the cross line CD locates the eye line. The length of the eye line is approximately one-half the length of the horse's head. Line CD is at right angles to line AB and is approximately one-third the length of the center line. Keep in mind that we are dealing with perspective, so the center line and the cross line should be foreshortened accordingly.

Square off the tip of the kite at point B, and that will give you an approximation of the nose position. Draw another line parallel to eye line CD about two-thirds down center line AB, and that will give you the approximate position of the end of the zygomatic bone, or cheek. In drawing a side view, the nose, eye, and ear line up in a straight line.

Pay particular attention to the construction of the *alar* cartilages, also known as the comma cartilage of the nose. These cartilages open and close the nostrils of the horse when it is breathing heavily or quietly. (See Figure 2.23.)

Additional attention should be paid to the construction of the nostril. Each nostril is divided into two sections: the true nostril, through which the air passes through to the lungs, and the false nostril that is located above the head of the alar cartilage. This false nostril does not serve any particular purpose. When the true nostril is fully opened, it tends to close the false nostril.

Other important parts of the horse include the mouth and the lips. Not all animals eat the same way. The horse, camel, sheep, and goat use their lips to eat. They use their incisors or front teeth to cut or nip the grass. (See Figure 2.22.) There are twelve incisors, six above and six below. Behind the incisors are the canines, two above and two below. These teeth will show when horses are fighting, biting, or whinnying.

The three centers of expression for an animal are the mouth, the eyes, and the ears. First in importance are the ears, with the mouth second and the eyes last. Most of the emotions of animals are expressed with the ears. There are many shapes and sizes of ears, as well as many degrees of firmness. The general form of ear structure is consistent with all breeds; the obvious difference will be in its main form, known as the *auricle*. Some animals are prick-eared, such as horses, cats, and quite a few dogs (like the German Shepherd). Prick ears usually indicate alertness. Many dogs have ears that fall forward, especially sporting dogs like pointers, setters, spaniels, and retrievers. Dogs with pendulous ears are considered to have a gentle nature. Ears of this type will be found in beagles, bloodhounds, and bassets.

For simplicity, the ear will be divided into three parts: the external ear, known as the *auricula*, which is a funnel-shaped organ that collects the sounds and directs

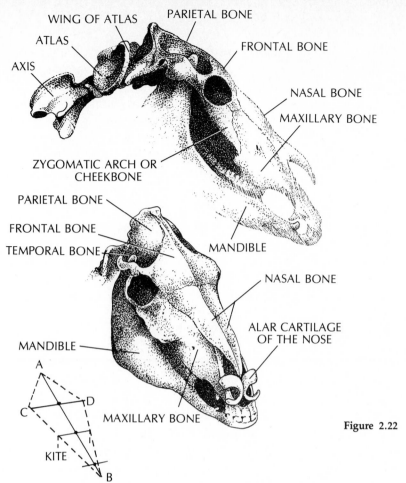

WING OF ATLAS
ATLAS
AXIS
PARIETAL BONE
FRONTAL BONE
NASAL BONE
MAXILLARY BONE
ZYGOMATIC ARCH OR CHEEKBONE

PARIETAL BONE
FRONTAL BONE
TEMPORAL BONE
MANDIBLE
NASAL BONE
ALAR CARTILAGE OF THE NOSE

MANDIBLE

MAXILLARY BONE

A
C
D
KITE
B

Figure 2.22

Figure 2.23

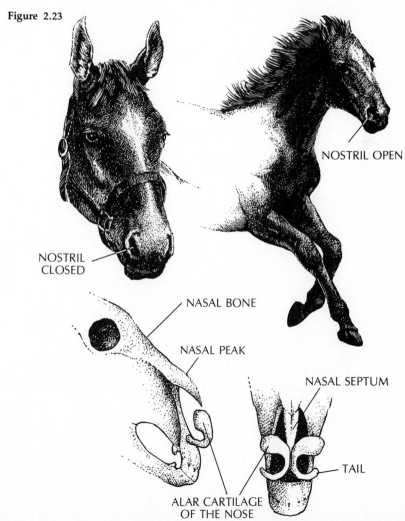

NOSTRIL OPEN

NOSTRIL CLOSED

NASAL BONE
NASAL PEAK

NASAL SEPTUM

TAIL

ALAR CARTILAGE OF THE NOSE

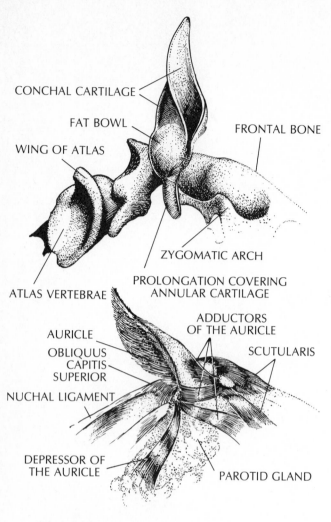

CONCHAL CARTILAGE

FAT BOWL

WING OF ATLAS

FRONTAL BONE

ZYGOMATIC ARCH

ATLAS VERTEBRAE

PROLONGATION COVERING ANNULAR CARTILAGE

AURICLE

OBLIQUUS CAPITIS SUPERIOR

ADDUCTORS OF THE AURICLE

SCUTULARIS

NUCHAL LIGAMENT

DEPRESSOR OF THE AURICLE

PAROTID GLAND

Figure 2.24

Figure 2.25
This photograph shows the front view of the ear structure. Remember that the ear can rotate forward and backward on its ball-and-socket joint.
Photograph courtesy of Mrs. Ronald Cyril.

them toward the inner ear; the *choncha cartilage*, also known as the *auricular cartilage*, which determines the shape of the ear; and the *subcutaneous muscles* that control the ear's actions. (See Figure 2.24.)

The ears, which operate independently of each other, rotate on a ball-and-socket joint that is formed by the fat bowl of the concha revolving on the nearby parotid gland.

The muscles that control the movements of the ear are many and complex. It is not necessary for the artist to learn all of these; just a few will suffice. The *adductor muscles* are used to erect the ear vertically and to turn it forward. These are the *scutularis* (see Figure 2.24) and the three adductors of the auricle. The *depressor* of the auricle and the *obliquus capitis superior* pull the ear downward and backward. There are many other small muscles that are also involved in rotating the ear, but they are not visible and are therefore of no importance to the artist.

Bones of the foreleg and hoof. Animals with hoofs belong to a large division called *ungulates*, which include the elephant, rhinoceros, hog, and horse, as well as cud-chewing animals (*ruminants*), deer, sheep, goat, bison, camel, and giraffe. All of these use their forelimbs and hind limbs, which are restricted to forward and backward movements only, as a means of traveling from one place to another.

The bones of the forelimb of animals, like those of the human arm, have four parts: the shoulder blade, the upper arm (*humerus*), the lower arm (*radius* and *ulna*), and the hand section (*pastern* in animals) consisting of the wrist, palm, and fingers. (See Figure 2.26.)

In the human the shoulder girdle includes the collar bone, the shoulder blade, and the *coracoid process*, which is a small projection of bone that extends forward from the back side of the *scapula* (shoulder blade) for the attachment of muscle. This girdle is fully developed in birds and lower mammals and is typical for the horse, the ox, and the deer, in which the forelimbs are used for support and loco-

motion, the coracoid process is reduced to a minor projection, and the collar bone does not exist. The absence of the collar bone allows animals like the horse and deer to jump great distances. One steeple-chaser schooled (jumped) over a hurdle a record distance of thirty-nine feet.

One difference between the construction of the human forearm and the similar section of the horse's lower limb is that the human forearm has two bones, the radius and the ulna, while in the horse the radius and ulna are fused into one. Figures 2.26 and 2.27 explain the construction from the wrist to the hoof. The *cannon* bone is formed by the fusing of the five bones that make up the palm of the human hand. The section from the *sesamoid* bones to the hoof corresponds to human fingers. (See Figure 2.27.)

Bones of the pelvis. The skeleton of the *croup*, also known as the *haunch*, has two bones that form the outer prominences of the pelvis and provide the hip sockets for the hind leg bones. It also includes the *sacrum*, which is a continuation of the spine terminating with the tip of the tail. The consolidation of these parts forms the *pelvis*, the solid platform of the hip area that provides for the articulation of the leg bones. (See Figure 2.28.)

The human sacrum is the vestigial trace of a tail, commonly known as the tail bone. It usually consists of five to seven caudal vertebrae. The tail of the horse has eighteen caudal vertebrae. In a drawing, the pelvis can be simplified by indicating the angle of the haunch and the angle of the buttocks, with the center line beginning with the angle of the croup and terminating with the tail.

Figure 2.29 illustrates the tilt of the croup when a horse is resting a hind leg. Figure 2.30 is a back view of the horse taken with a telephoto lens. It shows the distortion of a photo, which should be corrected. The head, too large, should be drawn smaller so that it looks in proportion.

Bones of the hind limb. The bones of the hind limb are the same as those in the

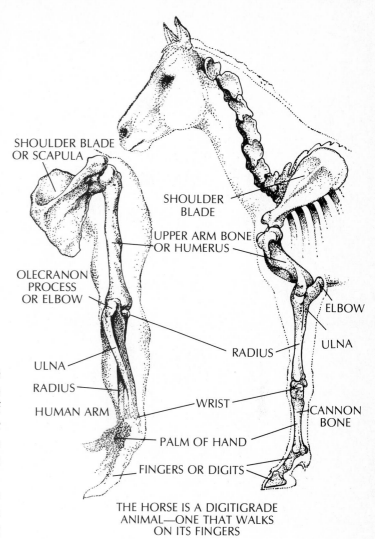

THE HORSE IS A DIGITIGRADE ANIMAL—ONE THAT WALKS ON ITS FINGERS

Figure 2.26

Figure 2.27
Photograph courtesy of Mrs. Richard Kuchicicki.

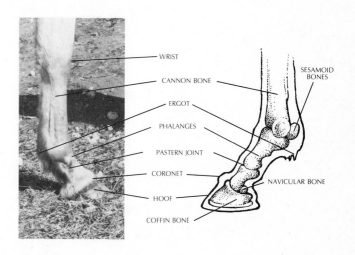

27

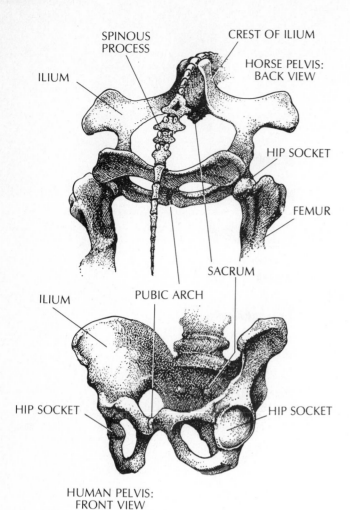

SPINOUS
PROCESS

CREST OF ILIUM

HORSE PELVIS:
BACK VIEW

ILIUM

HIP SOCKET

FEMUR

SACRUM

ILIUM

PUBIC ARCH

HIP SOCKET

HIP SOCKET

HUMAN PELVIS:
FRONT VIEW

Figure 2.28

human skeleton. (See Figures 2.28 and 2.31.) From the pelvis to the knee cap or patella, there is only one bone, called the *femur*. The next section is from the knee cap to the heel joint, and consists of the knee cap, tibia, and fibula. This section in the horse is called the *gaskin*. The last part consists of the heel bone, the *cannon* bone, which is the same as the *metatarsal arch* of the human foot (the final section of bones that make up the toes). In the horse this section is known as the *pastern* and the hoof. The drawing and photo of the hind limb are self-explanatory (Figures 2.32 and 2.33) and will help you in your studies of the horse.

Figure 2.30

Figure 2.29

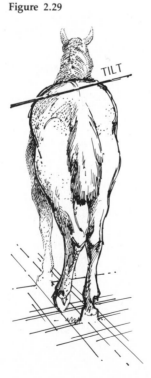

TILT

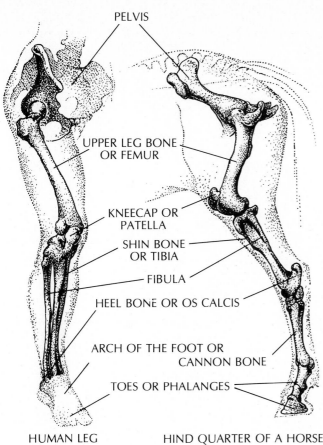

PELVIS

UPPER LEG BONE
OR FEMUR

KNEECAP OR
PATELLA

SHIN BONE
OR TIBIA

FIBULA

HEEL BONE OR OS CALCIS

ARCH OF THE FOOT OR
CANNON BONE

TOES OR PHALANGES

HUMAN LEG HIND QUARTER OF A HORSE **Figure** 2.31

Figure 2.32

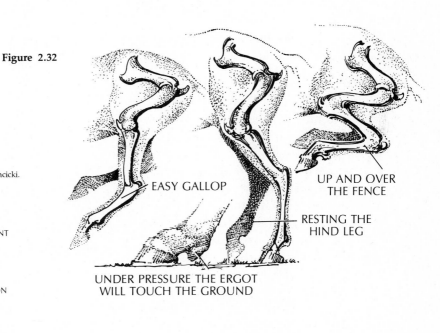

EASY GALLOP

UP AND OVER
THE FENCE

RESTING THE
HIND LEG

UNDER PRESSURE THE ERGOT
WILL TOUCH THE GROUND

Figure 2.33
Photograph courtesy of Mrs. Richard Kuchcicki.

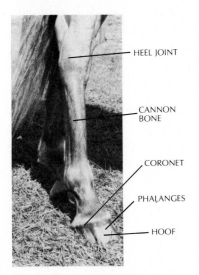

HEEL JOINT

CANNON
BONE

CORONET

PHALANGES

HOOF

29

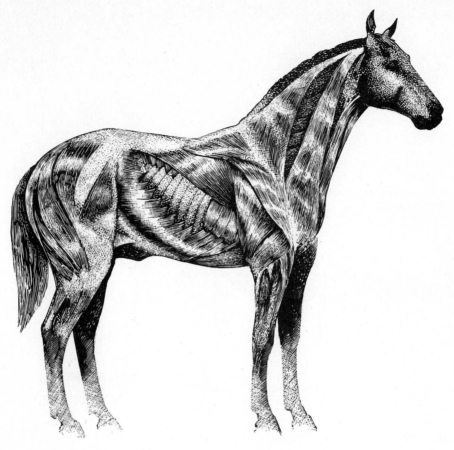

Figure 2.34

Muscles

The names have purposely been deleted from the scratchboard drawing of the muscular structure of the quarter horse. (See Figure 2.34.) Since we are going to be studying the muscles individually, it is not necessary at this time to label them.

The muscle structure of the head will be studied separately. It must be remembered that these are the superficial muscles that will have the greatest effect on the form of a horse or any other short-haired animal.

Try to visualize what happens to the shape of these muscles when the animal is under stress, such as when it is running, stretched out over a hurdle, or pivoting with the weight of a cowboy who is chasing a stray cow. It is not always possible to find a good photograph of such a scene. You should be able to sketch the pose wanted, however, and

then indicate the prominent muscles that are going to depict the action.

As you begin to understand the bone and muscular structure, your drawings will begin to improve. If you draw or paint animals or figures and do not indicate the joints of the legs, the shoulder blade, or the position of the hips and the knee cap (*patella*), your horse or figure will take on a rubbery appearance. The muscle study in Figure 2.34 is primarily for you to compare with Figure 2.35.

Muscles of the vertebral skeleton. Muscles are collections of fibers that, under the influence of the motor nerves, contract and produce the power for bodily movements. *Aponeurosis* or *fascia* are terms used to describe the sheath of tendonous material that envelopes and protects these fibers. Muscles are attached to bone by ropelike tendons. The firm, stable end of a muscle

30

is called the *origin*, and the movable section is called the *insertion* or *termination*. They may consist of a single muscle, such as the *masseter* (Figure 2.35), or a split or divided muscle, such as the *sterno mastoid* muscle of the neck (Figure 2.35). *Animal Painting and Anatomy*, by W. Frank Calderon (Dover Publishing), is highly recommended for advanced study of bone structure and anatomy.

Muscles vary in size, shape, and volume. When they contract they may shorten up to one-fourth their original length, depending on the amount of power that is applied. When they relax they lengthen to their usual normal size. When painting or drawing animals and birds, artists should be careful to show the muscles in their proper sizes and shapes, whether they are relaxed or under

Figure 2.35

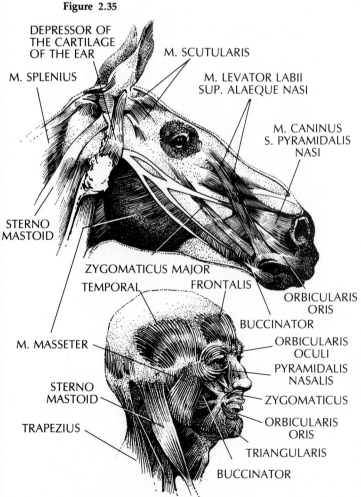

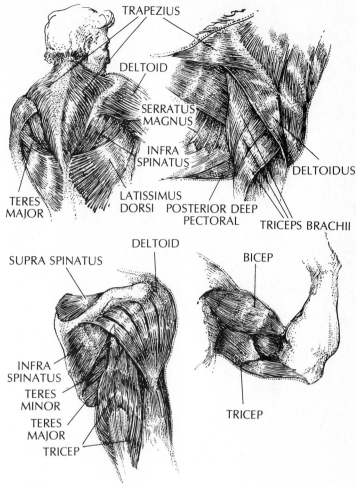

Figure 2.36

tension. If this is accomplished the work will appear more realistic. A good example is the human arm. (See Figure 2.36.) If bent and under power in order to lift a heavy object, the *bicep*, which consists of two heads and one insertion, would be short and bulging from the extreme pressure applied, while the *tricep*, which has three divisions and one insertion and is the opposite or opposing muscle, will be relaxed. If both muscles were under equal pressure it would not be possible to bend the arm.

Many plastic models of various animals, including a plaster muscle model of a horse, are available for the artist. The best way to use these is for perspective and lighting. The models usually are in a standing pose so that the artist can make and apply his or her knowledge of muscle

31

forms according to the action wanted. Some of the best sources are photographs, keeping in mind that you may be working with pictures that have been taken with a telephoto lens. Out of my own personal file of animals (12,000 feet of movies), I have not found one frame that could be copied. The only real purpose they served was to show me what size the animals were and what the lighting was at the moment.

The comparative scratchboard drawings of the heads of horses and humans illustrate the similarity of their muscular forms. (See Figure 2.35.) Each performs basically the same actions. Some are longer and more fully developed, particularly in the horse. It is important for the artist to memorize their shape and function and how they affect the surface contours.

It is necessary for an artist to know only a few muscles in the animal's head; too many muscles in an illustration tend to freeze the action. The first muscle is the *temporal*. It is evident in the human but is covered by the *scutularis* in the horse. It is the chief biting muscle. It is well developed in the carnivora, which is the main reason why cats have well-rounded skulls. The *masseter* is a very important muscle that affects the shape of the side of the head. It is the chewing muscle. It will probably be one of the first muscles

an artist will indicate when sketching the head since it fills the jaw area and defines the zygomatic bone (Figure 2.19) and the lower plane of the jaw. The next two muscles that hold our attention are the *levator labii superior alaeque nasi*, which uncovers the canine tooth, raises the upper lip, and wrinkles the nose, particularly in the dog and other carnivora, and another muscle with a long name, the *caninus superior pyramidalis nasi*, which is the "snarling muscle." The *buccinator* has two parts but we are interested only in its outer portion. It is a superficial muscle and is well developed. It adds fullness to the lower jaw and is evident near the "bars" of the jaw. It is used to press food between the molars.

The internal oblique is a fan-shaped muscle that covers most of the flank area. Its fibers are directed downward, forward, and inward toward the *linea alba*, which is a tendonous meeting of the aponeurosis. It forms a seam along the median line of the abdomen. It is not predominant in the horse but it is visible in the cow and the goat. This muscle helps arch the back.

The rectus abdominis (see Figures 2.37 and 2.38) is known as the "straight muscle of the abdomen" of the horse, which extends from the last five true ribs of the thorax and the lower portion of the sternum. In the human it extends from the *xiphoid appendage* (the tip of the ster-

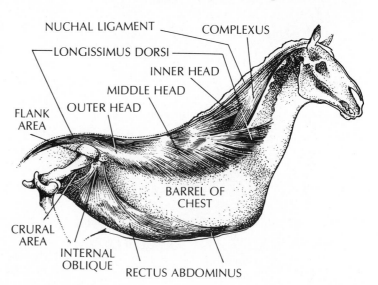

Figure 2.37 Muscles of the vertebral skeleton.

NUCHAL LIGAMENT — COMPLEXUS

— LONGISSIMUS DORSI —

INNER HEAD

MIDDLE HEAD

OUTER HEAD

FLANK AREA

BARREL OF CHEST

CRURAL AREA

INTERNAL OBLIQUE

RECTUS ABDOMINUS

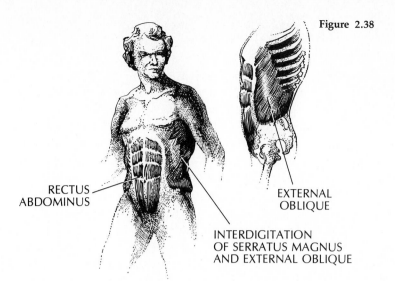

Figure 2.38

RECTUS
ABDOMINUS

EXTERNAL
OBLIQUE

INTERDIGITATION
OF SERRATUS MAGNUS
AND EXTERNAL OBLIQUE

num, or breastbone) to the anterior border of the pubic bone. It performs the same action in the horse and in the human as a flexor of the spine.

The external oblique in the human figure (see Figure 2.38) pulls the thorax downward and also rotates the spine to the opposite sides. When both sides of this muscle are operating together, they bend the thorax forward.

The nuchal ligament (*ligamentum nuchae*) is important to the artist because it defines the neck line. It is not visible but it is very important. This ligament helps support the horse's head and neck when resting. It originates at the occipital protuberance of the skull, extends down the neck, and terminates at the withers. This ligament is a powerful, elastic, fibrous tissue whose principal action is to assist the extensor muscles in pulling the head downward so that the horse can eat and drink. The sphincter muscle, the *orbicularis oculi*, is not evident in the horse since it is small and covered by the skin around the eye. The *orbicularis oris* is the round muscle of the mouth and helps to form the mouth area. It is visible near the corners of the mouth. These two muscles open and close the eyes and mouth.

The first set of muscles of the neck and thorax (Figure 2.37) are the *complexius*, the *longissimus dorsi*, the *internal oblique*, and the *rectus abdominus*. In addition, an important ligament whose func-

tion we should understand is the *nuchal ligament*. (Again, I must stress that it is not absolutely necessary to learn all these names; it is more important for the artist to know their shapes and their actions.)

The complexius is a large triangular muscle occupying the upper portion of the neck, from the nuchal ligament to the cervical vertebrae. It is a deep muscle and is not visible. It helps extend the head.

The longissimus dorsi is a very powerful muscle of the back and is divided into three heads. As shown in the illustration, this muscle extends from the stalk of the neck to the loins. Its shape rounds out the back and the loins. In the loin area it is often called the *common mass*. It is covered with an aponeurosis from which the latissimus dorsi has its origin. In a well-developed horse the longissimus dorsi will be higher than the spines of the lumbar area (the vertebrae), thereby forming a deep groove. It is a powerful extensor muscle that helps straighten out the spine.

Superficial muscles. Figure 2.39 illustrates most of the important superficial muscles of the horse. These muscles also appear in other animals, although there may be some variations. All of these muscles have been discussed already, except for the *trapezius*, the *sterno maxillaris*, and the *mastoid humeralis*.

The trapezius is triangular in shape

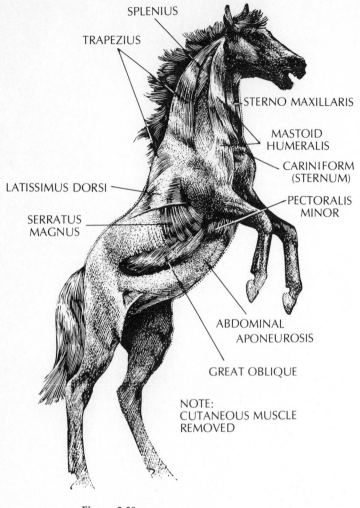

SPLENIUS

TRAPEZIUS

STERNO MAXILLARIS

MASTOID
HUMERALIS

CARINIFORM
(STERNUM)

LATISSIMUS DORSI

PECTORALIS
MINOR

SERRATUS
MAGNUS

ABDOMINAL
APONEUROSIS

GREAT OBLIQUE

NOTE:
CUTANEOUS MUSCLE
REMOVED

Figure 2.39
Superficial muscles illustrated.

Figure 2.40

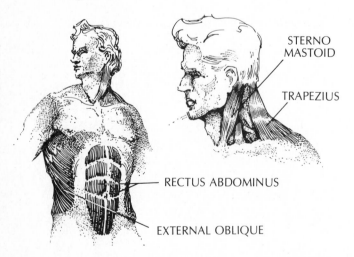

STERNO
MASTOID

TRAPEZIUS

RECTUS ABDOMINUS

EXTERNAL OBLIQUE

and extends along the center line of the body from the second cervical to the tenth thoracic vertebra. It is divided into two parts. The cervical portion arises along the center line of the neck, converges on the spine of the scapula, and terminates at the third thoracic vertebra, while the second part originates on the center line of the body, from the third to the tenth thoracic vertebra, and also terminates on the spine of the scapula. This part covers the withers. Its action is to elevate the shoulder. The first part pulls the scapula forward while the second pulls the scapula backward.

The sterno maxillaris, also known in the human as the *sterno mastoid* (Figure 2.40), is a long fleshy muscle that, in the horse, arises from the cariniform and terminates on the back border of the lower jaw. In the human it originates from two heads, the sternum and the collar bone, and terminates on the mastoid process. This muscle flexes the head and neck and inclines the head sideways.

The mastoid humeralis is a large muscle that arises from the top of the skull and terminates on the lower extremity of the humerus. It divides into two distinct parts that unite at the shoulder and then continue to a single termination on the humerus. (See Figure 2.39.) Its action pulls the shoulder and the leg forward and also assists in pulling the head and neck to one side.

Splenius, small anterior and posterior serratus, and great external oblique. The *splenius* is a widespread muscle that covers the upper portion of the neck. (See Figure 2.41.) Its origin is at the withers and from there it expands into five fingerlike digitations that terminate on the nuchal crest, the mastoid process, the wing of the atlas, and the transverse processes of the third, fourth, and fifth cervical vertebrae. This muscle is well developed in the dog and the other carnivora and is the reason why these animals have full and well-rounded necks.

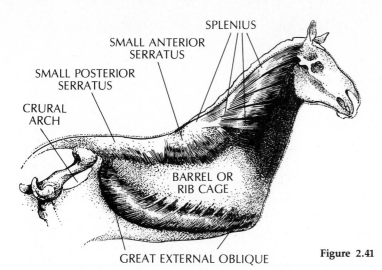

SPLENIUS
SMALL ANTERIOR SERRATUS
SMALL POSTERIOR SERRATUS
CRURAL ARCH
BARREL OR RIB CAGE
GREAT EXTERNAL OBLIQUE

Figure 2.41

When all of the digitations operate together, they elevate the head and neck. If one side is operating alone, it will incline the head and neck toward that side.

The *small anterior and posterior serratus* assist in the breathing process and help to round out the fullness of the back. (See Figure 2.41.) They are covered by the trapezius and the latissimus dorsi muscles and the fascia that overlays the lumbar region.

The *great external oblique* covers a large area, extending from the ribs of the chest to the midline of the abdomen (linea alba) and the tendon located near the pubic bone. In addition, there is a series of digitations that attach to the last fourteen ribs. This muscle is especially heavy on the side of the body and it assists in the act of breathing. It also helps in flexing the trunk to arch the back.

It is necessary to emphasize the importance of the construction and musculature of the thorax, lumbar, and pelvis, as the limbs are attached to it by their own set of muscles, especially the forelimb.

The splenius and the anterior and posterior serratus are deep-set muscles and do not have much importance in affecting the surface area, but the great external oblique does play a great part as a superficial muscle, and it is quite visible on the human and on short-haired animals. On the human torso the external oblique also assists in flexing the thorax.

(See Figure 2.42.) The bottom part is just above the crest of the ilium and will be noticeable when the torso is bent side-

Figure 2.42

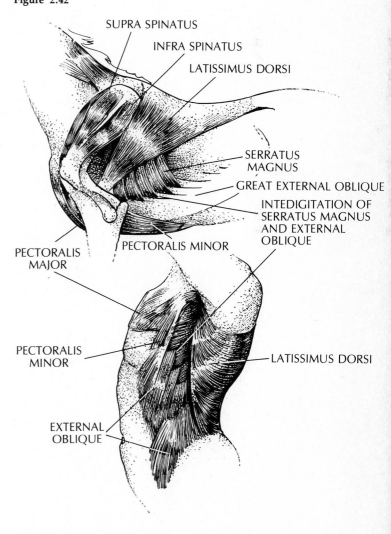

SUPRA SPINATUS
INFRA SPINATUS
LATISSIMUS DORSI
SERRATUS MAGNUS
GREAT EXTERNAL OBLIQUE
INTEDIGITATION OF SERRATUS MAGNUS AND EXTERNAL OBLIQUE
PECTORALIS MAJOR
PECTORALIS MINOR
PECTORALIS MINOR
LATISSIMUS DORSI
EXTERNAL OBLIQUE

35

ways. (See Figures 2.28 and 2.42.) This is called the *flank pad*, while the upper section that carries the digitations is flat as compared to the rounded digitations of the serratus magnus. (See Figures 2.38 and 2.42.) The abdomen, which is covered by the rectus abdominis muscle, is the most movable part of the human torso. This is also true in animals. Its function is to bend the thorax. The pelvis is a fixed platform and forms the fulcrum upon which the lumbar vertebrae rotate when the body is being twisted. The trapezius muscle in the horse and in the human has the same action; it draws the head backward and rotates it toward either side, while the sterno mastoid, the opposing muscle, pulls the head forward and also rotates the head to opposite sides.

Muscles of the forelimb. Animals use their forelimbs and hind limbs basically as a means of locomotion. The main difference between the human arm and the forelimb of the horse is that the horse does not have the capability to move the forelimb sideways to the degree that the human arm can be held in a lateral position and then raised and lowered. Most of the ungulates have some lateral movement, such as stepping sideways, but this is very limited.

We must first consider the arrangement of the bones of both limbs as mechanical devices and then the muscles that attach and bind them to a vertebral column. This same muscular system applies to the human as well as to most animals.

Attention should be paid to the various joints in the forelimb. The joint between the scapula and the humerus is a ball-and-socket joint, the same as in the human, while the joint at the elbow is a hinge joint that is capable only of forward and backward movement. The knee joint is formed by two joints. The joint at the end of the radius may be considered as a movable joint (the first hinge). Then, a series of irregular bones, arranged in two tiers, forms a platform on which the radius rolls. The next joint formed between

the cannon bone and the platform joint, which is a hinge joint, may be considered as a fixed joint. It is held together by strong carpal ligaments. This joint looks like a rectangular box in a vertical position. It has tapering ends, with each end tapering into the tendons of the upper and lower muscles.

The muscles that move the forelimb are many. Some have their origin and termination on the humerus; others originate on the scapula but terminate on the forearm. Another group originate on the forearm and motivate the cannon bone and the hoof. Then we can add those that originate on the humerus and also act on the forearm, but it is not necessary to learn all of these unless you are planning advanced study. All of these muscles are important but the number that the artist will use can be simplified to just a few.

There are three extensors that the artist will be interested in: the *extensor carpi ulnaris*, the *extensor carpi radialis*, and the *extensor digitorium communis*. (See Figures 2.43 and 2.44.) All three are located on the side of the leg. The extensor carpi radialis may also be seen on the front of the leg. This is the muscle that straightens out the leg.

The extensor carpi ulnaris is a large flat muscle that is located on the lateral side of the ulna. It does not play an important part on the horse. The extensor digitorium communis originates on the lower portion of the humerus (arm bone) and extends to the hoof. It assists in extending the cannon bone and the hoof.

The *flexor carpi radialis* is located on the inside of the leg behind the radius. Its action is to extend the *olecranon process* (elbow) and to flex the carpal joint. In the human the *extensor carpi radialis longus* extends the hand and also acts as an adductor.

Muscles that attach the shoulder blade to the trunk. The back and shoulder of the horse present many depressions, flowing rounded forms, and prominences caused by the presence of many bony structures near the surface and the muscles that cross and

recross, which are visible when in action. For this reason the artist needs to know prominent landmarks such as the withers, the cariniform process, the point of the shoulder, and the olecranon process.

Movement is great in this area as the shoulder blade slides over the deeper-set muscles and the cage (*thorax*) of the trunk, which moves forward and backward, up and down, as the legs flex and extend themselves. In the human, the upper fibers of the trapezius pull the scapula toward the spine and upward, while its lower fibers pull the scapula downward. (See Figure 2.36.) By comparison the cervical section of the trapezius in the animal also pulls the shoulder blade forward and upward, and the thoracic section pulls it backward and upward.

The *deltoid muscle* of the human raises the arm. Its anterior section pulls the arm forward and rotates it inward while its posterior section pulls it backward and rotates it outward. The same muscle in the animal, known as the *deltoidus*, abducts the upper portion of the forelimb and flexes the shoulder.

The chest muscles in the human are in two distinct parts. The largest of the pectoral muscles is the *pectoralis major*, while the smallest is the *pectoralis minor*, but in animals this is reversed. The largest pectoral muscle is known as the *posterior deep pectoral*, and the smallest is the *anterior deep pectoral* (pectoralis major).

The anterior portion originates on the lateral surface of the sternum and the cartilages of the first four ribs and terminates on the scapula. Its action is to adduct and retract the limb, and when the limb is advanced to a fixed position it draws the body forward. This muscle is shaped like a prism.

The posterior deep pectoral is shaped like a fan. Its origin is the sternum, the cartilages of the fourth to the ninth rib, and the abdominal tunic. Its action is the same as that of the anterior portion of the pectoral muscle.

The *latissimus dorsi* performs the same function in both humans and animals. It pulls the arm or forelimb backward. It is

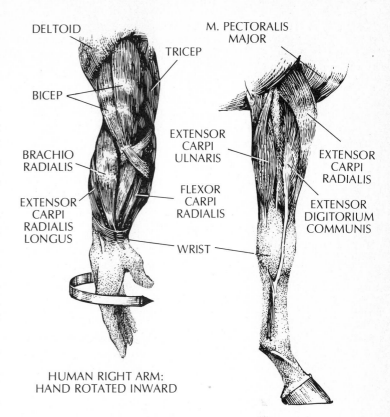

HUMAN RIGHT ARM: HAND ROTATED INWARD

Figure 2.43

Figure 2.44

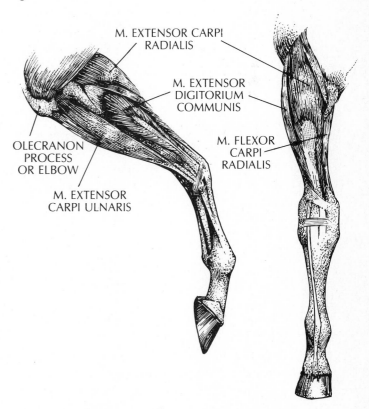

37

triangular in shape and covers most of the back and loins. (See Figures 2.36 and 2.39.) This is a large and very strong muscle and is visible on both humans and animals.

The *triceps brachii* of animals and the triceps of the human are the extensors of the forelimb and arm. Each consists of three heads, one of which originates on the scapula with the other two originating on the humerus. They terminate on the elbow. (See Figures 2.36 and 2.43.)

Muscles of the hind limb. The greater movement of both animals and humans is based on the pelvis. It is the mechanical axis of the body. Whether the animal is running, trotting, rearing, or jumping, the greatest action is at the pelvic area. It acts as the fulcrum point of the legs and the trunk. The spine, which is the support trunk for the forelegs, the neck, and the head, projects forward from the pelvis. It is large in proportion because of the task it has to perform.

The approach to the study of muscular structure requires two different angles. The side view in Figure 2.45 shows the area where the greatest leverage occurs, while the back view in Figure 2.46 will illustrate the muscular mass where its strength originates. This is required to move the great weight of animals such as the horse, the moose, the elk, the giraffe, the elephant, and the rhinoceros.

Figure 2.46 shows the back view of the quarter horse. The hindquarters are very heavily muscled, both inside the leg and outside. The rump area is very broad and heavy, and carries a feeling of great driving power and strength.

The *long vastus* is a large crescent-shaped muscle that extends from the upper portion of the femur and terminates at the stifle. This muscle is quite prominent on the hindquarters of the horse, particularly from the side view. This muscle is an extensor and pulls the thigh backward to straighten out the leg. It also acts as an abductor of the whole leg. Some authorities include this muscle with the *biceps femoris*.

The biceps femoris is a large triangular muscle that originates on the sacral portion of the angle of the buttock and

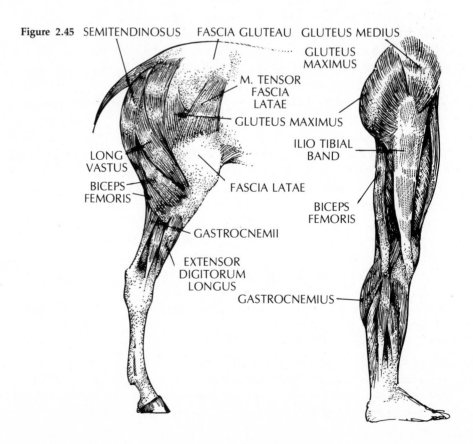

Figure 2.45 SEMITENDINOSUS FASCIA GLUTEAU GLUTEUS MEDIUS GLUTEUS MAXIMUS M. TENSOR FASCIA LATAE GLUTEUS MAXIMUS ILIO TIBIAL BAND LONG VASTUS BICEPS FEMORIS FASCIA LATAE BICEPS FEMORIS GASTROCNEMII EXTENSOR DIGITORUM LONGUS GASTROCNEMIUS

terminates on the posterior surface of the femur near the patella. If the long vastus is included as part of the biceps femoris, it would then have three parts. Having three heads or parts creates a complicated action.

The first part, originating near the sacrum and terminating near the patella, acts as an extensor, thereby straightening out the leg. The next part divides into two heads. It arises on the anterior portion of the ischium and terminates on the anterior crest of the tibia. The middle section extends the hip, and the posterior part of this muscle assists in extending the hock (heel joint).

The general action of this group of muscles is to extend the limb when the body is propelled forward, or rearing or kicking, and to adduct the limb. In the human, the bicep femoris adducts the leg, flexes the leg, and extends the thigh backward.

The *tensor fascia lata* (see Figure 2.45) originates at the angle of the haunch (angle of the ilium). It expands into a wide, triangular, fleshy mass that terminates in a wide aponeurosis, which is about midway between the point of the hip and the stifle. It acts as a tensor of the fascia lata, flexes the hip joint, and also extends the stifle joint.

The fascia lata acts as a brace when an animal is standing. For example, when an animal is trotting, one foot is on the ground and the other is off the ground. The fascia lata steadies the pelvis and opposes the action of the muscle on the opposite side, so that during this alternate action the pelvis remains practically level. This thin aponeurosis covers some of the underlying muscles and also strengthens the area. Some of the shapes in the region of the patella are visible when an animal is in action. This aponeurosis is the same as the ilio tibial band in the human, which has the same action.

The *gluteus maximus* muscle has a counterpart in the human, where it is also known as the gluteus maximus. This muscle arises from a portion of the lateral border of the ilium and terminates on a

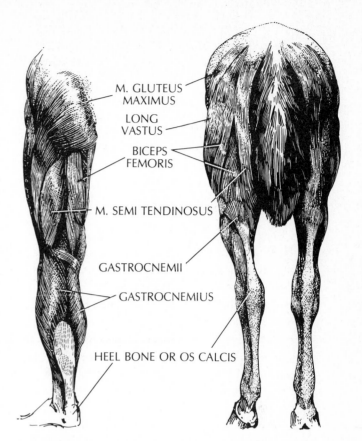

Figure 2.46

process or tuberosity that is about one-third of the way down the femur. This is a triangular muscle whose action is to adduct the limb, flex the hip, and add tension to the *gluteus fascia* (*fascia gluteau*). In the human, this same muscle extends the thigh backward, provides tension, and adducts the thigh.

The *gastrocnemii* originates from the distal or upper third of the femur by two heads and terminates on the point of the heel joint. Its action is to extend the heel or flex the stifle joint. It is impossible for these two actions to occur simultaneously. The tendon of this muscle is quite prominent on the heel. It flexes the leg and will also point the foot. It is known on the human as the "tendon of Achilles."

The *extensor digitorum longus*, also known as the *long digital extensor*, originates on the upper, anterior portion of the femur and terminates on the phalanges near the center of the coronet of the hoof. Its action is to flex the hock and extend the digit (hoof).

As we progress through the demonstration painting, it will be necessary to refer back to this chapter for anatomical explanations.

DRAWING AND PAINTING THE HORSE

Research, Sketch, and Composition

The generally accepted approach to a painting is to make a color sketch that will serve as your composition or layout. A composition is just a way to put your idea down on paper so that others can visualize it, and it is also a guide for working out the design, color, and values. It is not wise when making paintings of this order to experiment on the finished art. Be sure your design is right, and then research the problem so that you will thoroughly understand what you will be working with—the type of horse that will be used,

their packs and how they are tied onto the pack animals, the saddles, the clothing worn in that particular area, and finally the type of landscape.

In this demonstration painting, I felt that the black and white pen sketch (Figure 2.47) would be sufficient since I had my material for the landscape from color slides and personal experience in country of this type.

The next step was to research the cowboys' clothing and enlarge the sketch to the full size of the painting, which is thirty-six inches wide and twenty-four inches high. Enlarging is explained on pages 41–43. The next working procedure was to lay a transparent tissue, such as parchment paper, over the enlarged sketch and proceed to make a simplified drawing of the horses and cowboys. This sketch was then transferred to green paper that was rendered in two parts with charcoal and white chalk. The drawing of the rider and the two pack horses (Figure 2.48) was made first and the final drawing (Figure 2.49) was made last.

Figure 2.47

Figure 2.48

Figure 2.49

Four ways to enlarge your sketch. There are four ways to enlarge your sketch: by using squares, with the opaque projector, by photostat, or by projecting 35mm transparencies.

The most convenient methods are the squares and the opaque projector, if one is available. Figure 2.50 illustrates the use of the squares. Lay transparent tissue, such as parchment paper, over your sketch and lay out a series of squares, horizontally and vertically. These squares may be of any size, such as one inch, for example. The size of the squares depends upon the size of your sketch. In the example, I drew the squares over the photograph of the first rider so that you could easily follow the instructions.

Take another sheet of tissue and draw the same number of squares on it,

41

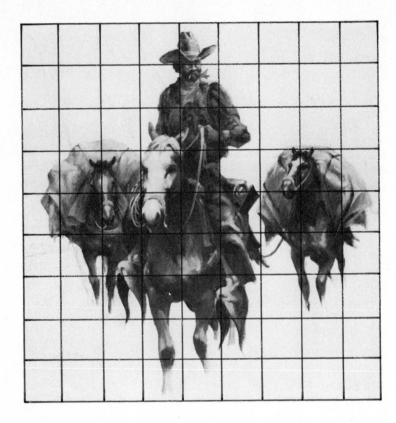

Figure 2.50

Figure 2.51

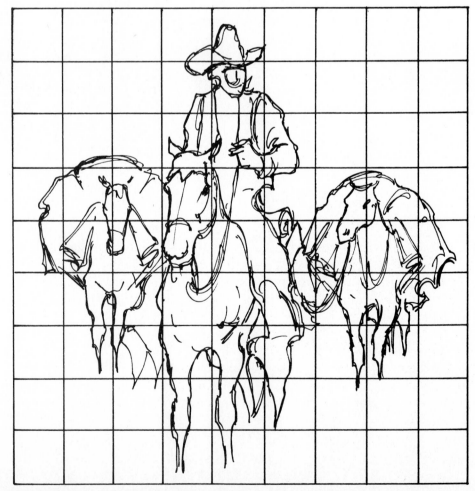

enlarging the squares to the size that you want the final drawing to be. (See Figure 2.51.) Then, match the same basic lines of your sketch. These squares may measure two to three inches in size, depending on the size of the final painting.

After the enlarged sketch has been drawn, refine the lines, trace them onto charcoal paper, and then proceed to make your final study for the finished painting. If you have an opaque projector available, use it in place of the squares. Be sure to keep your sketch small so that it will fit the enlarger. The photostat method, if that service is available to you, will take longer.

The use of the 35mm transparency is the method I prefer since I have the time available to wait for the return of the transparency. This method makes it possible to adjust to various sizes until you are satisfied with the proportions of the design. Then, trace the design onto a paper of your choice and complete your studies.

One of the difficult aspects of enlarging is to maintain the spirit of the sketch. Drawings look completely different when they are blown up to a larger size. Some enlarge easily and some do not. If you have a sketch that is three inches high and four inches wide, and you enlarge it to fifteen inches high and twenty inches wide, you are increasing the size of your sketch by 500 percent. Your sketch may suffer. Take time to study it. If it seems weak, strengthen the lines and use bold, vigorous strokes so that you will regain the verve and power of the original sketch.

Locating the most important point within your composition. A valuable device for an artist is to locate the most important point within a rectangle. This system was used to locate the best point to place the lead rider of the pack train, who is the point of interest in the painting in Figure 2.52. In addition, the horses "look" toward the rider, the other riders point to the lead rider and his horse, and, finally, the main lines of the landscape also point in that direction.

To locate this point, after the size of the rectangle has been decided upon, draw a diagonal from the lower left corner to the upper right corner. (See Figure 2.52.) Next, on the line just drawn, construct a right angle line to the upper left corner. Where these two lines meet is the most important point within this rectangle. This system will work on any size rectangle. It also may be used to locate a horizontal line, such as the horizon. If you draw these lines from opposite corners, the point of interest will be on the right-hand side of the rectangle.

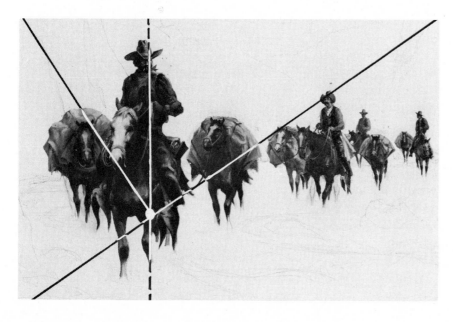

Figure 2.52

43

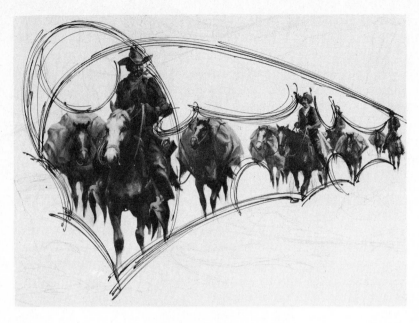

Figure 2.53

Rhythm in your art: making your paintings move. Again, photographs are being used in place of the rough sketches that would normally be used at this stage in developing the drawings and composition for a painting.

The rhythm lines are very important to a design. (See Figure 2.53.) These lines tie the painting together and prevent it from falling apart. The design, in addition to values and color, establishes a solid continuity. All of these units, when balanced, create a pleasing illustration or painting.

So as not to destroy your original sketch as you try various arrangements of your subjects, lay a clean tissue over your enlarged sketch and then freely draw the rhythm lines. Play with the drawing; have a good time rolling the rhythm lines until you are satisfied with the results.

Painting the First Stage

This is the fun part of a painting. Your idea and composition have been established, the research is out of the way, the sketches have been made and enlarged, rhythm lines are firmly entrenched within your mind, the canvas has been stretched, and you are ready. Now comes the color palette.

When I was in art school, I felt that it was necessary to use a large palette. I was learning about paint and how to use it. As the years progressed, somehow the palette kept getting smaller, the painting started to look a little better, the colors were not so garish, and the palette now consists of a very workable grouping of colors.

Ultramarine =	Blue
Viridian =	Green
Cadmium yellow light =	Warm yellow
Cadmium barium orange =	Warm orange
Cadmium barium red light =	Warm red
Burnt umber =	Brown
Raw umber =	Earth color, tones ranging from greenish and yellowish to a violet brown
Burnt siena =	Burnt red ochre
Raw siena =	Ochre-like in color
Yellow ochre =	Dull yellow
Ivory black =	Black

In Figure 2.54, after the necessary sketches were made of the horses and the riders, they were transferred to a previously

Figure 2.54

stretched canvas that had two coats of a white gesso. The outlines of the rocks and canyon walls were lightly indicated since they would be painted freely and might be changed as the painting progressed.

The pack train was painted first since it is the point of interest and it was felt necessary to establish the color and values. The rest of the painting—the landscape and sky—would be keyed to the pack train.

The Halfway Stage

The painting of the pack train and its riders was only half finished. The details would be painted after the rest of the painting was nearly completed. First, the landscape areas were painted. The sky and clouds, distant mountains with their ice fields, and the darks of the canyon walls were next. Particular attention was paid to establishing a value scale in these

Figure 2.55

darks, running from a dark foreground to a lighter distance. These darks and the perspective of the river add depth to the landscape.

The texture of the rocky walls was indicated next. This texture was patted onto the canvas with paper napkins (you have to experiment with various ones to find the texture that works well for you), rags, and brushwork. Figure 2.55 shows the painting at the halfway stage.

Completing the Painting

The shadows were next, with an indication of the rough water and its eddies. Then the water in the sunlight was painted.

At this stage the painting was approaching the finish. As the various parts dried out, especially on the rocks, glazes were rubbed on with a brush. Here again, you will have to experiment with various brushes. Highlights were scrubbed out with turpentine to give the effect of broken rocks and rubble.

After all of this dried, the golden color was washed on the canyon walls that were not in shadow, and light rays were scrubbed out with a firm, round, pointed-bristle brush. The palette knife was then introduced to loosen up the painting and to add additional texture to the rocks, the spray from the water dashing against the rocks, and the hoofs of the horses. Final touches were added to the pack train and its riders. The evergreens were added, highlights were indicated to the sunlit water with an impasto, whitish paint (if you tint your whites with a touch of yellow, they will look better), and now the painting was finished. (See Figure 2.56.)

Figure 2.56
FREDRIC SWENEY (American, 20th century)
White-Water Trail (oil).
Courtesy of the American Western Collection.

PRACTICE SUBJECTS

These photographs of horses in various poses and the dry brush drawing of a bucking bronco (Figures 2.57–2.64) were made particularly for artists to copy and use as models in creating their own paint- ings. These photographs should be en- larged, possibly reversed in their posi- tions, or combined to make a pleasing grouping for a pastoral scene. The artist then should research an appropriate back- ground and follow the working procedure that was explained for "White-Water Trail."

Figure 2.57
Photograph courtesy of Mrs. Richard Kuchcicki.

Figure 2.58
Photograph courtesy of Mrs. Richard Kuchcicki.

Figure 2.59
Photograph courtesy of Mrs. Richard Kuchcicki.

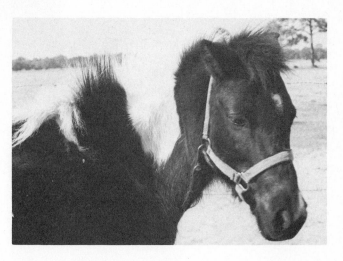

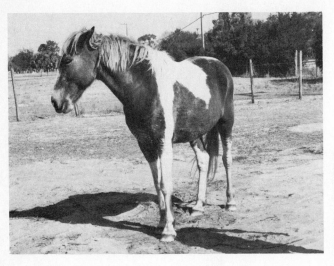

Figure 2.60
Photograph courtesy of Mrs. Richard Kuchcicki.

Figure 2.61
Photograph courtesy of Mrs. Ronald Cyril.

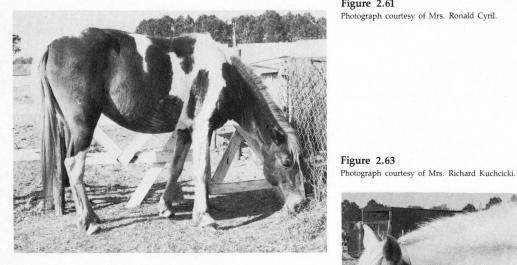

Figure 2.62
Photograph courtesy of Mrs. Richard Kuchcicki.

Figure 2.63
Photograph courtesy of Mrs. Richard Kuchcicki.

48

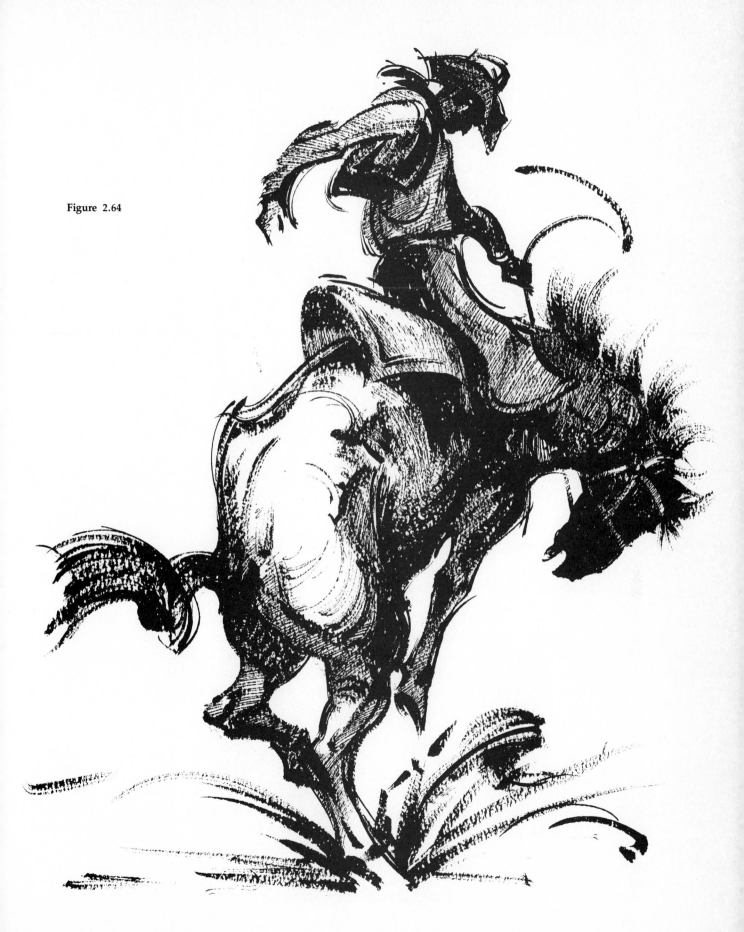

Figure 2.64

49

CHAPTER THREE

The dog

THE DOG IS PROBABLY the most widely known of all domestic animals. There are many hundreds of breeds today, ranging in size from the Irish Wolfhound (which weighs a minimum of 120 pounds) to the smallest, which you can hold in your hand. Everyone seems to love dogs, whether they are working animals or family pets.

HISTORY

Dogs were the first ancient domesticated animals to develop a close companionship with human beings. Their origin is still being investigated and has yet to be positively established. There are many theories about how dogs first approached prehistoric people. They may have scavenged campsites for leftovers and slowly

made friends with the people, or pups may have been captured and then slowly domesticated.

The dog's ability to hear sounds and to identify the scents of approaching people or animals long before the hunters could was soon recognized. In addition, its capability to track animals made it a valuable hunting companion.

ROUSSEAU

Percival Rousseau began his artistic career rather late, at the age of thirty-five, at the Academie Julian in Paris. His early paintings showed the influence of the French Barbizon School.

The Barbizon School sought a new approach to nature and landscape paint-

Figure 3.1
PERCIVAL ROUSSEAU (American, 1859–1937)
Best in the Field—English Setter.
From the archives of and copyright Brown and Bigelow, St. Paul, Minnesota.

ing and wished to emancipate artists from the restraint of the academic tradition of art, although they never really broke away from this bondage.

Rousseau eventually freed himself from the Barbizon style of classical painting and soon developed his own natural technique. His handling of abstract design, his use of color, and his thorough understanding of the anatomy and natural poses of dogs soon made him America's finest sporting dog painter (see Figure 3.1).

ANATOMY OF THE DOG

The greyhound has been selected as the best example for the study of bone and muscle structure since it is a slender, smooth-coated animal with excellent conformation.

The lineage of the modern greyhound can be traced back to the year 4,000 B.C. The first signs of the dog came from the valley of the Nile in Egypt. Surprisingly, the Saluki, the Afghan, and the Irish Wolfhound all belong to the greyhound family. Under the long coat of the Afghan you will find the same graceful outline as that of the greyhound.

All three of these dogs are among the few that hunt by sight and not by scent. Formerly, greyhounds were used for coursing hares, but in recent years they have been used mainly for racing. Possessing great speed, a flexible body, and the grace of a swallow, the greyhound is excellent for studying, drawing, and painting.

There is great variety in the sizes and bone structures of the various breeds of dogs. As an example, the differences in conformation and size between the grey-

51

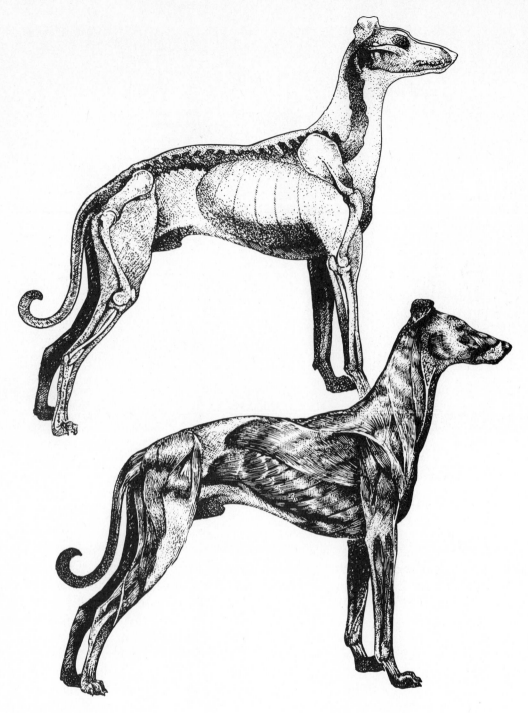

Figure 3.2

hound and the dachshund may be seen in Figures 3.3 and 3.22. The same bones are present, but they differ in size and length. In most dogs, it will be possible to use the same approach in establishing proportions as was used in sketching the proportions of the horse. The English bull, with its square, blocky shape and short legs, will be an exception to the rule. For this dog, the length of the head is used as a ruler.

The figure is described as being so many heads long, so many heads wide, and so many heads high.

The artist must pay close attention to differences in head structure and, also, hair forms and direction. Observe, for example, whether the dog is smooth-haired, long-haired, or curly coated. You will still have to indicate first the skeleton, particularly the joints, and the body form.

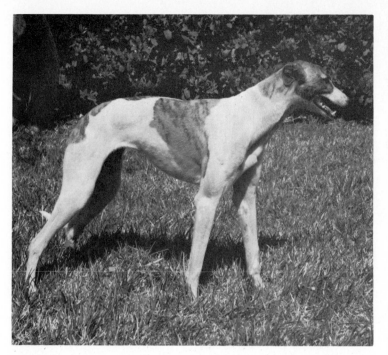

Figure 3.3
Greyhound.
Courtesy of Ms. Nancy Kelly.

Figure 3.4
Greyhound.
Courtesy of Ms. Nancy Kelly.

Figure 3.5
Forelegs and toes (front view).
Courtesy of Ms. Nancy Kelly.

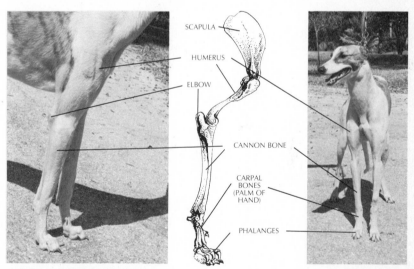

SCAPULA

HUMERUS

ELBOW

CANNON BONE

CARPAL
BONES
(PALM OF
HAND)

PHALANGES

Figure 3.6
Hind legs and toes (back view).
Greyhound courtesy of Ms. Nancy Kelly.

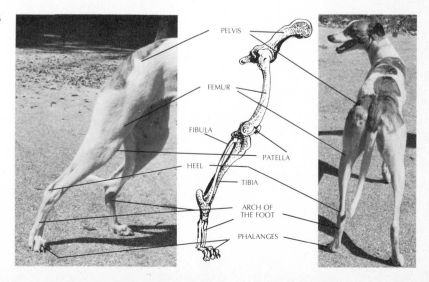

PELVIS

FEMUR

FIBULA

PATELLA

HEEL

TIBIA

ARCH OF
THE FOOT

PHALANGES

Figure 3.7
Greyhound.
Courtesy of Ms. Nancy Kelly.

Then, sketch the hair, paying attention to its direction and to the way the folds of the hair of long-haired dogs indicate the form underneath. A good working procedure is to sketch a simplified drawing of the skeleton and form first, put a tissue over the top of the sketch, and draw the hair folds and directions. This is the tissue that you will trace over onto your canvas or paper.

The simplified scratchboard drawings of the greyhound's skeleton and muscle structure in Figure 3.2 illustrate the basic knowledge of anatomy needed for making the studies and drawings for a painting of a dog. If it is necessary for additional identification about nomenclature, you may refer to the many anatomical drawings of the horse in Chapter Two because the bones and muscles are the same as those found in the horse. The only differences are in sizes and shapes.

The photographs and drawings of the greyhound in Figures 3.3, 3.5, 3.6, and 3.7 will help you in sketching these forms. The bones and joints are well defined, and the hair directions on their legs are indicated. You should make individual studies of the photographs of the legs so that you understand them thoroughly.

DEALING WITH YOUR MODEL

As was the case for the horse, a working knowledge of the dog's anatomy is extremely valuable, particularly when you are drawing or painting from a live model, because dogs do not always hold still. This is one of the most formidable and frustrating aspects of animal art—trying to get good sketches of an animal that practically refuses to hold still, unless you are lucky enough to catch the animal asleep. Here is where your knowledge of anatomy will pay handsome dividends, because you will be able to make simplified action sketches followed by solid studies, with the basic bones and muscles indicated, all in their proper places. You should keep several drawings or sketches going at the same time. As the dog moves around, keep adding to the sketches that have similar poses until you have enough studies for the painting you wish to make.

The amateur is bound to get discouraged but will soon get the knack of making quick sketches. The experienced artist knows how to solve the problem of drawing an animal that refuses to hold still. It is important for the beginner to maintain a good frame of mind when sketching. Approach your drawing with enthusiasm.

Big dogs and working dogs are more apt to hold still than small dogs—particularly puppies that somehow manage to be in a dozen places at one time. Dogs naturally tend to have nervous temperaments and will not hold a pose for long. The best dog to practice on, if you own one, is your own, because you probably know all of its idiosyncrasies and behavior patterns.

As the word gets around that you are a good dog portraitist, you will probably

get requests to paint some. The new model will be a complete stranger to you. Take time to get acquainted with the dog, and, to be fair, give the dog a chance to get acquainted with you. Do not force yourself on the animal by trying to make it hold a pose that you want to paint. Patience with animals pays off.

Today, we are fortunate to have good camera equipment available for making quick-reference studies. Contemporary portrait artists use the camera for preliminary work. They use their photographic references to make their final studies before starting the painting. Busy people do not have the time to sit through long poses; neither do our animal friends. This axiom holds true for wild animals as well as domestic ones. Obtain as much reference material on your subject as necessary, make your studies, and then paint your picture.

The sketch and painting of the German short-haired pointer (Figures 3.8 and 3.9) were handled in this manner. I accumulated as much material as possible first,

Figure 3.8
Full-size sketch of a German Short-haired Pointer, later enlarged for the painting.

Figure 3.9
FREDRIC SWENEY (American, 20th century)
German Short-haired Pointer.
Courtesy of Ralph Wilhelm, D.V.M.

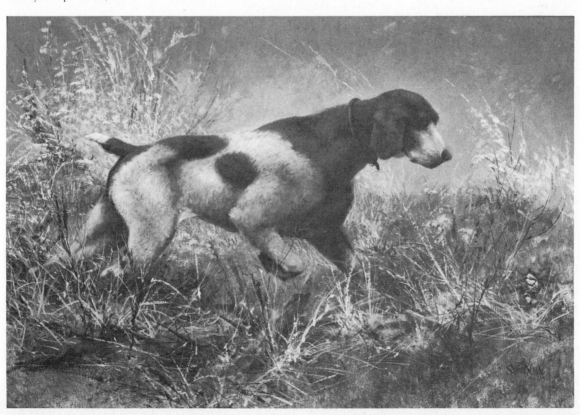

then took photographs of the dog, and composed a pleasing pose. After making the sketch and studies of the quail, I had the dog brought to my studio so that I could check the markings and color. A final check was made later, to get the approval of the owner.

DEMONSTRATION PAINTING

It is early morning, with the wind beginning to freshen as a late fall storm swings in over the lake. Biting cold nips the air, and the surface of the lake is beginning to get choppy. Ducks appear in small groups making their swift passage against the strong wind. A Labrador is retrieving a fallen duck and comes splashing to the hunter with the bird.

This painting was begun with a small ink sketch (Figure 3.10). A photograph was made of the dog's head (Figure 3.11), and the large charcoal drawing was sketched on a tissue. Note that the positions of the front legs in the sketch were changed because they froze the action (Figures 3.12 and 3.13). The same palette was used as for the horse painting "The White-Water Trail" in Chapter Two. The sky was painted first; then the reeds and water were blocked in. The dog and duck were laid in with a general coloring, and their forms were indicated. The sky was completed and then all of the reeds, including the ones flat on the water, and finally the dog and the duck were finished. A palette knife was used on the reeds and the water in order to loosen up the painting. (See Figure 3.14.)

Figure 3.10

Figure 3.11

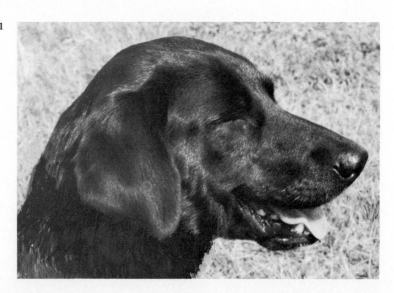

56

Figure 3.12

Figure 3.13
Eager Beaver.

Labrador retriever and mallard duck two-thirds completed.

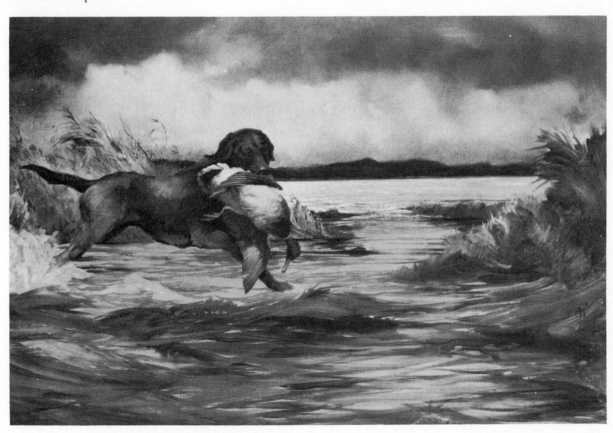

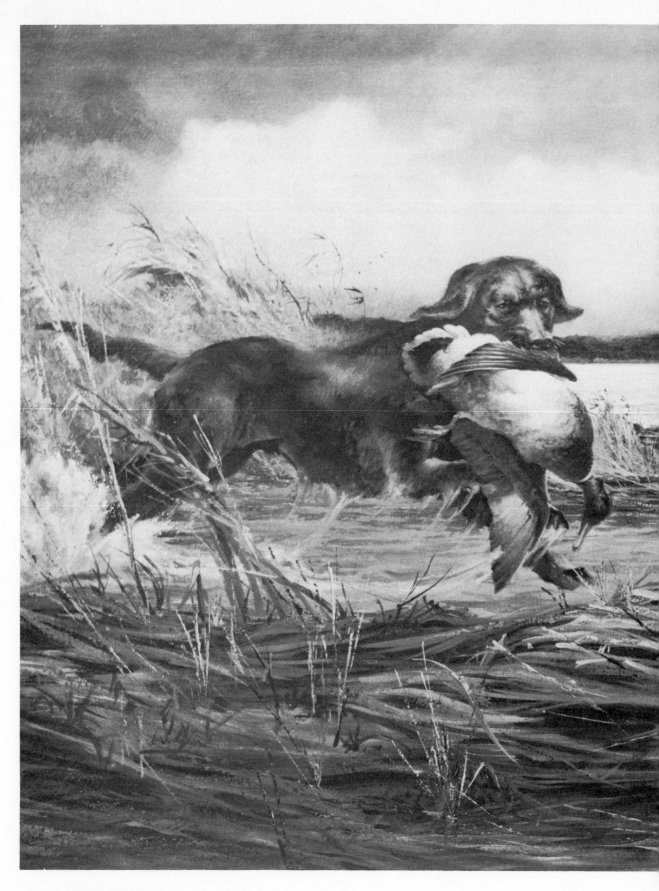

Figure 3.14
FREDRIC SWENEY (American, 20th century)
Eager Beaver (Black Labrador retriever).
Courtesy of Wild Wings, Inc.

PRACTICE SUBJECTS

The accompanying photographs (Figures 3.15, 3.16, 3.17, and 3.18) may be used for a practice painting. You should pick one, not all of them, at this time.

The Yorkshire terrier will probably be the most difficult to do since it is a long-haired dog and much of the anatomy will be covered up. If you decide to paint this particular one, you still should sketch out the body, especially the bone structure of the legs and their positions in relation to the body in order to get all four feet on the floor. Do not try to take a short-cut by sketching the outline of the dog and its hair structure and then hanging the legs and feet on it; it will not work out and you will be cheating yourself.

Figure 3.15
Poodle.
Courtesy of Mrs. D.D. Stoun.

Figure 3.16
Schnauzer.
Courtesy of Mrs. D.D. Stoun.

Figure 3.17
Irish setter.
Courtesy of Ms. Nancy Kelly.

Figure 3.18
Yorkshire terrier.
Courtesy of Mrs. Edward P. Driscoll.

The borzoi is a wonderful animal to paint because it is so aristocratic in appearance. The background in Figures 3.19 and 3.20 obviously needs to be redesigned into one more fitting for a dog with this patrician bearing. Select your landscape with care, for it will affect the mood that you wish to depict.

The dachshund also will make an in-teresting painting. It will require some research on the structure of the legs and paws, which are hidden in the blades of the grass. You also may want to paint a more pleasing background, possibly an interior scene.

It will be necessary to sketch the anatomy of both the borzoi and the dachshund.

Figure 3.19
Borzoi, Russian wolfhound.
Courtesy of Ms. Nancy Kelly.

Figure 3.20
Borzoi, Russian wolfhound.
Courtesy of Ms. Nancy Kelly.

Figure 3.21
Dachshund.
Courtesy of Mrs. William Lowe.

Figure 3.22
Dachshund.
Courtesy of Mrs. William Lowe.

CHAPTER FOUR

The cat

ARTISTS AND SCULPTORS are attracted to cats, wild and domestic, not only because of the beautiful colors and fascinating patterns of their coats, but also for their ability to twist and turn their bodies into unusual positions and graceful movements. Cats can quickly turn a peaceful pose into a fierce and violent action.

HISTORY

About 60 million years ago the mammals slowly evolved from insect eaters to meat eaters known as the "miacids," the true ancestors of the carnivores. These eventually divided into ten separate families,

one of which was the felids, the cats that we know today.

Cats belong to the group of mammals, including humans, that are considered to be hunters or animals of prey. Eagles, hawks, and owls are also in this category. The eyes of these animals are located at the front of the head. (Their potential victims—such as the deer and the rabbit—whose eyes are located on the sides of the head, must be able to see forward, upward, and especially backward for their protection.)

The painting of "Cardinal Albrecht of Brandenburg as St. Jerome" by Lucas Cranach the Elder (see Figure 4.1) is a prime example of a painting by an artist who has veered away from his natural talent of

painting portraits, landscapes, secular and religious subjects, and nudes. Cranach was most famous as a painter of sensuous nudes, but his animal and bird subjects lacked the craftsmanship, anatomical detail, and feelings that his other subjects imparted.

ANATOMY OF THE CAT

There are small cats, big cats, wild cats, tame cats, cats with long tails, cats with short or kinky tails, cats with short hair and long hair, and, finally, there is the common alley cat that makes up ninety-nine percent of all domesticated cats.

For all these variations, the anatomy is basically the same. Furthermore, if you compare the bone and muscular structure of the cat (Figure 4.3) with the physical structure of the horse in Chapter Two, you will see that there is little difference. We should direct our attention to the character and physical variations that distinguish the cat from other animals.

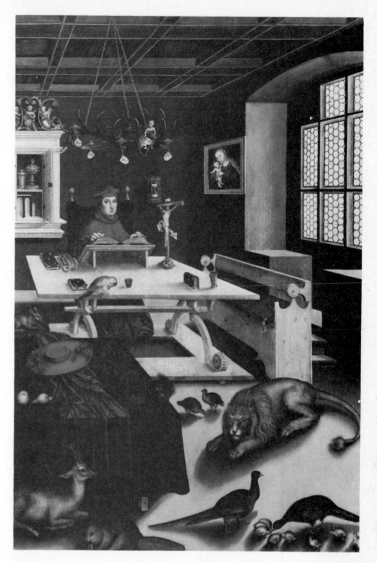

Figure 4.1
LUCAS CRANACH THE ELDER (German, 1472–1553) *Cardinal Albrecht of Brandenburg as St. Jerome* (oil on wood).
Courtesy of the John and Mable Ringling Museum of Art, Sarasota, Florida.

Figure 4.2

63

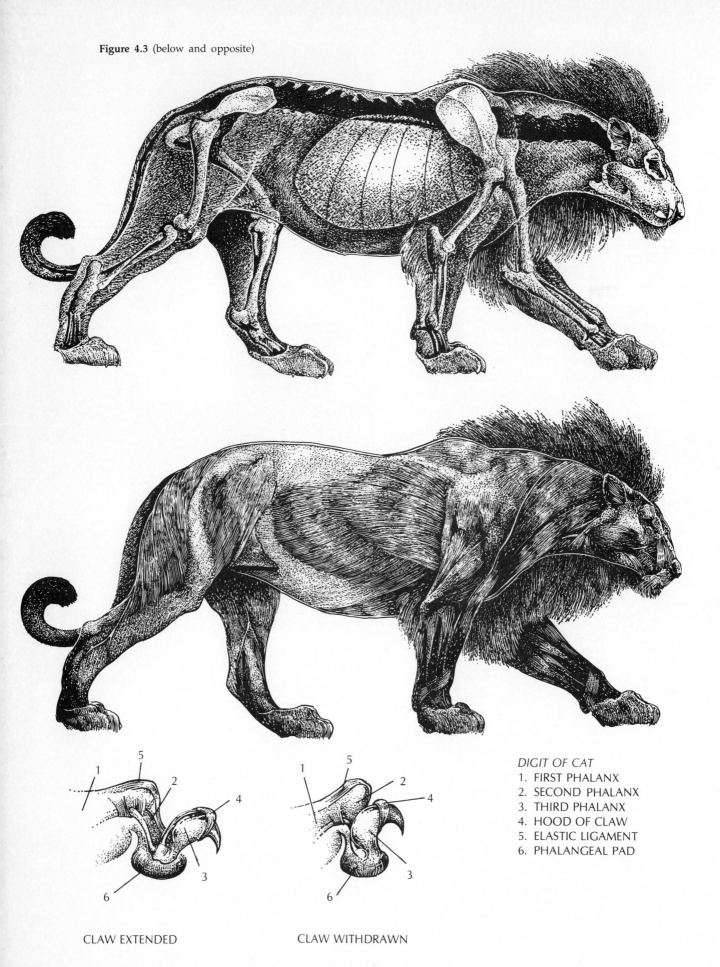

Figure 4.3 (below and opposite)

DIGIT OF CAT
1. FIRST PHALANX
2. SECOND PHALANX
3. THIRD PHALANX
4. HOOD OF CLAW
5. ELASTIC LIGAMENT
6. PHALANGEAL PAD

CLAW EXTENDED

CLAW WITHDRAWN

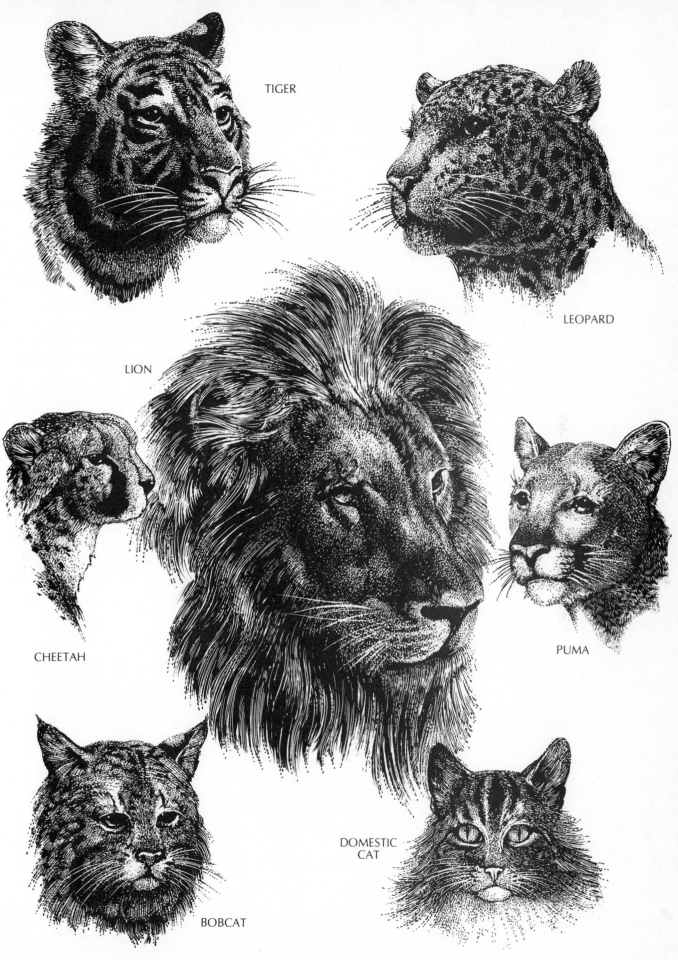

TIGER

LEOPARD

LION

CHEETAH

PUMA

BOBCAT

DOMESTIC
CAT

In general, cats are extremely graceful. They have rounded heads, and their eyes are toward the front of the head. They must turn their heads in order to see sideways because their eyes are in a fixed position. Dogs can roll their eyes to see sideways, but a cat must turn its head.

A cat's feet are generally small in comparison to its body size, although lions and cougars have large feet. Cats are blessed with retractile claws, which they keep sharp by scratching wooden posts or trees. A dog's nails touch the ground, so they get worn down.

Another distinctive feature of the cat is its long whiskers, which it uses to feel its way around in the dark. If a cat's whiskers pass through an opening freely, then its body will also clear the same opening.

Cats do not chew their food. They use their teeth to hold their victims and to tear and chop their food. Their heads are rounded because they use their temporal muscles, which are attached to the lower jaw, as a biting muscle. This muscle is heavily developed and, consequently, rounds out the upper portion of the head.

The color of a cat's coat might be light or dark, striped or spotted, and in a beautiful range of colors. An artist will have to be discerning in the choice of pigments.

The cheetah is unique in the family of felidae. It has doglike characteristics that are not found in other members of the cat family. The cheetah's legs, which are unusually long and extremely strong, have been designed by nature for great bursts of speed and sudden turns when chasing prey. In addition, the powerful legs and claws make the cheetah lethal in a fight.

The cheetah's feet are unusual in that they are constructed like a dog's foot. The pads have hard edges, instead of soft pads. Its claws are blunt and only partly retractile. The head of the cheetah is small in proportion to its body, and the eyes are set high in the skull. One of its outstanding features is its fast acceleration and high speed, which can be up to sixty miles an hour over a short distance. Its flexible back is like a coiled spring that snaps its body forward.

There are many variations within the felidae family. A cheetah is completely different from a leopard. The cheetah hunts by day, singly or in pairs, and by sight, running down its prey with tremendous speed. The leopard is a night hunter and hunts by itself. A leopard has round pupils just like the other big cats, but the smaller cats have pupils that contract to vertical slits. Leopards hunt by sight and stealth. Their icy green eyes have remarkable vision at night, and their homes are in the trees.

You should make a complete checklist of all the known facts about the animal you wish to paint: its physical features, hunting habits, family life, and any other facts that will enable you to paint an authentic portrait of the animal. Then go ahead and enjoy yourself; the hard work is behind you!

The painting of the charging jaguar will help illustrate the problem that all animal painters eventually face: Do you paint the pattern first and then fill in the background color of the fur, or do you paint the fur, with its lights and darks, and then the spots? As shown in the small sketches (Figures 4.4, 4.5, and 4.6), you probably would choose to paint the fur without any pattern, let it dry, and either freely paint the pattern or trace it onto the dry painting of the fur and then paint it, paying particular attention to the perspective as the rosettes (in this case the jaguar's coat) and the values of the pattern change as it goes from light to dark to reflected light.

Cats have more fur than any other animals. Of the three well-known cats, the cheetahs have single spots only, the leopards have a pattern of rosettes consisting of spots in a circular pattern without a spot in the center, and the jaguar has rosettes formed by a circular pattern of four or five spots with a spot in the center.

Figure 4.4 (right)
The sketch of the jaguar represents the feeling of the action of a charging cat, with its legs extended and claws in position to grab the victim. (A sketch visually illustrates your thinking. It is not meant to be a finished drawing.)

Figure 4.5 (below)
This is a study of form and its lights and darks. The next step in developing the drawing is to enlarge it to painting size and then establish the light direction and the resultant core and reflected light.

Figure 4.6 (right)
This is a detail study of the head and claws. Care should be exercised in drawing the action of the leg positions and especially the claws. If the jaguar were jumping a stream, the claws would not be extended as they would be if it were running down prey. The ears are shown laid back because the animal is on attack. If the jaguar were hunting, the ears probably would be turned forward in order to pick up the sounds of an intended victim.

Figure 4.7 (below)
FREDRIC SWENEY (American, 20th century)
The Jaguar (oil).

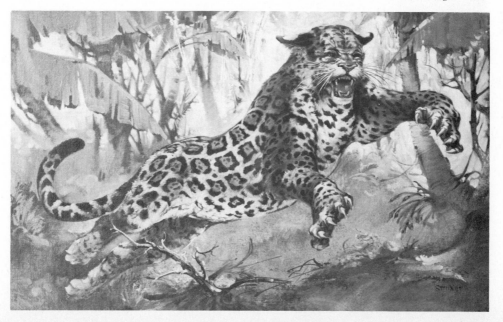

DEMONSTRATION PAINTING

Cougar, puma, catamount, panther, or mountain lion—no matter by what name it is called, it is a very elusive cat. It is an animal of the mountains, the desert, the South American jungle, and as far south as the tip of South America. "Felis concolor" is North America's wild lion. It has been very much maligned and misunderstood.

The cougar is my favorite animal and one that I really love to paint. If you see one in the wild, you are very fortunate, for it is seldom seen. It may be watching you, but you will probably not see it or hear it.

After many sketches and ideas about how the cougar should be portrayed, I chose a scene with a pair of cougars silently watching an intruder approaching their territory, possibly a pack train, a hunter, some backpackers, or a family camping in the valley below. In any event, the cats would avoid "The Outsider" but would keep a careful watch of the activity.

The oil sketch of "The Outsiders" was painted on a canvas panel (Figure 4.8) using the same palette as for the demonstration painting of the "White-Water Trail" in Chapter Two. This is a very workable and easy-to-use palette.

The design of the sketch is based on triangles. The pose of the cougars and the rocks form one of the triangles, the angle of the rocks in the foreground from the left border to the right border form another triangle, and the distant mountain with the snow field and glacier form the third triangle. Using a combination of geometric angles of this type produces a very strong design. Triangles have a solid base and will not fall over.

The charcoal study of the cougar in Figure 4.9 was made on a tissue in the actual size that would appear in the painting, which is on canvas. The final size of the painting was thirty-six inches wide by twenty-four inches high. A second study of the reclining lion was made on a separate tissue in order to be able to arrange the composition of the two tissues into a pleasing design.

The rocks and mountains were sketched in lightly since they would be painted freely and did not need separate studies. The local color of the rocks was brushed in quickly. The darks were added, and their edges were softened with a sable brush and a rag. The rough texture was indicated next, using wadded-up paper. The paint was spread on lightly

Figure 4.8
Oil sketch for *The Outsiders*.

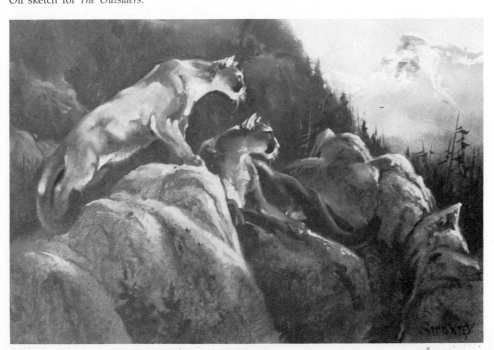

onto a palette and the balled-up paper was used to pick up the paint from the palette and then carefully stipple it onto the rocky areas.

Stippled combinations of color will create a pleasing rocky texture. Figure 4.11 illustrates the general brushwork that was used before the details were added.

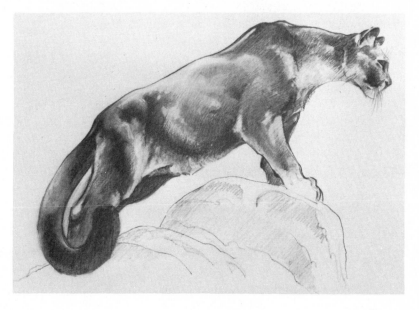

Figure 4.9
Charcoal sketch for one of the cougars.

Figure 4.10

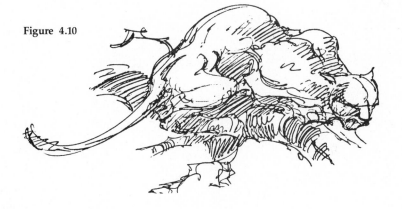

Figure 4.11

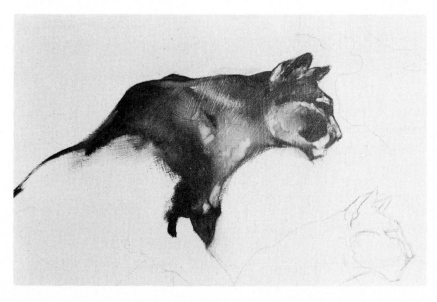

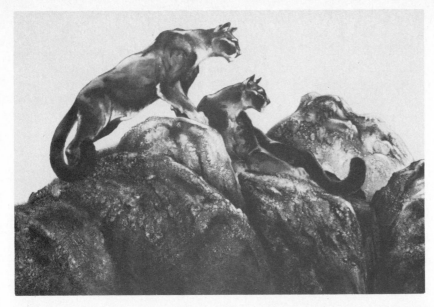

Figure 4.12

The Halfway Stage

Both of the cougars were painted next, with special attention given to the simplified anatomy and the light and dark forms of the animals. This work was carried forward until it was about eighty percent finished. The final details were completed after all of the canvas had been painted. My usual working procedure is to paint the sky first, then the distant mountain, next the middle ground, and, finally, the foreground, but in this case I felt it was important to paint in the forms of the cougars and rocks first, and then

Figure 4.13
FREDRIC SWENEY (American, 20th century)
The Outsiders.
Courtesy of the American Museum of American
Wildlife Art, Lake City, Minnesota.

proceed with the sky and the mountains until those were about eighty percent complete.

The light on the cougars and rocks was handled in the "Rembrandt" style of illumination, with the light coming from the right side, which the animals were facing. Light coming in from the side produces a very effective shadow on the main subject. It dramatizes the cougars and gives a theatrical feeling to the scene.

Completing the Painting

The last stage of the painting is where the important details are added. Beginning with the sky, additional colors were put in with a soft sable brush, the overall colors leaning toward a neutralized blue. The clouds were painted next, with the edges softened so that they bled into the sky. Here again, warm colors were glazed into the clouds so that they would not be too bold.

The distant mountain, with its snow cap and glacier, was the next part to be completed. These forms were painted with a more solid technique. The edges of the snow were kept soft but the rocky walls were painted in a more blocky fashion.

Next, the heavily wooded mountain and its trees were painted with slight detail so that the background remained in a supporting role and did not weaken the animals. Attention was then turned to the two cougars. The hair structure and its direction were carefully dry-brushed. The oil paint was thinned down with turpentine and a touch of painting medium. The strokes were dry-brushed from the back of the animal toward the front, in order to give the effect of overlapping hairs. As the painting progressed near the heads of the animals, the detail was tightened in order to force the viewer's eye to the center of interest.

In addition, there was a slow build-up of the whites on the head and chest. The texture of the paint was kept to a heavy opaque to increase the feeling of thick fur. After this heavy paint dried it was given a fine glaze of a warm, light yellowish tint. Whites look better if they are slightly yellowed to take away the rawness. There are no dead whites in nature but they are bound to pick up some reflected color, in this case a warm color from a low sun.

The final painting of the rocks with a stipple and brushwork was softened with a palette knife and paper that was slightly twisted. After this work dried it was given a variety of colorful glazes that would be found in rocks. When these glazes were dry they also received a thin glaze of raw siena. A glaze of this type, when painted over all of the rocks, helps pull them together into a solid unit. This stabilizes the foreground and completes the painting (see Figure 4.13).

As you draw and paint a variety of animals and birds, you will find that each one becomes a separate problem. This prevents you from falling into the trap of repeating the same working procedure, which in time can become monotonous.

PRACTICE SUBJECTS

These photographs are for the artist's use in composing a painting. Individual taste dictates the artist's preference. Some prefer to paint only domestic cats and their kittens, while others prefer painting the wild members of the Felidae family. The background should be redesigned into a more pleasing composition. Animals, and cats in particular, do not like to hold a pose for any length of time, which makes it difficult to get the cat and a suitable background in the same photograph.

Figure 4.14
Courtesy of Mrs. Alice McClean.

Figure 4.15
Courtesy of Mrs. Rose Forgie.

Figure 4.16
Courtesy of Mr. and Mrs. Fredric Sweney.

Figure 4.17
The Bengal tiger is the largest of the living cats in the world. These tigers weigh between 400 and 600 pounds, are three feet high at the shoulders, and extend thirteen feet when stretched out.
Photograph by Fredric Sweney. Courtesy of Woodland Park Zoological
Gardens, Seattle, Washington.

CHAPTER FIVE

The bull, the ox, and the cow

WE MUST TRACE BACK into the mists of time to the Neolithic period when the domestication of animals and plants began. With the cultivation of certain plants and the domestication of animals that could provide food, clothing, and work power, humans were able to put down their roots in one place. Thus began the advance of civilization and its culture.

HISTORY

It has been generally established that of the five animals useful to humans, the sheep, the dog, the goat, and the pig preceded the cow in the domestication process. The huge Ice Age ox, the auroch, which probably originated in India, roamed Europe 250,000 years ago. It was domesticated about 6,500 years ago, and the last one, a female, died on a Polish preserve in 1627.

When asked to describe some of the animals that belong to the cattle family, most people would probably think of the various milk cows, the bull, and beef cattle, but they would ignore the wild buffalo, such as the African Cape buffalo, the gaur of southern Asia, the musk-ox of the Arctic tundra, and the American bison, just to name a few. All of these animals belong to the genus *Bos*. Some of these animals are of a gentle disposition, while others, such as the Cape buffalo, are considered to be among the world's most dangerous animals. The fighting bull has been bred for four centuries into a beautiful but lethal wild animal. The term "cattle" covers hundreds of the genus *Bovine*.

With cross-breeding, the specialized cattle of farms and ranches do not even remotely resemble the cattle sketched by Cro-Magnon on cave walls.

Cattle belong to the group known as ruminants, which means that they are large animals that chew their cud. They also belong to the ungulates, the hoofed mammals, which includes other animals such as the elephant, the horse, and the hog. Domestic cattle are divided into two types: those that have humps, such as the Brahman and the European breeds such as the Shorthorns, Hereford, Jersey, Aberdeen Angus, and Guernsey.

There is a continuous parade of new breeds, like the Santa Gertrudis that was developed at the King Ranch in Texas and thrives on the damp Gulf Coast. This breed was developed by crossing a Brahman bull with a Shorthorn cow. Other cattle, such as the Charolais, Normande, and Limousin, are being introduced from Europe in experiments aimed at developing a better breed of beef cattle.

Drawing and painting cattle can be interesting and not as frustrating as sketching animals that are continuously on the move. There are many interesting breeds to draw, from the farm and ranch cattle to the exciting rodeo cattle. There are five standard events in a rodeo, and

Figure 5.1
PAULUS POTTER (Dutch, 1625–1654)
Cattle Resting in Landscape (oil, prior to 1978 restoration).
Courtesy of the John and Mable Ringling
Museum of Art, Sarasota, Florida.

Figure 5.2

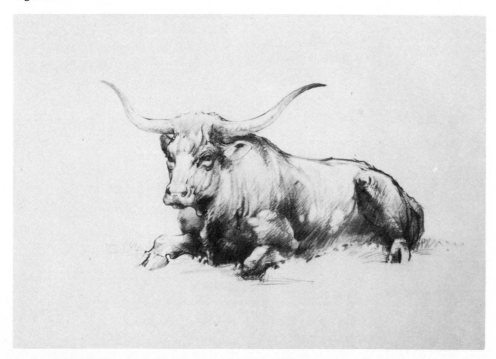

they all present an opportunity for sketching cattle as well as horses. Three of them feature riding bareback and saddle bronc, and bull riding, which is the most dangerous. The other two are calf roping and steer wrestling.

NOTEWORTHY PAINTERS OF CATTLE

The painting of the resting cattle with a simplified background by Paulus Potter is more like a posed portrait. (See Figure 5.1.) This photograph of the painting before restoration shows the true technique of the artist. It demonstrates his drawing ability, but, interestingly, this painstakingly executed painting is lifeless. Unfortunately, the artist's career as a painter covers a span of only ten years. At this same time, Rembrandt van Rijn, Peter Paul Rubens, and Albert Cuyp were also making their mark as animal artists. Rembrandt's studies of animals are unsurpassed. His sketches were made at the zoos of traveling shows that visited Amsterdam, and he probably did not see his subjects in the wild. Artists should

keep in mind that caged animals lack the alertness that an animal has to have in the wild in order to survive. Rembrandt's sketch of a male lion's mane is too full for a wild lion. The mane of an African lion is usually quite thin, because as the lion passes through thorn bushes the hairs are pulled out. Zoo studies are great for detail, but if you are painting action pictures the look of the wild has to be built in.

Other artists worthy of study are Rubens for his swirling animal actions and the English painter Edwin Landseer who excelled as an animal painter. The "Monarch of the Glen," a portrait of a stag, is his most famous painting. Other painters worthy of study are Theodore Gericault and Eugéne Delacroix. Both were from the Romantic era of painting.

And, lastly, we owe a world of thanks to the great animal anatomists W. Ellenberger, H. Baum, and H. Dittrich, and George Stubbs, for their wonderful detailed plates on the animals, and to Eadweard Muybridge for his outstanding series of animals in action.

The painting by Rosa Bonheur in Figure 5.3 is excellent for a study of oxen plowing a field. She is known worldwide for her animal paintings.

Figure 5.3
ROSA BONHEUR (French, 1822–1899)
Labourages Nivernais (oil).
Courtesy of the John and Mable Ringling Museum of Art, Sarasota, Florida.

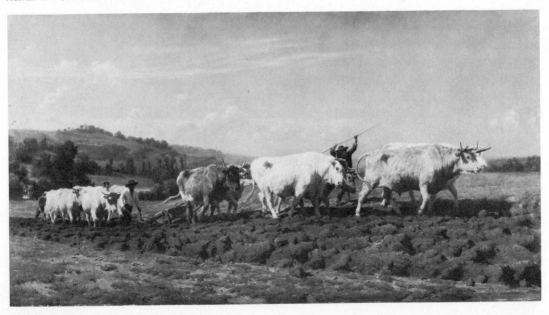

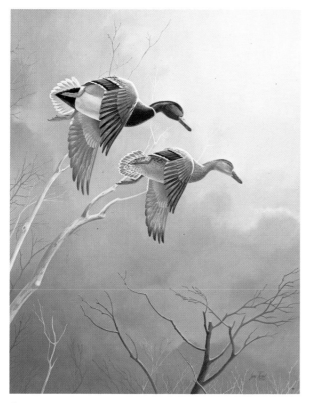

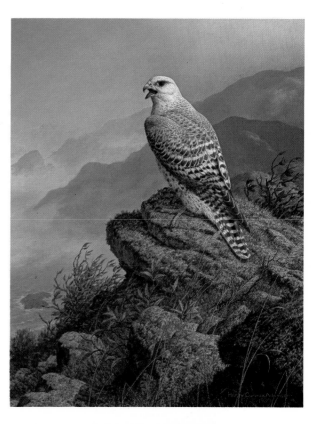

Plate 1
LARRY TOSCHIK (American, 20th century)
Whistling in—Mallards (oil).
Courtesy Mr. and Mrs. Ralph B. Feffer Jr. Collection and Wild Wings.

Plate 3
FREDRIC SWENEY (American, 20th century)
Sunset—Bobwhites (oil).
Courtesy of Wild Wings.

Plate 4
ROBERT BATEMAN (Canadian, 20th century)
Great Blue Heron (oil).
Courtesy of Robert Bateman and Wild Wings.

Plate 5
TERRILL KNAACK (American,
20th century)
Cedar Waxwings (oil).
Courtesy of Terrill Knaack and Wild Wings.

Plate 6
OWEN J. GROMME (American,
20th century)
Wintertime (oil).
Courtesy of Owen J. Gromme and Wild Wings.

Plate 7
ROBERT K. ABBETT (American,
20th century)
Second Season (oil).
Courtesy of The King Gallery, New York City.

Plate 8
MELVIN C. WARREN (American,
20th century)
Remnants of the Herd (oil).
Courtesy of Melvin C. Warren.

Plate 9
FREDRIC SWENEY (American, 20th century)
Early Winter Storm—Pheasants (oil).
Courtesy of Wild Wings.

Plate 10
DAVID A. MAASS (American, 20th century)
Abandoned Orchard—Ruffed Grouse (oil).
Courtesy of Wild Wings.

Plate 14
ROBERT BATEMAN (Canadian, 20th century)
Coyote in Winter Sage (oil).
Courtesy of Robert Bateman and Wild Wings.

Plate 15
RICHARD PLASSCHAERT
(American, 20th century)
Moonan Marsh—Mallards (oil).
Courtesy of Wild Wings.

Plate 16
FREDRIC SWENEY (American, 20th century)
The Outsider—Cougars (oil).
Courtesy of the American Museum of Wildlife Art.

Plate 24
OWEN J. GROMME
(American, 20th century)
Yellowheaded Blackbird (oil).
Courtesy of Owen J. Gromme and Wild Wings.

Plate 23
WILLIAM GILLIES (American, 20th century)
Locked in—Brittany (oil).
Courtesy of Wild Wings.

Plate 25
MICHAEL SIEVE (American, 20th century)
October Snowfall—Whitetail Deer (oil).
Courtesy of Wild Wings.

Plate 26
LEE LeBLANC (American, 20th century)
*McCollum's Flooded Timber—
Mallards* (oil).
Courtesy of Wild Wings.

ANATOMY OF THE BULL, THE OX, AND THE COW

If we study the simplified skeleton of the cow in Figure 5.4 a few variations from the horse will be noted.

The first variation is in the number of ribs. The horse has eighteen while cattle and oxen have thirteen ribs. These ribs are much longer and wider than those on the horse, making the cattle longer in the lumbar. The next difference is seen in the portion of the contour of the area between

Figure 5.4

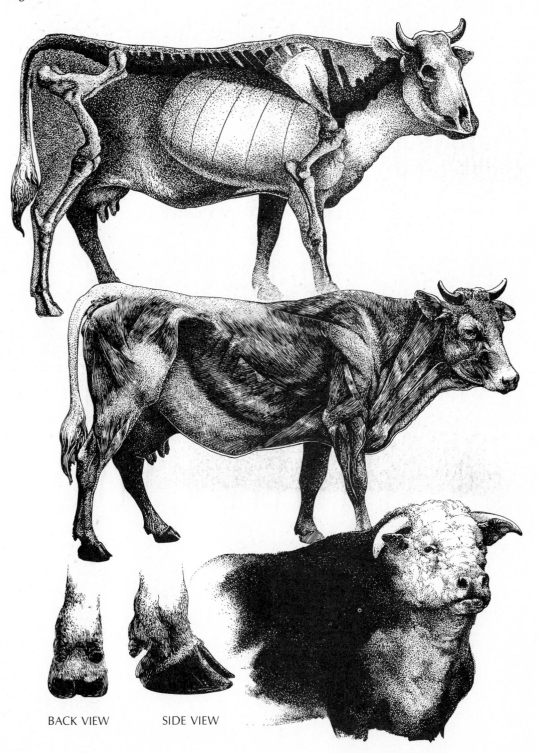

BACK VIEW SIDE VIEW

77

the termination of the neck and the beginning of the chest. The ox, which is one of the working cattle, has what is known as the *incipient hump*. This hump is in front of the spinous processes of the ribs and is caused by the wooden yoke of the ox teams. This area becomes enlarged and hardened so that it forms a protective pad. This condition will be noticed when the ox is used as a draught animal and for plowing.

The Brahman, the sacred cow of India, also has a large hump at the base of the neck. This hump consists mainly of fat and if the animal is well fed and in good condition it will be erect. If drought conditions occur and the animal is not in good condition, the hump will partially dry up and tend to fall over. In addition, this animal has a heavy dewlap, the pendulous folds of skin that hang under the neck and project a short distance toward the rib cage. The Brahman was crossed with a Shorthorn to produce the well-known Santa Gertrudis of the Gulf States. It was also crossed with the Aberdeen Angus to produce the Brangus.

Another feature of which the artist should be aware is where the line of the neck connects with the horn ridge at the top of the skull. The neck should project to the base of the horn ridge, not in line with the top of this ridge. Finally, the hoof is split into two parts. It is not a solid hoof as is found in the horse.

The basic muscle structure is the same for the cattle and the horse. Obviously, the bull is going to have heavier muscle structure, depending on the breed. The Hereford bull is a very heavy beef animal, as illustrated in the lower right corner of Figure 5.4.

A Potpourri of Horns

Drawing and painting animals with horns is fun. Cattle have a great variety of horns, as illustrated in Figure 5.5, so there is a veritable potpourri of horns in the bovine family. There is a difference between horns and antlers. Cattle and many wild animals have horns, while others, such as the deer and elk, for example, have antlers.

Dictionaries describe horns as a hard, bonelike growth of epidermal tissue that occurs in pairs and projects from the heads of animals. These horns are usually curved. Antlers are a deciduous outgrowth (shed at certain times of the year), usually branched, and are found on various members of the deer family.

Horns belong to sheep, goats, cattle, bison, and antelopes as well as the rhinoceros. These animals do not shed their horns. They grow throughout their lifetime. If they are damaged by an accident or in combat, they do not grow back. Horns have an extremely hard outer core and are porous inside. The Pronghorn is the only horned animal in the world that sheds a part of its horn. This occurs annually when the new horn pushes off the old horn.

Antlers belong to deer, elk, moose, and caribou. They are shed annually. Antlers are true bone. They are solid when mature and do not have a marrow.

When we think of cattle, we usually think of the Longhorn, which roamed the open ranges of the Southwest. They are sturdy animals and their horns reached a span of six feet. The Longhorn's opposite is the Black Angus, which is a polled, or naturally hornless breed (Figure 5.6).

Figure 5.7 shows the wild African Cape buffalo bull, an aggressive ox with wide, heavy-based horns that sweep outward, then backward, and finally forward. They travel in large herds and are extremely dangerous. The Cape buffalo has probably killed more big-game hunters than any other animal.

The bull raised for the arena (Figure 5.8) is considered to be a domesticated animal on ranches of Spain, Portugal, and Mexico as long as it remains in the herd, but by itself in the arena, where it pits its strength and cunning against the matador, it becomes a very clever and dangerous wild animal. Thirty-five percent of the matadors that face this animal are either killed or crippled for life.

78

Figure 5.5

AMERICAN
BISON

EAST AFRICAN
CAPE BUFFALO

ZEBU BULL:
"BRAHMAN"

INDIAN
WATER
BUFFALO

ANKOLE
OF
AFRICA

WHITE-FACED
HEREFORD

JERSEY

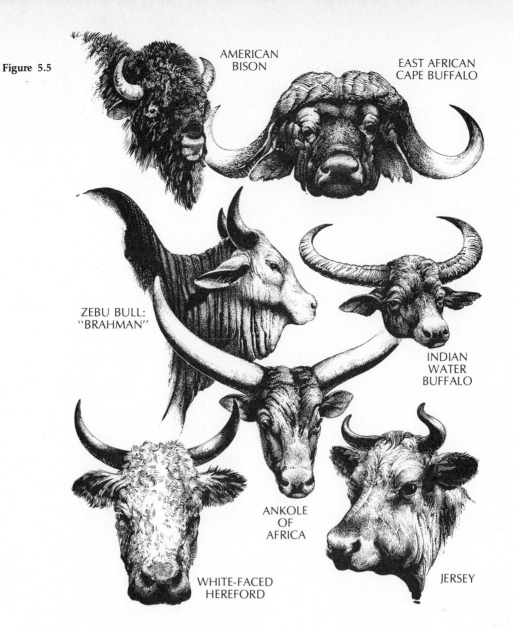

Figure 5.6
Longhorn.

Figure 5.7
FREDRIC SWENEY (American, 20th century)
Cape Buffalo.
Courtesy of the Fall River Group, Milwaukee, Wisconsin.

The cape buffalo is a large and dangerous animal and should be respected. It is very agile and clever and is prone to attack, particularly when injured. It is usually caked with mud in order to protect itself from the bites of insects and flies.

Figure 5.8
Toro, the Brave Bull (scratchboard drawing).
Bred for the arena.

Figure 5.9
VIKTOR SCHRECKENGOST (American,
20th century)
Bovine (glazed terra cotta).
Courtesy of the artist and the Cleveland Museum of
Art, Cleveland, Ohio.

The third example of the bull (Figure 5.9) is the beautiful sculpture from the collection of the Cleveland Museum of Art. This piece shows the great physical strength of the bull even though it is highly stylized. It is a sculpture worthy of serious study.

In 1521, a Spanish sea captain named Don Gregorio de Villalobos unloaded a cargo at a port in Mexico that is now the well-known city of Veracruz. This cargo included a black bull, just like those used in the arenas in Spain, and a cow that was the milk, meat, or work animal of the 16th century.

These two were the progenitors of the Texas Longhorns that trudged to mar-

ket over famous trails such as the Shawnee, which was the first to open in the 1840s from Brownsville, Texas, to Kansas City and St. Louis. The Chisholm Trail was the most used. It carried half of the cattle that were moved from Texas to railheads at Abilene and Ellsworth in Kansas.

The painting of "Three A.M. and All's Well" illustrates how the cowboys told the time at night by the angle of the two points of the Big Dipper in its rotation around the North Star. The sketches in Figures 5.10 to 5.12 were some of the many that were made preliminary to painting this night scene of the bedded-down Longhorns on their long trail to market.

80

Figure 5.10

Figure 5.11

Figure 5.12

Figure 5.13
FREDRIC SWENEY (American,
20th century)
Three A.M. and All's Well.
Courtesy of Joel R. Rachlin, Milwaukee, Wisconsin.

DEMONSTRATION PAINTING

Not all animal paintings are of the usual animal and landscape concept. "A Friendly Conversation" was painted to demonstrate the use of an architectural background, in this case the portico to the church and convent of Santa Isabel la Real in Granada, Spain. It portrays a quiet conversation between a priest and a peasant.

The priest, with a pole that was used to guide the yoked oxen, is standing in a two-wheeled cart called a carreta. The carreta's wheels were cut from a solid piece of oak or made of sections of wood that were criss-crossed in a rather loose fashion and held together with wood pegs.

Figure 5.14

81

An eight-inch hole was roughly cut out for the axle, which was very seldom lubricated. The squealing of this contraption as the wheels rotated could be heard for a mile, adding much discomfort to the nerve-weary traveler (Figure 5.16).

The Halfway Stage

The lines were first sprayed with a fixative so that they would not smear when painted over. Next, the wall behind the architectural detail of the portico was toned by rubbing a mixture of raw umber with just a touch of viridian and raw siena in order to warm it slightly. These colors are all transparent so they could be rubbed over the traced lines without disturbing them. The door was also toned at this time with a dark, reddish brown.

The upper portions of the walls on both sides of the entrance were also rubbed with a lighter tint of raw umber and raw siena. The bottom sections then received a greenish gray tint of color. The tree was next, quickly brushed in with a dark, reddish brown.

With all of this preliminary work out of the way, my attention was then directed to putting in the detail of the portico; this would be the most tedious to do. After this was executed, the priest, carreta, oxen, and peasant were painted. This was carried to the eighty percent finished stage.

Figure 5.15

Figure 5.16

Figure 5.17
Two-point perspective was used in projecting the architectural detail necessary for the portico. Because the building is shown at an angle and not a straight-on view, it is necessary to show the depth of the decoration as well as the height and width.

82

Figure 5.18
A separate tissue of the flower vendor and the priest talking to the nuns of the convent was also necessary. This sketch was made on a separate tissue so that it could be moved about on the canvas to add to the composition.

Figure 5.19
A separate tissue was made of the patient oxen. Each ox was sketched separately, and then all were compiled onto a single tissue. You cannot draw one ox and use it for the other one as well because the distant animal is slightly smaller.

Figure 5.20
The final tissues were traced onto a canvas that measured twenty-four inches wide by thirty-two inches high. The architecture was the first to be traced, then the priest and oxen, and finally the flower vendor. The tree was just indicated.

Figure 5.21
A Friendly Conversation.

Priest and peasant and the portico of the Convent of Santa Isabel La Real, Granada, Spain.

After the main parts of the picture were established, the tiled roof was painted to completion. The dappled sunspots on the rough wall in back of the flower vendor and tree were textured with an impasto. In this case, a palette knife was used and then it was finished with a brush. When this area had completely dried, the cast shadows were carefully painted in.

The dirt road was filled in with a sandy color and textured with a palette knife. Cast shadows were indicated next to carry the eye to the main subject and also to illustrate the perspective of the ground. The ground was painted with a combination of palette knife and brush.

The door, nuns, and flower vendor with her colorful flowers were next to be finished. Finally the priest, peasant, oxen and carreta were carried to completion.

After the painting was dry, glazes were applied to enhance the colors and also to adjust the values, especially in the foreground. This adjustment should not be too prominent as it would weaken the main subject matter, which is the priest and peasant. The portico sets the scene so it should remain in the background.

PRACTICE SUBJECTS

These photographs of cross-breed cattle are for the artist's benefit and are to be enlarged and used in practice paintings. It is suggested that working tissues be made of the bone and muscular construction in order to obtain a better understanding of the animal that is going to be used in a painting.

Figure 5.22
Charolais—Brahman cross.

Figure 5.23
Brangus, a Black Angus—Brahman cross.

84

Figure 5.24
White-faced Hereford—Brahman cross.

Figure 5.25
Guernsey—not a cross-breed.

Figure 5.26
Charolais—Brahman cross.

Figure 5.27
Charolais—Brahman cross.

The dry-brush drawing of a cowboy riding a Brahman bull (Figure 5.28) should be enlarged to a workable size. The artist is to put in a suitable rodeo background.

The grip on the bull rope may vary with individual riders. Some have handholds and some do not.

Figure 5.28

CHAPTER SIX

The deer

THREE TYPES OF DEER are found in the United States: the white-tail, the mule, and the black-tail. Of these three the white-tail and the mule deer are the true members of the very exclusive family of the American deer. The others that are frequently seen are subspecies.

HISTORY

The native American deer has an ancestral lineage that goes back to the Pliocene era of ten million years ago. The deer that is common today in America evolved about one million years ago. There are thirty subspecies of the white-tail deer that inhabit the North American continent. Of these, seventeen are found from Mexico northward. The Coues and the Key deer and other similar white-tail deer are all subspecies. The Virginia white-tail deer, which is the prototype, and its subspecies are found in all forty-eight states.

The Rocky Mountain mule deer, which is the prototype for the mule deer, has seven subspecies. This deer and its subspecies are not found east of the Mississippi River, except for a few black-tails that were transplanted to Tennessee. The range of the black-tail, which is a coastal deer, extends from Alaska to California.

It is very important for the artist who is painting a white-tail or mule deer to be aware of the common terrain of these animals so that the appropriate background and landscape can be maintained.

Figure 6.1
KEN CARLSON (American, 20th century)
Stillwater Passage (oil).
Courtesy of Wild Wings, Inc., Lake City, Minnesota.

Figure 6.2

Other members of the deer family are the elk, the moose, and the caribou.

Deer are exquisite, dainty animals that have learned to adapt themselves to an exploding civilization that is encroaching upon their territory. They belong to the herbivorous, ungulated, ruminant animals. In other words, they feed on vegetable matter, are four-legged with cloven hoofs, and they chew their cud.

They have survived many other animals that could not cope with civilization. It has often been said that there are more deer now than there were at the time when the Europeans came to settle this land. It is estimated that there are approximately nineteen and a half million deer in the United States. This is quite a comeback when you consider that during the late 1880s they were almost annihilated. Deer adapt readily to changing conditions and with the help of applied conservation, their future will be secure.

Figure 6.3
GARY SORRELS (American, 20th century)
Pronghorn Range (oil).
Courtesy of Wild Wings, Inc.,
Lake City, Minnesota.

Figure 6.4
FREDRIC SWENEY (American,
20th century)
Mule Deer (oil).
From the archives of and copyright
Brown and Bigelow, St. Paul, Minnesota.

ANATOMY OF THE DEER

Figure 6.6 shows the muscular structure of a white-tail in a jumping position. Rather than illustrating the muscular forms of a static animal, it is better for the artist to think of them as living, vibrant animals in which the muscles are contracting and stretching according to the action.

Many animals have the same skeleton and muscular structure as the deer, such as the American Pronghorn Antelope and the many varied species of the deer-like animals of Africa and South America.

Fawns are born with a spotted coat.

This spattering of white polka-dots on a reddish brown coat and the fawn's ability to lie perfectly still when danger approaches make it practically indistinguishable among the grasses and weeds where it hides.

When drawing fawns, accent their delicate bone structures. They are long-legged and knock-kneed at an early age. When sketching the adult white-tail, be sure to indicate their angular look. They are very graceful, slender, and rhythmic in appearance. The buck has a much stockier body as compared to the doe. The muscles are blockier and the neck much thicker.

89

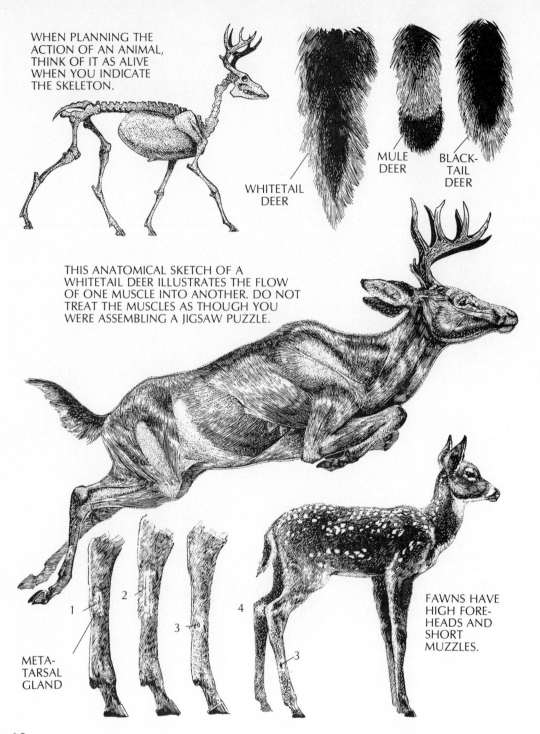

WHEN PLANNING THE ACTION OF AN ANIMAL, THINK OF IT AS ALIVE WHEN YOU INDICATE THE SKELETON.

WHITETAIL DEER

MULE DEER

BLACK-TAIL DEER

THIS ANATOMICAL SKETCH OF A WHITETAIL DEER ILLUSTRATES THE FLOW OF ONE MUSCLE INTO ANOTHER. DO NOT TREAT THE MUSCLES AS THOUGH YOU WERE ASSEMBLING A JIGSAW PUZZLE.

META-TARSAL GLAND

FAWNS HAVE HIGH FORE-HEADS AND SHORT MUZZLES.

Figure 6.5

Three definite areas serve as a means of identification as to whether deer are white-tail, mule, or black-tail: the tail, the metatarsal gland, and the antlers. Facial markings can also play an important part in identification but they can also be very deceiving, particularly for the cross-breed. The normal markings of the tails of the three deer are illustrated in Figure 6.5. The tail markings of a hybrid will proba-

bly be a combination of the two adult species.

The metatarsal gland, which is found about halfway between the heel joint and the hoof, is probably the truest means of identification. This is a very important area that the artist should not ignore when painting deer. The metatarsal gland of the black-tail is approximately three inches long, including the hair tuft. The

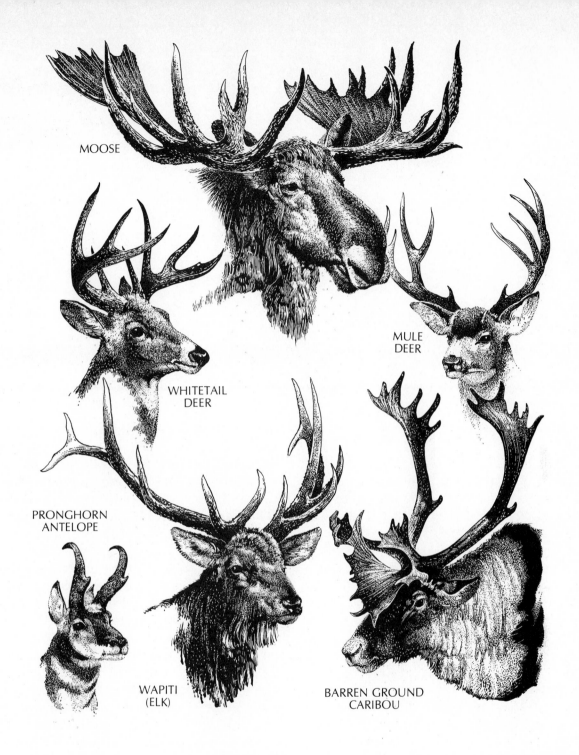

MOOSE

WHITETAIL
DEER

MULE
DEER

PRONGHORN
ANTELOPE

WAPITI
(ELK)

BARREN GROUND
CARIBOU

metatarsal gland of the mule deer is five inches in length, while the metatarsal gland of the white-tail is round and one inch in diameter.

The tarsal gland is located on the hind leg of the fawn and is an area of still another gland that should be indicated in drawings and paintings of deer. It is marked by a large, dark, tufted patch of hair. This gland and the metatarsal gland

are not true glands but are basically scent glands.

The scratchboard drawings of the simplified skeleton and the action pose of the white-tail deer are self-explanatory (see Figures 6.6 and 6.7). It is more important to indicate the flow of the muscles as they blend into one another than to treat them as individual little maps without any form.

Figure 6.7
This is an exact-size sketch of the arrangement of the white-tail deer used in the demonstration painting. It was not necessary to make a detailed study of the deer at this time since it would be carefully drawn on the canvas, and the necessary lights and darks sketched in to indicate the light direction and the forms. This sketch was made with a Thinrite pen on parchment paper.

Antlers and Horns

For centuries people have been fascinated with the glamorous adornment of the antlers and horns of animals. Deer do not have horns, they have antlers. As was discussed in Chapter Five, according to dictionaries, "horns" are hard, bonelike, permanent growths of epidermal tissue that occur in pairs (except in the rhinoceros) and project from the heads of various hoofed animals, such as cattle, sheep, and oxen. (The horn of the rhinoceros is not made of a horny substance, neither is it bony, but consists of congealed hair.) Horns are continually growing and they are never shed. If they are damaged or broken, the animal lives with them that way the rest of its life.

The American pronghorn antelope has the distinction of being the only animal in the world that sheds only the outer covering of its horn. The old black outer sheath is slowly pushed off as the new sheath grows.

Antlers belong to deer, elk, moose, and caribou. They are deciduous, which means that they are shed each year and are replaced with a new set. If antlers are damaged, the animal lives with the damaged antler until the end of the rut,

when they are shed and replaced with a new pair.

The first sign of antlers in a young buck will be in the second summer of its life, and these are called *spikes*. These spikes are usually straight, although at times they will grow with a pronounced curve. They project straight up from the top of the skull. With each successive summer, the white-tail buck will develop a main beam and from this a series of unbranched *tines* will develop. The antlers of the white-tail project further forward over the face while those of the mule and the black-tail project upward from the head and their tines branch and then branch again. These are called *bifurcated* tines. During the growth of these tines they are covered with a skin that looks and feels like velvet. At this time the deer are spoken of as being "in the velvet." Since these antlers will not solidify until autumn into a solid, bonelike form, they are soft and extremely tender and are subject to damage.

Generally, these antlers grow larger and more massive each year, and new tines or *points* are added until the deer reach maturity. After a buck reaches its prime, the number of tines will remain the same. Depending on its diet, a mature

eight-year-old white-tail will have a beautiful set of antlers.

A mature white-tail buck in the prime of its life will generally carry from four to six tines on each beam. To count the tines you would count the tip of the main beam, plus the tines that project from the main, plus the brow tine, so that if you had the tip, three tines on the main beam, and the brow tine you would have a total of five tines on a side. Adding the other side, which usually has the same number of tines, you would then consider the buck to be a ten-point deer. That would be quite an impressive set of antlers.

During old age a deer will begin to lose the massiveness of its antlers, and the tines will decrease in number until it degenerates to a set of spikes at the probable old age of twelve years.

The scratchboard drawings in Figure 6.6 illustrate the members of the deer family that are found in the United States. The largest member of the deer family, and also one of the largest of the hoofed animals, is the moose. Its antlers, also known as the "rack," will have a spread greater than six feet. The tiniest member of the deer family is the pudus, which lives in the temperate forest zone of the

Andes. Adult stags are about the size of a small terrier. They are covered with a thick fur, have slender but strong legs, and their antlers are mere spikes.

DEMONSTRATION PAINTING

With the warm-colored rays of the autumn sun touching the trees and the trunk of the giant oak, and a small stream moving swiftly, almost inaudibly, through a cleft in the rocks of the forest, a buck white-tail pauses briefly in the thick cover to test the clean, crisp morning air with his black, moist nose. His ears are swung backward, listening for forest sounds that would spell danger to the does and himself as he pushes them ahead into the sanctuary of the deeper forest. He was a giant among the giants of the virgin forest. This is the scene that I wished to paint.

The sketch in Figure 6.8 has already been projected onto the correct sized canvas, and the forms of the deer have been indicated. The next step is to paint the sky. A light tint of orange and yellow ochre was applied and rubbed into a soft tapering value to the top of the trees.

Figure 6.8
A separate sketch was also made of the forest landscape on parchment paper, and then the two were combined to form the completed composition. This final sketch is shown in its actual size, which was then projected with an opaque projector onto a two-foot by three-foot canvas mounted on a stretcher.

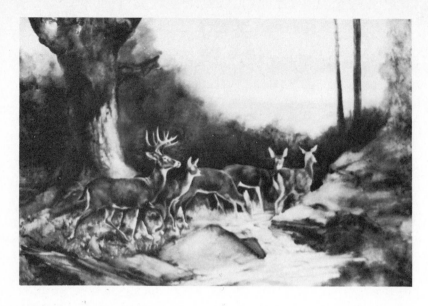

Figure 6.9
The halfway point.

Figure 6.10
FREDRIC SWENEY (American, 20th century)
The Virgin Forest (white-tail deer, oil).

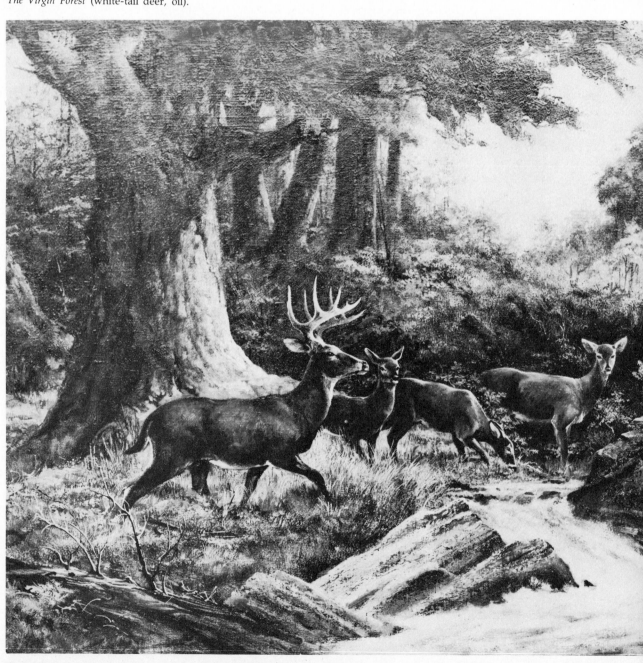

Next, the dark in back of the giant oak was painted using a combination of raw umber and burnt siena. The trunk was painted next, taking care to keep the light area of the trunk white, as this would be painted with clear glazes of raw umber for form, and burnt siena and cadmium orange for basic color. All of these colors were applied as a glaze in order to enhance the brilliance of the sun. It is suggested that you study J.M.W. Turner and Maxfield Parrish for this technique.

The forest floor with the fallen log, brushy areas, grasses, and sunlight were next to be indicated with oils thinned with turpentine and medium. The colors were a combination of raw umber, burnt siena,

and raw siena. They were applied in a sketchy manner, almost a watercolor technique.

The rocky wall and its drooping ferns were lightly painted. The reference material on the rocks, moss, ferns, and small branches and twigs came from a set of transparent color slides. These slides were not copied exactly, but were used to gain an understanding of the general appearance.

Finally, the deer were painted with a local color overall. A word of caution to artists: Deer in their summer colors are more reddish, which is known as being "in the red," while the winter colors are a more grayish brown. This color phase is known as being "in the blue." The deer were eighty percent completed at this stage. The final details were added at the very end.

The final phase was begun by completing the distant woods. Remember that all trees in the fall of the year will probably be a combination of greens, reddish browns, brownish yellows, and deep reds, depending on the species and varieties of the trees. The forest was painted from back to front, from a light background to a dark foreground, so that the brush strokes and attention to the now critical values could be controlled.

As the painting neared completion, texture was added to the rocks. This was handled by using paper towels and aluminum foil that were rolled up into a small ball and pressed into the oil color that was spread upon the palette and then stippled using a combination of various colors until the desired effect was achieved.

The depth of the trees also was painted by using an opaque paint mixture and overlapping the branches and leaves in front of the tree trunks. Remember to paint a tree that has leaves in front of and behind the trunk, as well as those that are to the left and right; in other words, a four-sided tree will look much better.

The forest floor and the stream were carried to completion. The final step was to use the palette knife in order to loosen up the painting, which is now finished.

PRACTICE SUBJECTS

I chose not to use photographs of deer to be copied although there are plenty in my movie and clip files. The artist can use these sketches as an advertising or magazine art director uses a sketch of a pose that they want to use in an advertisement or a magazine story that they want to illustrate. The technical research is up to you.

Give yourself a reasonable time frame for the work. Pick your own medium, one with which you will be comfortable.

Figure 6.11
The buck black-tail deer lives in the humid forests along the Pacific coast. It is not as large as the mule deer that occupies the same area. Its antlers usually do not have the same number of points, and its coat is darker. This sketch was made from a photograph taken in Washington's National Forest.

Figure 6.12
This action sketch of a buck mule deer is an interesting one to use for a painting. Mule deer are the largest deer in the United States. They have a strange gait, an adaptation that permits them to escape in a rocky country: They bounce stiff-legged instead of running. They are found throughout the West. The largest ones are found on the Kaibab plateau on the north rim of the Grand Canyon in Arizona.

Figure 6.13
The elk, or *wapiti*, as the Indians called it, is the grand sultan of the deer family. Some bulls have collected huge harems and may have as many as fifty or more mates. In the fall, its challenging call to other bull elk as it proceeds to keep adding to its harem can be heard for great distances. Large elk herds remain in Canada, in Yellowstone Park, and on the Olympic Peninsula.

Figure 6.14
This quick sketch of a female black-tail deer shows the deer to be gentle and delicate. These deer's tails are almost a duplicate of those of white-tail deer, black on top and white underneath. They are not ropelike like a mule deer's tail, even though they are a subspecies of the "muley."

CHAPTER SEVEN

The bear

As CHILDREN, we were introduced to the bear by way of the Teddy bear, which was named after our twenty-sixth president, Theodore Roosevelt. Then, to add to our knowledge of bears, we were told the story of Goldilocks and the Three Bears. Our impression of bears by this time was that they were cute and cuddly.

TYPES OF BEARS

The following are the members of the genus Ursidae that are found on the North American continent.

The black bear (Ursus Americanus) is found only on the North American continent, in Newfoundland, and on Van-

couver Island. Its subspecies are the cinnamon bear found in the Rocky Mountains, the glacier bear found in the glacial regions of the St. Elias Alps and as far southeast as Glacier Bay. It has a beautiful blue-white pelt. The small Kermode bear is a striking pure white bear from the islands and coast of British Columbia.

The polar bear (*Ursus maritimus*) is the only true carnivorous bear. Its range is from northwestern Alaska to as far east along the Alaskan coast and islands to Labrador, which includes the shores of the Hudson Bay region. Its main habitats are the circumpolar ice fields that are at a great distance from the mainland. The polar bear is on the mainland for only a very brief time during the year. Surprisingly, it is not found in the Antarctic.

Figure 7.1
FRANK HOFFMAN (American, 20th century)
King of the Hill—Grizzly.
From the archives of and copyright
Brown and Bigelow, St. Paul, Minnesota.

Finally, we have the grizzly, which was classified at one time as "Ursus horribilis." It is a member of the brown bear group that also includes the Alaskan brown bear and the Kodiak bear, which are subspecies of the grizzly. The grizzly bear is a solitary animal, very aggressive and ferocious, with a distinctive hump at the shoulders and extremely long and sharp toenails.

The brown bear also has the hump. Its coat has many color variations, from blackish, through the reddish browns, to beige and an almost light yellowish cast. The long hairs of the pelt have whitish tips, hence the name "grizzly" to denote a grizzled color.

The largest carnivores in the world are the Alaskan brown bear—a coastal bear—and the Kodiak bear that lives on Kodiak Island. When standing erect, they reach a height of ten feet.

SIZE AND BEHAVIOR

A bear is a *plantigrade* animal, one that walks on the sole of the foot, not on the finger tips as do the hoofed animals, which are called *digitigrade*.

Bears are classified as being carnivorous, but they are actually omnivorous in their diet, which includes a wide variety of vegetable matter such as berries and nuts. During the great salmon runs in the Northwest and Alaska, they subsist mainly on fish.

Bears are massive in size, weighing from 200 to 300 pounds for an average black bear, 500 to 700 pounds for an aver-

Figure 7.2
Polar bear.

Figure 7.3

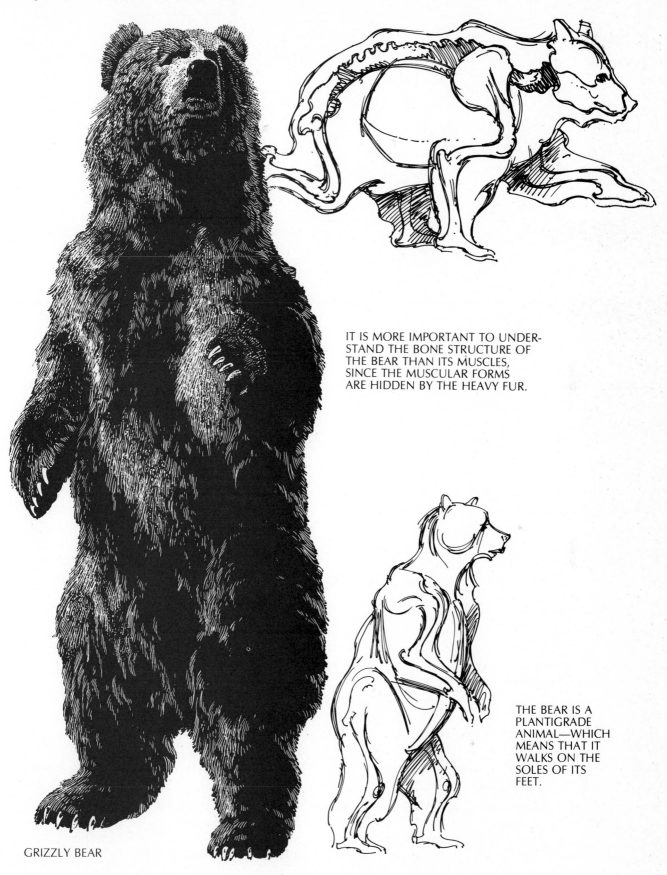

IT IS MORE IMPORTANT TO UNDER-
STAND THE BONE STRUCTURE OF
THE BEAR THAN ITS MUSCLES,
SINCE THE MUSCULAR FORMS
ARE HIDDEN BY THE HEAVY FUR.

THE BEAR IS A
PLANTIGRADE
ANIMAL—WHICH
MEANS THAT IT
WALKS ON THE
SOLES OF ITS
FEET.

GRIZZLY BEAR

Figure 7.4
The Alaskan brown bear is listed with the world's most dangerous game animals. It is very powerfully built, with thick muscles covering an exceptionally strong skeleton. It can break a steer's neck with one blow of its paw. Animal experts say that no bear is to be trusted.

DEMONSTRATION PAINTING

This portrait is of Nanook, the great white bear of the frozen northern seas, one of the most interesting and romantic animals on the face of the earth. The polar bear has adapted itself to a nomadic, lonely existence in a land of cold, jagged, drifting ice. This painting shows the great bear on the ice floe, looking at the aurora borealis as it pulses snakelike in the still Arctic night. It is a fitting tribute to a great animal. The only study that was necessary for this painting was a sketch (Figure 7.5), which was projected onto a twenty-four-inch by thirty-six-inch canvas. After the bear was traced onto the canvas, it was very carefully drawn, particularly the bone structure. It is very important for the bone structure to be indicated, especially the joints. Draw all of the leg bones, including those on the far side, so that the legs and feet are in their proper locations. The individual muscles do not show through the thick fur. Treat the muscles as great masses to depict strength. The muscular forms do affect the light and darks and the hair directions as they curve around these forms.

The rough contour of the pack ice was sketched in lightly next. Attention was paid to the serpentine path of the Arctic water as it winds its way through the ice field toward the open water ahead. This path leads the observer to the northern lights and finally to the star-gazing bear. The angle of the bear's feet on the sloping ice directs the eye toward the water and the process starts all over again.

The first section of the painting to be executed was the sky and the aurora. The colors of the aurora were first applied with a brush and then the edges were rubbed with a soft cloth. Next, the color of the northern night sky was painted with a wide brush, taking care to keep the paint thin as it neared the edges of the aurora. Finally, the two edges were blended with a wide sable brush. The au-

age grizzly, and 1,600 pounds for an average Alaskan brown bear and polar bear. The record weight for a polar bear is 1,700 pounds. In most cases, it is next to impossible to weigh a huge bear. This is especially true of a polar bear since they live on the Arctic ice fields. There is a perpetual argument over which animal is larger, the brown bear or the polar bear. Knowing the sizes of these animals, an artist should pay attention to the scale of objects like trees and rocks, and whether they should be drawn from eye level or a worm's-eye level in order to give a feeling of massiveness and weight.

Polar bears are exceptionally strong swimmers and have been seen as far out as 200 miles at sea, far from the circumpolar ice fields where they spend most of their life in the Arctic. The male polar bear does not hibernate, but the female on the mainland does hibernate like other bears. The male is constantly hunting for food, in winter and summer, with the seal as its major supply.

Figure 7.5

Figure 7.6
The halfway point. It is very important for the emotional and visual effect to be created at this stage. Bad starts do not result in outstanding paintings.

rora received a final thin glaze of colors in order to enhance the brilliance of the northern lights.

The next step was to paint in the bluish green colors of the ice field. This is a very tricky lesson in values, with the local colors being neutralized with the colors of the night sky. I chose to paint the ice in a low value, remembering to keep the edges rounded to indicate the melting of the ice at the water's edge. The final color of the ice was glazed with a thin tint of the reflected colors of the aurora and the night sky.

The warmish color of the polar bear was painted next. Actually, a polar bear is not dead white but more like a thin raw siena or a yellow ochre in color. In the wild, white fur becomes stained; museum and zoo animals are whiter. White picks up the surrounding local colors, so strict attention must be paid to the colors and their values in order to make the bear

look white against the night scene. On a value scale of ten, with white as zero and black as eleven, the final painting of the bear was in number six, seven, and eight values; glazes were applied over them with the colors of the aurora and the night sky.

The bear has purposely been silhouetted against the ice field, which is a lighter value. The sides of the bear are on the shadow side, away from the light of the aurora. Attention was paid to the reflected colors of the ice underneath the bear, which are necessary to show form. Remember that to achieve form you must have a highlight, a middle-tone, a dark, and a reflected light.

Final glazes were applied and the necessary details of fur direction, eyes, nose, and feet were painted, and the portrait of the polar bear was completed. This is a difficult painting to execute but one that an artist can really learn from.

Figure 7.7
FREDRIC SWENEY (American, 20th century)
The Star-Gazer—Polar Bear.

PRACTICE SUBJECTS

The photographs of the bears show some pleasing positions and actions for you to enlarge and draw. Make certain to indicate the bone structure and make a value study for the lights and darks that are necessary to indicate forms. The photo- graphs give you a choice of a young Kodiak bear, an older female Kodiak bear, and a polar bear. Make sure that you have the correct background. The Kodiak is found on coastal Alaska while the polar bear is found on the ice floes of the northern oceans and seas and seldom on land. Landscape plays a very important part here.

Figure 7.8
Young Kodiak bear.
Courtesy of Woodland Park Zoo, Seattle, Washington.

Figure 7.9
Polar bear.
Courtesy of Woodland Park Zoo, Seattle, Washington.

Figure 7.10
Kodiak bear.
Courtesy of Woodland Park Zoo, Seattle, Washington.

CHAPTER EIGHT

Goats and sheep

As we begin our study of goats and sheep we suddenly become aware that most of us have had some incorrect notions about these animals, especially the wild ones.

TYPES, BEHAVIOR, AND ANATOMY

Mountain goats look and act like goats but they really belong to the antelope family. Goats and sheep are very closely related; the main distinguishing characteristics between the two species are their horns. The wild sheep have massive, spiraling horns; goats do not. Strangely enough, the wild Rocky Mountain Bighorn sheep do not have coats of wool like their do-mestic cousins, but are covered with hairy coats quite similar to those of the deer family. In addition, wild goats have beards, and sheep do not. The wild goat that lives in North America is closely re-lated to the European Chamois, which is the intermediate link between the wild goats and the antelope.

The bone and muscle structure of goats and sheep is almost identical to that of the deer. When drawing any of these animals you can safely sketch the anat-omy of the deer.

The living species of wild sheep, which were the successful mammals of the Ice Age, are the mouflon (which is the smallest), the urials, the snow sheep, the thinhorn, and the bighorn, which includes the desert bighorn and the giant argalis. The argali (Ovis ammon) is the Eurasian

106

species that also includes the Marco Polo sheep, named in honor of the great Venetian explorer.

The sheep of North America are divided into four classifications. The desert bighorn, which is a subspecies of the Rocky Mountain bighorn, is found in the Southwest. The Rocky Mountain bighorn is found in the western mountain areas, particularly in the Sierras, Rockies and Cascades. The stone, which is a subspecies of the dall, is found in western Canada and Alaska, and the dall, which is entirely white with golden-colored horns, lives in Canada and Alaska.

Many hunters consider sheep to be the greatest game animal. Animals like the Cape buffalo and the elephant are more dangerous, but the odds for a successful sheep hunt are not very great on account of the lung-bursting physical strain of the high altitudes and the biting cold, in addition to the windy areas hunters must traverse with their icy, narrow ledges and vertical drops of hundreds of feet. This is a tremendous challenge that faces the sheep hunter and, also, the nature photographer and artist as they wait for that moment when they sight a ram with a beautiful, spiraled, full-curled pair of horns.

The wild goat, which is easier to see, is more placid, does not show great fear of humans, and is interesting to sketch

Figure 8.1
HARRY CURIEUX ADAMSON (American, 20th century)
The Upper Gorge—Argali Rams (oil).
Courtesy of Mr. and Mrs. John H. Batten.

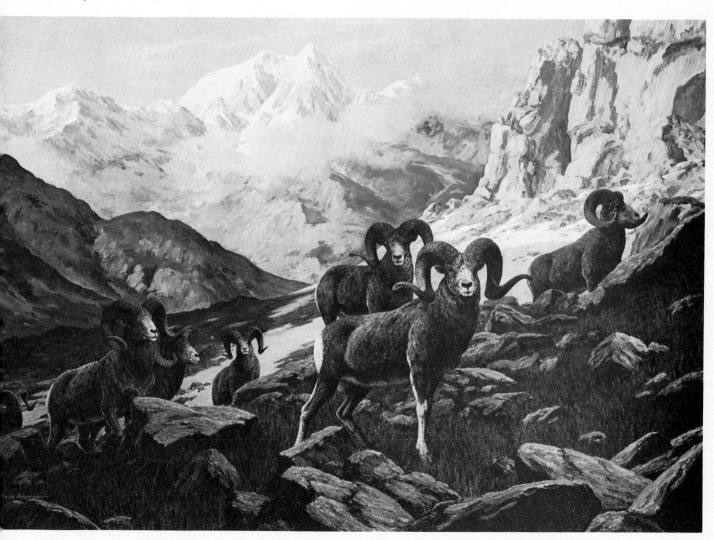

107

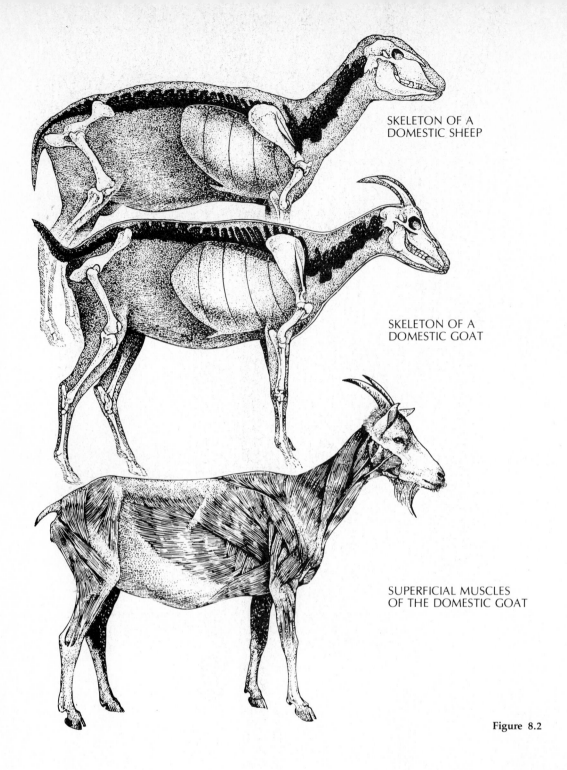

SKELETON OF A
DOMESTIC SHEEP

SKELETON OF A
DOMESTIC GOAT

SUPERFICIAL MUSCLES
OF THE DOMESTIC GOAT

Figure 8.2

Figure 8.3
This is the sketch of the Rocky Mountain bighorn sheep.
When drawing wild sheep, pay particular attention to the
overall span of the horns.

Figure 8.4

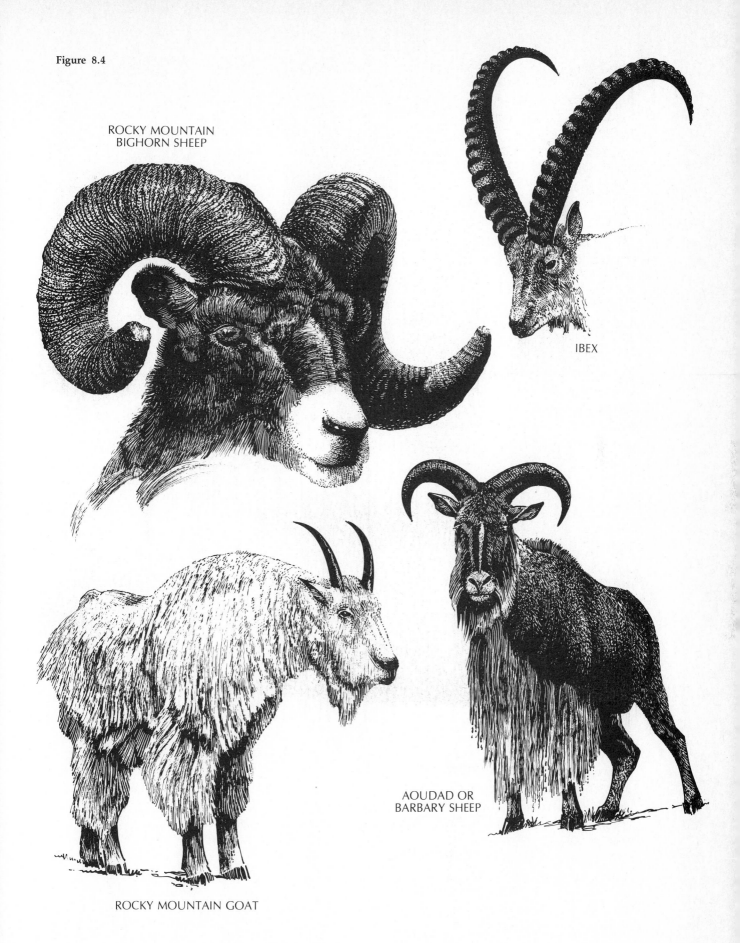

ROCKY MOUNTAIN
BIGHORN SHEEP

IBEX

ROCKY MOUNTAIN GOAT

AOUDAD OR
BARBARY SHEEP

and photograph. The wild goat, the dall sheep, and the polar bear are the only large game animals in the North American continent that are completely white year-round. The goat is found in the mountain ranges of Montana, northern Idaho, Washington, Oregon, British Columbia, and the Yukon.

USE OF THE CAMERA FOR ANIMAL AND BIRD ART

There are many misconceptions among artists about the use of the camera in research for a drawing or painting. Some neophytes seem to feel that artists are cheating if they use a camera in the production of a painting. In animal and bird art the camera has proved itself many times over as a useful tool for the artist, just as a triangle and T-square are valuable to an architect.

Edgar Degas did not hesitate to study action photographs of Muybridge horses as they ran and trotted before his bank of cameras. Jan Vermeer used a *camera obscura*, possibly the portable type that was the innovation of the 17th century, in his scenes of Delft. Canaletto, or Giovanni Antonio Canal, is also suspected of using the camera obscura in his scenes of Venice. It was used as a point of departure, not as the means to an end. These artists used the camera obscura well, just as a portrait artist today uses the camera to make studies first, and then, with very selective taste, sketches the pose and the features, compiling them into a basic study. Then the model is called in for corrections and approval and they proceed with the final portrait.

My own personal movie and still file of animals and birds is quite extensive. Out of all the thousands of frames from my pictures of animals, particularly of bears and other dangerous animals, I have not found one frame that I could trace. Either the legs were in the wrong positions or the lighting was not what I desired.

Figure 8.5

Actually, all I wanted to know was how big the bird or animal is, its head construction, and its general color at that moment, whether it was in a shadow, in bright sunlight, or on a cloudy day. From that point, I preferred to be an artist and to impart my own feelings for that bird or animal. Use the camera, but do not let the camera use you.

DEMONSTRATION PAINTING

The original conception of this painting was to be a portrait of dall sheep high up in the mountains, above a fog bank that was slowly engulfing the distant ridges (Figure 8.6), but as I gathered my material and researched the material that was available I decided it would be more characteristic to show the rams assembling for their annual summer "bachelors' club." Hence, the new composition. (See Figure 8.7.)

This grouping of rams would make it possible to illustrate the various age groups. Age is indicated by the length of

Figure 8.6

the curl of their horns. The ram on the left of the painting is an adult in the prime of life. The full curl develops when the ram is approximately seven to eight years old and continues growing until the animal reaches the end of its life, which is about twelve to fourteen years. The youngest ram is shown on the right, with his horns beginning to curl. He is probably only a few years old.

The rest of the rams belong to various age groups. When the ram's horns develop a curl that interferes with its vision, it will rub the tips on rocks. This is known as "brooming," and it wears the horns down until the ram is able to see better.

The Halfway Stage

After the sheep were traced onto the canvas and the general shape and contours of the mountains and the cloud between the mountains were indicated, the planes of the snow and the ice-covered mountain above the cloud were begun. A paint-and-scrape technique was used, painting the planes of the rock and snow areas in just a few values and then using a palette knife to scrape off the paint, leaving just an indication of the distant mountain. Minor touch-ups are left until the later stages of the painting.

Next, the clouds and the lower section of the mountain were painted with

Figure 8.7

Figure 8.8
FREDRIC SWENEY (American, 20th century)
The Top of the World—Dall Sheep (oil).
Courtesy of Ira Milton Jones.

actual brush strokes using only a minimum of paint-and-scrape technique. The snow, the rock, and the grassy areas of the foreground were next. This was carried to three-quarters complete. The foreground was indicated so that the values of the white sheep could be established. After the painting of the forms of the sheep was completed, the details of horns, eyes, nose, and mouth were indicated.

Completing the Painting

The three-quarter phase of the painting has been completed. The next step is to give the painting a light spray of a retouch varnish. This brings up the dull colors, such as the umbers, so that the painting has an overall brilliance. Some colors have a brilliant appearance while others look dull. This retouch varnish not

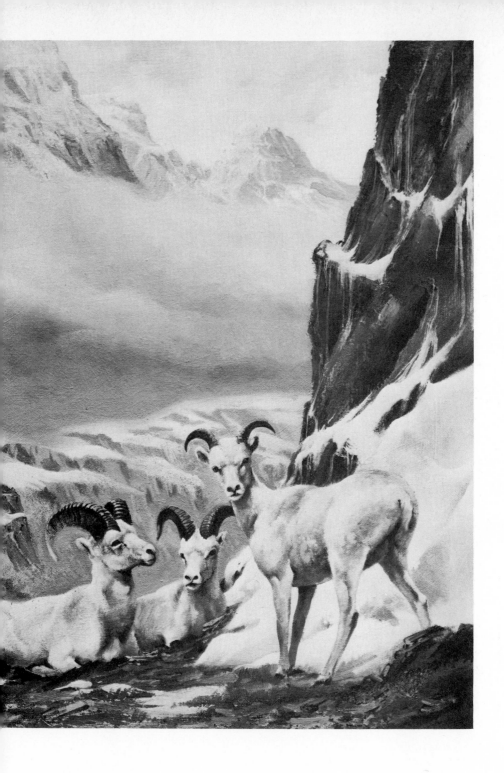

only corrects this problem, but it also binds the new layer of paint onto the older paint film. You do not have to wait until this varnish is dry to continue with your painting.

The minor touch-ups of the mountains were next; then, the final stages of softening the edges of the clouds were finished, using a soft cloth and paper towels. The cloud edges were rubbed un-

til the proper effect was achieved. The reflected color of the sky on the rocks was next, along with the small touches of snow among the rocks on the cliff and foreground. The final hair indications on the sheep were dry-brushed onto the bodies.

After the painting was completely dry, glazes were applied, values were adjusted, and the painting was complete.

113

Paintings of this type are very interesting to do, because they combine your knowledge of landscape and animal art.

PRACTICE SUBJECTS

The sketches of the Rocky Mountain bighorn sheep, the dall sheep, and the mountain goats are for your use. These have not been completed on purpose. They are similar to an art director's sketch and it is up to the artist to research the animal, sketch out the simplified skeleton and the head and hoof structure, and then enlarge the anatomical sketch to a larger size, indicate the necessary background, and complete the painting. A small color sketch would be helpful as a guide, particularly with the landscape. Remember that if you are painting the dall sheep, you should not place them against a light sky. You need a darker background in order to make them look white.

Figure 8.9

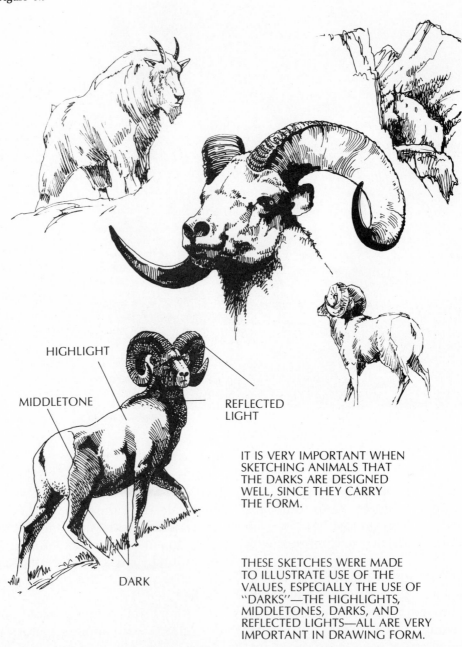

HIGHLIGHT

MIDDLETONE

REFLECTED LIGHT

DARK

IT IS VERY IMPORTANT WHEN SKETCHING ANIMALS THAT THE DARKS ARE DESIGNED WELL, SINCE THEY CARRY THE FORM.

THESE SKETCHES WERE MADE TO ILLUSTRATE USE OF THE VALUES, ESPECIALLY THE USE OF "DARKS"—THE HIGHLIGHTS, MIDDLETONES, DARKS, AND REFLECTED LIGHTS—ALL ARE VERY IMPORTANT IN DRAWING FORM.

The photograph of the mountain goat is for the artist who does not want to use the small sketch. This also requires an anatomical sketch. When you are drawing animals you usually draw from the inside out. In other words, the action sketch comes first, then the skeleton and necessary muscular indications, then the hair structure, and finally the value study in order to indicate light direction. By the time you have completed these steps you will have a very good working knowledge of the animal.

Figure 8.10
Mountain Goat.
Courtesy of Woodland Park Zoo,
Seattle, Washington.

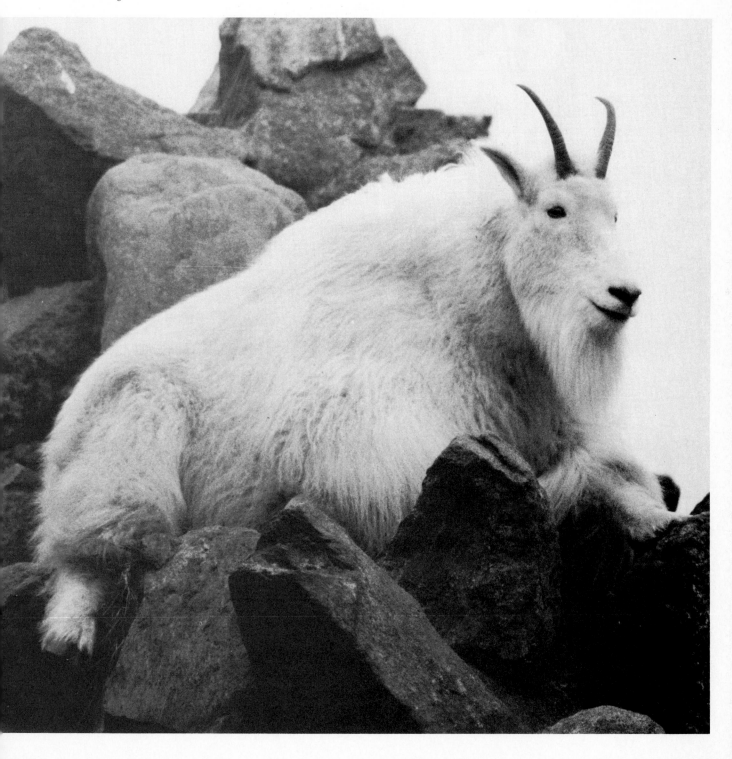

CHAPTER NINE

Small animals

FOR CENTURIES, humans have had a fond affection for the small animals that inhabit this world. Unfortunately, some of them are still used to feed and clothe people. As children we were made aware of small animals at an early age. Many nights we drifted off to sleep while listening to fanciful folklore, fables, and tales about small animals and birds that somehow assumed human characteristics.

Not all of the tales and stories were about the happy-go-lucky rabbit that outsmarted the crafty old fox in the brier patch. Some of the earliest fables that are still read today are attributed to Aesop (619–564 B.C.), a freed Greek slave. His stories generally had morals. They were a method of teaching standards of right and wrong. Some were derived from ancient oriental sources.

Many of these tales were beautifully illustrated, such as the German folklore that was collected and published by the brothers Grimm. Other writers of animal stories were Hans Christian Andersen, Lewis Carroll (author of *Alice's Adventures in Wonderland*), Beatrix Potter (for her outstanding stories and illustrations of fanciful animals dressed in human clothes), and, of course, we give special mention to Walt Disney, who was able to put animal stories on the big screen and on television for all to enjoy.

TYPES, BEHAVIOR, AND ANATOMY

Volumes could be written on the thousands of small animals that populate this

116

Figure 9.1
LAWRENCE A. MAY, JR.
(American, 20th century)
Squirrel (ink and watercolor).
Courtesy of the artist.

world. To illustrate all of their bone and muscular forms would be an impossible task. Many small animals, however, do fit into general categories. Woodchucks and ground squirrels include the woodchuck, the marmot, the prairie dog, and the ground squirrel. The next workable category would be chipmunks and squirrels. These include the gray squirrel, the chipmunks, and the interesting flying squirrel. These animals spend their days living aboveground, as compared with the marmot, which spends a lot of time underground and deep inside rock piles. Next would come the many "chisel-teeth" animals, such as mice, gophers, rats, beavers, and porcupines. Members of these groups of animals have the same basic skeleton that can be used as patterns for bone and muscular structure. Finally,

Figure 9.2

117

Figure 9.3
The rabbit will serve as the model for the small animals, which include the leaping mammals, such as rabbits and hares. Here, the bone structure and actions are more important to the artist than the muscles, since the latter are covered by a thick fur. All of the leaping mammals and the rodents, which includes more than 5,000 species of the living mammals, have basically the same bone and muscle structure.

there is the bat, which is the only mammal with wings. There are approximately 2,000 species of bats in the world. Most of them are tiny (one is only two inches long), and the largest is the bat found in the East Indies that has a wing span of slightly more than four feet. The bat has a different skeleton from those of most animals. Its arms and legs are imprisoned within a winglike membrane. The bat's hands (the thumb terminates with a claw) and feet are of little use except for hanging itself upside-down from the ceiling of a cave or in the dark recesses of buildings like barns.

PROBLEMS OF PAINTING AND DRAWING SMALL ANIMALS

When sketching, drawing, or painting small animals, more so than with birds, the artist must analyze what type of bone and muscle structure is to be used as a pattern. As an example, the western jack rabbit's bony structure is similar to but definitely not the same as that of the beaver. This is a case where the artist must have a discerning eye.

Drawing the family pet, such as a cat or dog, is very easy since they are usually

118

nearby for study; there are also excellent reference plates that are easily obtainable. But drawing the anatomy of a wolverine, for example, which is a vicious animal of the northern woods, is another matter. There are not any plates of this animal readily available. You have to locate caged, live specimens at zoos, mounted specimens in museums of natural history, or excellent photographs. Naturally, you will change the pose that is in the photograph; copying a photograph will not help you very much and is generally frowned upon.

One of the problems of drawing small animals is to establish a unit of measure so that the viewer will be able to know how small the animal is. The three ink drawings in Figures 9.5, 9.6, and 9.7 all have yardsticks so that it is easy to visualize the size of the adult raccoon. The leaves of the tree and the baby raccoon establish that yardstick.

Figure 9.4
This is a charcoal study of a gray squirrel. All that is necessary is an interesting composition that shows the salient characteristics of the animal, its action, and the necessray lights and darks. This was made near the actual size of the animal on parchment paper.

Figure 9.5
CHARLES W. SCHWARTZ (American, 20th century)
Raccoon.

From *Wildlife Drawings* by Charles W. Schwartz. Copyright 1980, Missouri Conservation Commission. Reprinted by permission.

119

Figure 9.6
CHARLES W. SCHWARTZ (American, 20th century)
Cotton-tail Rabbit.
From *Wildlife Drawings* by Charles W. Schwartz. Copyright 1980,
Missouri Conservation Commission. Reprinted by permission.

Figure 9.7
CHARLES W. SCHWARTZ (American, 20th century)
Eastern Chipmunk.
From *Wildlife Drawings* by Charles W. Schwartz. Copyright
1980, Missouri Conservation Commission. Reprinted by
permission.

The fleeting cotton-tail rabbit in Figure 9.6 is silhouetted against the grass and the small leaves in the foreground, which establish the scale, and the direction of the windblown grass also helps by adding action to the drawing.

The drawing of the eastern chipmunk and the moth in Figure 9.7 has great appeal. The curiosity of the chipmunk silhouetted against the dark leaves as it sits up and looks at the moth clinging to the branch will interest the viewer. The common moth establishes the scale for the drawing.

Another important factor is the angle from which the viewer sees the animal, whether from human eye-level, looking down from a bird's-eye view, or looking up from a worm's-eye view. Another problem is whether to show a dark animal against a light background or a light animal against a dark background. It all depends on whether the same animal is dark against a light background or whether it is in full sunlight. It is up to the artist's sense of design to capture the viewer's interest. People appreciate a well-balanced composition, in which the placement of the lights and darks and the

120

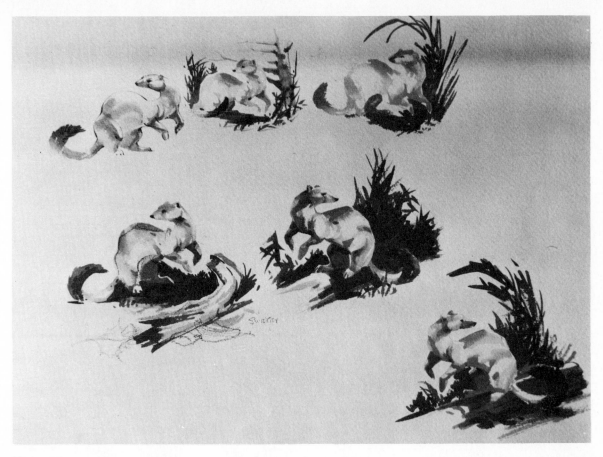

Figure 9.8
These small sepia-tone watercolor sketches were made as compositional studies for a painting of the short-tailed weasel, commonly known as the ermine in its winter dress of white.

correct values are all in harmony. This applies to black and white art as well as to color.

These three drawings are well worth study, not only for the ideas described above but also for their draftsmanship and pen technique.

DEMONSTRATION PAINTING

The simplified sketch of the beaver (Figure 9.9) was enlarged after the composition of the overall scene was completed. This scratchboard drawing was made in order to show the watery habitat of the hard-working beaver as it is cutting a fallen tree into smaller pieces with its chisel-shaped teeth. The beaver is the

Figure 9.9
This is a quick pen-and-ink perspective study that was made for the demonstration art. It locates the main forms of the beaver.

121

Figure 9.10
This small sketch represents the rhythm
of the composition. The rolling lines
give motion to the scene.

Figure 9.11
FREDRIC SWENEY (American, 20th century)
The Beaver Pond (scratchboard).

world's first engineer. It is also one of the world's largest rodents. The capybara of South America is the largest. Thousands of years ago the giant beaver that lived in North America was longer than the black bear. Including the tail, it measured seven and a half feet.

The compositional sketch was enlarged to seventeen inches wide by eleven inches high. Next, the small sketch of the beaver was roughly blown up to seven and one-half inches wide. The rhythm lines were sketched onto a transparent tissue and the position of the beaver was then indicated. Four different planes were to be drawn next: the distant shoreline of trees surrounding the beaver pond, the location of the beaver lodge, the island to the left of the beaver, and, finally, the immediate foreground with the fallen trees and the beaver, which is the main subject. Indicating these planes gives a slight aerial view of the pond and adds depth to the drawing.

A separate small tissue was made of the beaver's lodge and the other beavers. This was then positioned on the tissue. As the drawing developed, the wind direction was sketched with a series of lines into the sky. This also added aerial perspective and made the skyline of the woods a little less stark.

A second tissue was placed over the first rough tissue and was very carefully redrawn, with special attention to the beaver house and the adult beaver in the foreground.

A graphite "carbon" was made by taking a graphite stick and rubbing it onto a full sheet of tissue until it was as dark as possible. It was smoothed out by squirting cigarette lighter fluid and, while it was still wet, rubbing it smooth with a wad of cotton. The fluid dissolved the graphite, which, when dry, was placed under the working tissue, face downward, and the tracing of the working tissue was transferred onto the white scratchboard that had been mounted onto a firm piece of mounting board.

Completing the Drawing

After the final tissue has been traced onto the prepared scratchboard, it should be touched up with a pencil, and important edges such as the head, tail, and feet should be redrawn.

Now comes the final cutting of the scratchboard, which is a comparatively new medium. It is similar to a wood engraving in appearance. In simplified terms, it is created by cutting through a black coating that has been placed upon a special chalk-coated board by blackening the areas with India

123

ink, or it may have been printed black on the chalk surface by the manufacturer. Using sharp tools, it is then cut through the black to reveal the white underneath, which gives the effect of a woodcut or a wood engraving if it is finely done. Personally, I prefer to work on a white-surfaced scratchboard.

The solid areas in this particular drawing, which are to be painted in with the black ink, are the distant lower portions of the trees, the individual trees on the island, the beaver house and animals, the beaver in the foreground, and some of the foreground. The black ink is applied with a watercolor brush. Be sure to wash the brush after using it.

Some of the fine work can be drawn in with pen and ink. After the ink has thoroughly dried, the cutting or scratching can begin. The distant trees, the sky, and the fine details are first to be cut; the beaver house and beavers and the reflections on the water are next. The last part to be cut is the adult beaver in the foreground. Care must be exercised when cutting so that you do not cut too deeply into the chalk surface; this is next to impossible to correct.

PRACTICE SUBJECTS

There is no practice page for this chapter, which would normally carry photographs or sketches. You probably have your own preferences for small animals or birds that you would like to draw. Any photographs in the other chapters may be used for practice. Do not try too large a drawing for your first attempt unless you are an experienced artist, for these can be very frustrating.

CHAPTER TEN

Exotic animals

ACCORDING TO THE DICTIONARY, *exotic* is defined as belonging by nature or origin to another part of the world, or strangely different and fascinating. There are hundreds and hundreds of foreign animals and birds that interest the artist very much, not only because they are from a strange and interesting land but also because of their general appearance, such as the horns of some animals and the brilliant and interesting colors of some birds.

The head of the kudu was a class demonstration drawing by Paul Travis, who was my figure instructor and an excellent draftsman. (See Figure 10.1.) He taught with great enthusiasm and inspired my interest in wildlife art. His stories about his foot safari into the pygmy country of Africa sparked my own desire to see the animals of Africa.

EXAMPLES OF EXOTIC ANIMALS

One of the interesting animals for the artist to paint is the leopard. (See Figure 10.3.) It is the most widely distributed of the wildcats. It is found throughout Africa, Asia Minor, Persia, India, and as far as China. The leopard has rosettes, as does the jaguar, which is found in South America and not in Africa as many people believe. The main difference between their rosettes, which are the spots or markings, is that the leopard does not have a black spot in the center of the rosette as the jaguar does. Both have scattered spots on the lower parts of their bodies and legs. The leopard is the smaller of the two cats and is not as stockily built as the jaguar. The

Figure 10.1
PAUL TRAVIS (American, 1891–1975)
Charcoal drawing of kudo.
Courtesy of Mrs. Paul Travis.

Figure 10.2
Monkey.
Courtesy of Woodland Park Zoo, Seattle, Washington.

Figure 10.3

OWEN J. GROMME (American, 20th century)
Hanging Loose—Leopard (oil).
Courtesy of Wild Wings, Inc., Lake City,
Minnesota, and Owen J. Gromme.

melanistic phase of the leopard is called the black panther. It is quite common and is not a separate species as often believed. Their habitat ranges from the jungle through the grasslands to the semideserts.

Another fascinating animal for the artist to draw is the wallaby, a member of the large grouping of marsupials that are found throughout Australia, New Guinea, Tasmania, and some of the outlying islands. This is a case for which it probably would be difficult to find material on skeletal structure. It is up to the artist to use his or her own judgment. There are plenty of magazines that have good photographs for reference. It is suggested that a simplified skeleton be sketched and special attention be paid to the head structure, forelegs, and feet.

Another great animal to paint is the giant panda. The panda is actually not a bear; it is the Asiatic member of the raccoon family. Here again, the same problem presents itself to the artist of whether to base the skeleton of the panda on that of the raccoon or the bear. If it is possible to find photographs that show the side view, then you can approximate the simplified skeleton, probably based on the bear since that bone structure is more readily available.

The skeleton of the springbok, a gazelle native to South Africa, does not differ from the skeleton of the antelope, which is a member of the deer family. The springbok has an unusual habit of jumping high into a vertical leap with its tail (fan) extended, all four legs and hooves held tightly together, back arched, and head held downward. This is known as "stotting" or "pronking."

The gibbon will serve as the model for some of the monkeys. The scratchboard drawings in Figures 10.7 and 10.8 show the natural gait of the gibbon. Since these animals are tailless and generally arboreal, they travel by using their versatile limbs to swing from branch to branch through the trees. This swinging motion is called *brachiation*. The gibbon is the smallest of the apes. When gibbons find it necessary to come down from their aerial homes, they walk upright with their arms bent and held to their sides quite like a human who is holding a balancing pole while walking a tightwire. The gibbon's arms are approximately twice as long as its trunk, and its hands are long and thin with hooklike fingers. The gibbon is considered to be the most intelligent of the anthropoid apes. Gibbons are extremely clean and live in small families. The simplified sketches should serve as a model for their anatomical bone structure.

Figure 10.4
Wallaby.
Courtesy of Woodland Park Zoo,
Seattle, Washington.

128

Figure 10.5
LAWRENCE A. MAY, JR. (American, 20th century)
Panda Bear (watercolor).
Courtesy of the artist.

Figure 10.6
Springbok.
Courtesy of Woodland Park Zoo,
Seattle, Washington.

129

Figures 10.7 and 10.8

Figure 10.10

Figure 10.9
The filmstrip contains a few of the many animal pictures that I have taken with my camera for background material and action scenes. The 35mm camera is used primarily for landscape and details of birds and animals. My movie camera is reserved for the action scenes, such animals in various modes of locomotion and close-up shots of different angles of head movements, as well as for many bird flight attitudes that are valuable for authenticity.

An African Safari

Figure 10.10 is an oil sketch that I made after my safari trip into Africa. I do my hunting with a camera. We traveled as far north from Nairobi, the capital of Kenya, up to Ethiopia. The members of the safari in-

cluded the guide, the hunter, gun-bearers, trackers, a skinner, a cook, camp personnel, five horses and twelve pack camels, and myself.

The landscape played a very important part in the material I wanted for paintings (see Figure 10.10). We were in the high country, not the African jungles. The charging elephants were done from pencil sketches that were later developed in the studio. You do not stand and make sketches in front of a charging elephant! Hence the necessity of knowing the basic anatomy of an elephant. The tree behind the elephants is the baobab, the "upside-down tree." It looks like the roots are in the sky instead of the leaves.

The scratchboard drawings are of some of my favorite animals. It may interest you to draw or make paintings of them with the proper backgrounds.

There are five distinct types of giraffes. Their color patterns vary according to their habitats. There are minor variations depending on whether they are from coastal, forest, savannah, or other small areas of Africa. The reticulated giraffe differs from the common giraffe by its jagged, starlike pattern, as illustrated. The common giraffe's pattern is more rounded.

The African elephant, with its huge ears as compared to the Indian elephant whose ears are smaller, is an outstanding animal to paint.

TARSIUS

BABOON

ELEPHANT
(AFRICAN)

Figure 10.11

GIRAFFE

KANGAROO

KOALA

Other Exotics

The horned animals such as the kudu and the ibex are also interesting to draw and paint. The ibex are the mountain animals of Europe. They range from the Alps, through Spain, Portugal, the Caucasus, and Persia, all the way to the Himalayas. Their horns are very heavily ridged.

The blackbuck of India is a very graceful animal and should be interesting to paint. The sable antelope of Africa, which carries the most awe-inspiring set of horns in the animal kingdom, also should make a striking subject. Its five-foot scimitarlike horns are greatly feared, even by the mighty lion.

The koala—the pert, tubby, and tailless Teddy bear of Australia—is a great animal to draw and paint.

There are two types of camels. One is the Arabian camel, which has a single hump and is also known as the dromedary. It is found in Africa, Syria, Afghanistan, and northern India. The other camel is known as the bacterian and has two humps. It is found in the wilds of the Gobi desert. History records the domestication of the Arabian camel as far back as the 11th century in Palestine. The camel is an animal whose two toes are united by a thick web of skin. Nature has given the camel a nostril that can be closed and eyes with long lashes that can also be closed against the strong blasts of the desert sandstorms. The hump is a reserve storage area for fat that is used for energy when needed. When drawing this animal, pay attention to the angle of the eye; it does not match the slope of the mouth. The camel has a deep chest, long legs, and very small hindquarters. The sketches of camels were made during my trip into Africa. (See Figure 10.12.) Camels have a very arrogant attitude and their bite is very dangerous. Be careful not to caricature the camel. The anatomical sketch shows the skeleton with one leg that has been tied up. (See Figure 10.13.) This is done to prevent the camel from wandering, not only in the market areas but also in lion country where they become easy prey.

Figure 10.13

Figure 10.12

DEMONSTRATION PAINTING

The concept for this painting developed after an exciting and very interesting trip into Morocco, traveling from Tangiers as far south as Marrakesh, then westward to Casablanca and north to Ceuta, a Spanish enclave in Morocco. The camels that are seen in Morocco are working camels, and there are very few wild camels.

Rather than paint another picture of charging, wild elephants and cape buffalo, the idea to show a camel caravan entering the gates of a typical Moroccan town became very intriguing. In addition, I had plenty of 35mm transparencies from the trip, so my material was authentic and it also gave me the opportunity to incorporate the people, the gate, the old walls, and a view through the stone gate of a few typical shops.

The rough sketch was all that was needed to jot down the idea. (See Figure 10.14.) This rough was then enlarged to the finished size of the painting, which is thirty-six inches wide by twenty-four inches high. This enlarged sketch was made on a single sheet of tracing paper in the actual size of the painting.

Individual studies were next. All of these studies were kept quite simple. It was more important for their sizes and proportions to be correct. These individual studies were of the gate, each camel, the figures, the shops, brassware in the foreground, and, finally, the wall, the minaret, and the dome of the mosque. The sketches were trimmed so that they could be taped into position on the enlarged tracing paper, forming a pleasing composition.

Since I was working from individual 35mm transparencies, it was necessary to correct the perspective. This was done by placing another tissue over the enlarged one with the taped-on studies, then laying out a horizon and very carefully drawing each study over again and correcting the perspective as each study evolved.

After these tissues were completed, a final value study was made in charcoal.

Figure 10.14

Figure 10.15

This study was fixed with a fixative so that it would not smear. (See Figure 10.15.)

Using a graphite carbon, the final study was then traced over onto the prepared canvas (Figure 10.15). This canvas had three coats of a white gesso, the last coat being sanded with a fine sandpaper.

It is important, particularly when you are working with figures, for hands, faces, and feet to be carefully redrawn. Usually the tracing will not have sharp lines and they need to be cleaned up.

Here is where the fun begins. All of the preparatory work had been produced and a small but quick color sketch was made to be used as a guide. The first area

135

to be painted was the sky. This was carried to about a two-thirds finish. The wall was next to be toned in. The overall color and values were laid in but no details were added yet. The radius point for the arch was located. The spaces between the stones were slightly tapered so that the arch would not appear to collapse. Some engineering was necessary for this particular gate; then the general tone of the gate was brushed in.

The next phase was to paint the color and values of the shops as seen through the gate. The values had to be correct, otherwise the shops would not appear to be farther away from the entrance.

The usual halfway photograph was not made, since it would not mean much with the working procedure this painting required. In other words, the painting was begun at the extreme distance—the sky—and slowly progressed to the immediate foreground. Nothing was detailed. All that was accomplished was an overall

Figure 10.16
FREDRIC SWENEY (American, 20th century) *Moroccan Caravan.*

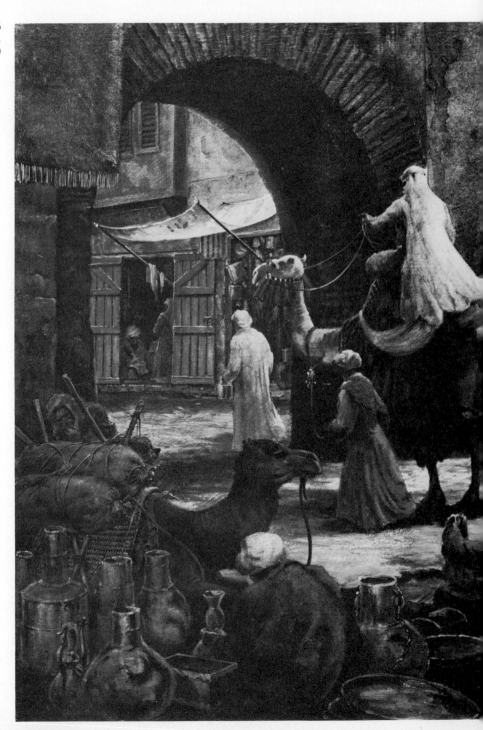

feeling of the color and the general scene.

Now the painting was ready for the next phase. Usually, my plan is to work in three phases. The first is the general toning in, the second is enhancing the various areas, particularly the designing of individual areas, and all necessary detail work comes last.

The clouds were purposely directed toward the awning in the shopping area. This tied the two areas together optically. The vertical tower of the mosque stopped the eye from wandering out of the picture.

The wall received its detail. A palette knife was used to paint the sections of the wall where the outer covering over the stones had chipped away. Stains were added to the ancient walls, and the rugs that were hanging on the walls and the one in the upper left corner of the painting were completed.

The shops were finished except for minor details, and then the camels were

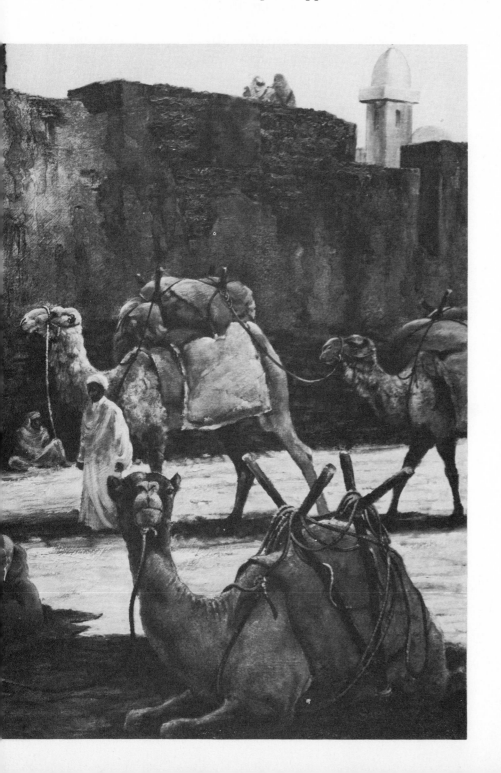

done, including the rider and escorts. A sign-painter's striping brush was used in painting the ropes and reins for the camels. The ground shadows of the caravan were next, and then attention was turned to the merchant, his beautiful brassware, and the two women who were admiring their silks.

Finally, the camel in the lower right of the painting and all details were completed. This concluded phase three. After the painting was completely dry, it received its final glazes in order to enhance the colors and to correct minor value changes. It was a pleasure to paint this picture, not only because it brought back fond memories but also because I enjoyed the challenge.

PRACTICE SUBJECTS

Here are a set of animal photographs that present great possibilities for interesting and intriguing paintings. Naturally, the correct habitat will have to be researched as these are obviously zoo backgrounds, with the animals in open pens so that they may move about freely.

Today, lions are found mainly in central and southern Africa. The zebra roams a wide range in Africa, south of the Sahara. The zebras are the type found in the southern part of Africa. They have a more brownish stripe. The gorilla is the coastal species found in the equatorial forests of Africa.

Figure 10.17
Lioness.
Photographs by Fredric Sweney. Courtesy of Woodland Park Zoo, Seattle, Washington.

Figure 10.18
Zebra.
Photograph by Fredric Sweney. Courtesy of Woodland Park Zoo, Seattle, Washington.

Figure 10.19
Gorilla.

Photograph by Fredric Sweney. Courtesy of Woodland
Park Zoo, Seattle, Washington.

CHAPTER ELEVEN

Birds

As we watch the flight of birds in the air or the soaring of an eagle as it travels through the invisible updrafts, we assume that they always knew how to fly, but birds have to learn how to fly. Their ability to fly is the culmination of millions of years of gradual changes and modifications from the first birdlike reptile, Archaeopteryx, which dates back to over 100 million years ago. This first bird found out how to glide from tree to tree. Its clawlike wings enabled it to climb to the great heights of one tree and then glide to the next one.

Of all the higher forms of life, birds are the most beautiful, the most admired, the most melodious, and the most protected and defended in our world today. They are found from the Arctic to the Antarctic and in every country throughout the world.

Birds have been called glorified rep-tiles because they have certain reptilian features, such as an egg tooth and similar eggs and structures. The outstanding feature that separates them from all other animals and reptiles of the world is the feathers. All birds have feathers and no other creatures or animals, including the bat, possess them.

EXPRESSIONISM, IDEALISM, REALISM, AND IMPRESSIONISM

There are four artistic traditions for the artist to use in painting birds: expressionism, idealism, realism, and impressionism. Probably the oldest form of art is the *expressionistic*, which belonged to the most primitive of humans. This type of art has

continued from the cave drawing era to contemporary times. The watercolor by Viktor Schreckengost in Figure 11.1 is an outstanding example of today's expressionistic art. The painting is very well designed and is symbolic of the rooster, hen, and chicks. It maintains the character and proportions of the leghorn chickens but it certainly does not represent the realistic style of art.

Idealism in art means that after the artist selects the subject, he or she then designs, simplifies, and stylizes it, while still maintaining its physical form, into a very decorative and interesting painting. The idealistic art form dates back to the Greek period and is still used today, especially in human and animal art. It is frequently seen in fashion art. Using the human head as a unit of measure, the average figure is approximately seven and a half heads high. This is known as the *academic figure*. Fashion artists will go to extremes, designing a figure that may measure up to ten heads high. This device is used to glorify the figure and to give a sleek look to clothing.

Realism in art means exactly what it says. The artist strives to paint the absolute reality of the subject. In this particular case, if the subject is a bird, it means that the proportions, color, and exact feather count of the wings are correct, especially if the wings are in an extended position. It also means that the tail feather count is correct for a particular species. There is variety among the different species. Attention is also paid to the bird's head structure, which includes the proportion of the bill, the eye structure, and the anatomy of the foot. People love to see detail in paintings.

Figure 11.1
VIKTOR SCHRECKENGOST (American, 20th century)
Leghorns (watercolor).
Courtesy of the artist.

141

Some artists prefer to paint in an expressionistic manner, others like idealism, and others prefer to paint in detail.

Diego Velasquez painted in a realistic manner, but with his powerful, broad technique and his analytical mind, his art achieved a very high level and was propelled into the impressionistic art style. *Impressionism* means that the artist paints what the eye sees rather than what the mind knows exists. The work of Claude Monet is an outstanding example of pure impressionistic art.

Whether the artist prefers to paint birds or animals in the expressionistic, idealistic, realistic, or impressionistic manner, all are acceptable. It just depends on the individual.

Figure 11.2 (left)
FREDRIC SWENEY (American, 20th century)
Snow Geese (oil).
Courtesy of *Sports Afield* magazine.

Figure 11.3 (below)
JIM SPRANKLE
Hooded Merganser—Drake (wood carving).
Courtesy of the Wildfowl Art Museum of the Ward Foundation, Salisbury, Maryland.

Figure 11.4
FREDRIC SWENEY (American, 20th century)
Wood Ducks (oil).
From the collection and courtesy of Mrs. Colet Coughlin.

Figure 11.5
FREDRIC SWENEY (American, 20th century)
*American Goldeneye Drake, Canvas-back Drake,
and Wood Duck Drake* (oil).

ANATOMY OF THE BIRD

The parts of a bird are as follows:

1. *Crown*—Upper section of the head above a line formed by the ear opening and the eye.
2. *Ear*—Organ of hearing, located directly in back of the eye and covered by a grouping of feathers known as the *auriculars*.

3. *Nape*—Upper division of the neck, located directly below the base of the skull; the occipital portion of the skull.
4. *Hind Neck*—Posterior or rear section of the neck.
5. *Side of Neck*—Lateral or outer section of the neck.
6. *Back*—Upper area of the body, located between the base of the neck and the rump; the dorsal region of the spine.

Figure 11.6

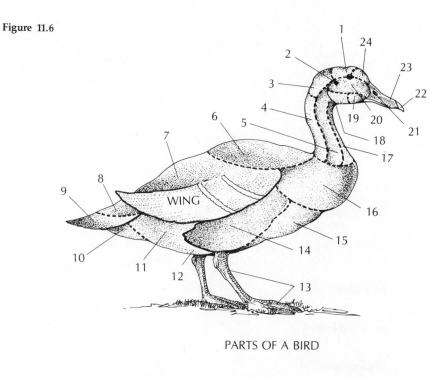

PARTS OF A BIRD

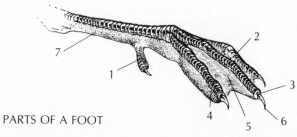

PARTS OF A FOOT

7. *Pelvic Area*—The lower section of the back; the hip section.

8. *Upper-Tail Coverts*—Grouping of feathers overlaying the base of the tail.

9. *Tail*—Posterior extremity of the body.

10. *Under-Tail Coverts*—Feathers located under the base of the tail.

11. *Flank*—Posterior area of the sides of the body.

12. *Belly*—Abdomen area.

13. *Tarsus and Toe*—Located between the heel and the tip of the toes.

14. *Side*—Area covering the lateral portion of the rib cage; the area between the back and the breast.

15. *Breast*—Section between the belly and the chest; the breastbone or sternum section of the rib cage.

16. *Chest*—Area between the lower division of the neck and the breast.

17. *Foreneck*—Anterior or front portion of the neck between the chest and the throat area.

18. *Throat*—Anterior upper section of the neck.

19. *Chin*—Area located on the undersection of the skull, at the base of the lower mandible.

20. *Cheek*—Side of the head located between the eye and the chin.

21. *Nostril*—External opening located on the upper area of the mandible or bill.

22. *Nail*—Raised section located on the tip of the mandible.

23. *Bill*—Term applied to mandible, beak, or mouth.

24. *Forehead*—Front of the skull.

The skeleton of a bird contains:

1. Mandible or bill
2. Skull
3. Neck
4. Clavicle or collar bone
5. Sternum or breastbone (keel)
6. Knee or patella

Figure 11.7

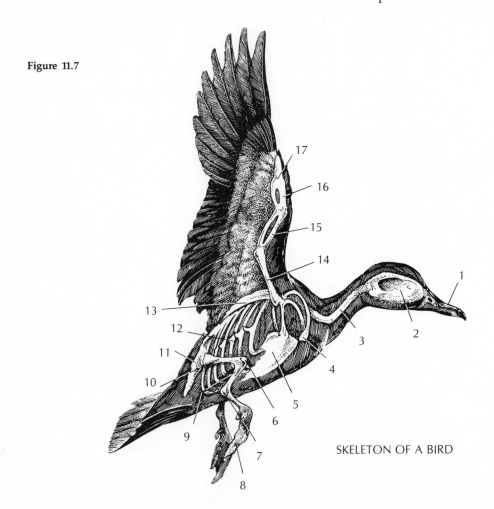

SKELETON OF A BIRD

144

7. Os calcis or heel
8. Toes or phalanges
9. Shin (tibia and fibula fused into one)
10. Thigh or femur
11. Pelvis
12. Ribs
13. Shoulder blade or scapula
14. Humerus or upper arm bone
15. Forearm (radius and ulna combined)
16. Thumb (spurious wing, location of the winglet)
17. Digits (first two fingers of the human hand and the stump of the thumb fused into a single wing bone)

The following are parts of the wing:

1. *The Primaries*—Ten feathers (curve away from the body).
2. *The Secondaries*—Twelve feathers (curve toward the body).

3. *Tertials*—The inner secondaries (trailing edge of the wing, nearest the body); these feathers form a canopy between the wing and the body.
4. *Scapulars*—The feathers of the shoulder region, nearest the back.
5. *Coverts*—Any one of the special feathers that cover the bases of the quills of the wing and the tail; these are called the lesser, middle, and greater wing coverts.
6. *Bend of the Wing*—The curve that is formed by the junction of the primaries, the winglet, and the forearm section.
7. *Wing Bars*—Found on the greater wing coverts (top of wing only).
8. *Under-Wing Coverts*—The under, anterior portion of a wing.
9. *Winglet*—The thumb from which three feathers project.
10. *Speculum or Chevron*—Color patch on the wing; found on the upper wing secondaries.

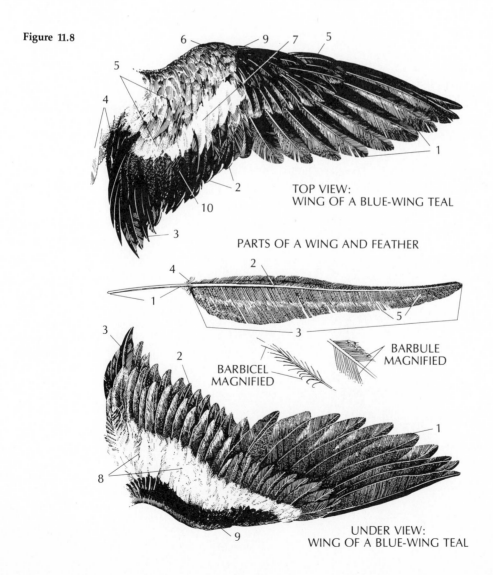

Figure 11.8

TOP VIEW:
WING OF A BLUE-WING TEAL

PARTS OF A WING AND FEATHER

BARBULE
MAGNIFIED

BARBICEL
MAGNIFIED

UNDER VIEW:
WING OF A BLUE-WING TEAL

The Folding of a Wing

It is very important for wildlife artists who specialize in bird art to thoroughly understand the folding of a wing. This folding action is so rapid that the eye does not see it. I have slow-motion movies of a mallard duck landing on the water, and at the instant that the duck's body touches the surface of the water the wing-folding process has been almost completed.

This folding of a wing takes only a fraction of a second to complete. Thousands of small muscles that control the individual feathers are brought into play. Each muscle rotates the feathers and also controls the positions of the individual wing segments as they are quickly brought into action. It is a complicated process and should be understood by the wildlife artist if the wing is to be illustrated in a painting. This folding process is shown in Figures 11.9 and 11.10. The unfolding process is just the opposite action.

The folding of a bird's wing is quite a simple action. It consists of four basic motions. The first illustration shows the wing being pulled toward the body from an extended position. The primaries are moving toward the body so that they pass underneath the secondaries. In position number two, the primaries slide under the secondaries, and they in turn slide under the tertials as the wing continues to fold. Upon completion of the folding process, the wing is held tightly to the body. This is shown in drawing number three. To complete the folding action, the tertials are covered by a grouping of feathers located directly over the shoulder blade, the scapulars. Their purpose is to help streamline the wings to the body shape and to protect the opening between the folded wing and the body from weather. The final step is for the side feathers to cover the wing.

The following are parts of the feather structure:

1. Quill
2. Shaft
3. Vane
4. Soft barbules
5. Barbs
6. Barbules
7. Barbicels

The Colors of Feathers

The various colors of feathers are produced by three different means. The reds, oranges, browns, yellows, and grays are *pigmentary colors*. These colors are opaque.

Figure 11.9

HAND

WRIST

ELBOW

SHOULDER

FOLDING STARTED

HALFWAY

Figure 11.10

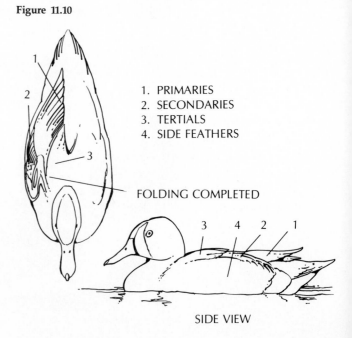

1. PRIMARIES
2. SECONDARIES
3. TERTIALS
4. SIDE FEATHERS

FOLDING COMPLETED

SIDE VIEW

The iridescent colors seen on the speculum of a duck's wing and also on the wild turkey's neck and wing, to name a few, are *structural colors*. These are the greens, blues, bronzes, violets, and also white and black.

The third group of colors are the combinations of the pigmentary and structural colors.

Iridescent colors are composed of reflective cells or prisms in the barbs of the feather. These cells break up light rays, the same condition seen in rainbows and oil on water. The only effective way I have found to paint the iridescence is to glaze the colors over a white ground. You are dealing with light rays and not pigments.

The following are the parts of the foot:

1. Hind toe—one joint
2. Inside front toe—two joints
3. Middle front toe—three joints
4. Outer front toe—four joints
5. Web
6. Claw
7. Tarsus

APPROACHES TO PAINTING BIRDS

When you decide that you want to become a wildlife artist, probably the first questions to enter your mind will be: Where do I begin? Do I approach it by drawing mounted birds in a museum? Do I begin by copying another artist's paintings from a book? Or do I begin by studying the anatomy of birds and animals?

One of the first things that I did was to teach myself to make quick action sketches. Birds and animals do not hold still for you!

I improvised my outdoor study by sketching another artist's paintings and by training myself to draw while studying any available bird through a telescope mounted on a tripod. Fortunately, I had a copy of *Birds of America*, published by Garden City Publishing. This book has 106 plates in full color and is illustrated with watercolors by Louis Agassiz Fuertes, a master of bird drawings.

While studying the actions of birds through the telescope, I allowed myself fifteen seconds a sketch, knowing that I could check the details from Audubon plates, and from the colors of mounted specimens at the Cleveland Museum of Natural History.

On weekends I spent many hours in the field watching wildlife. My sketching time by now was reduced to about five seconds. The medium that was used was dry-brush, which is a combination of a split-haired brush and India ink. I soon learned, for example, that small birds require thick underbrush in order to protect themselves from preying animals and birds, particularly hawks and owls, and also from storms and windy weather.

My interest soon turned toward advanced study of the anatomy of birds and animals. I had completed a course in art school in human anatomy, which was quite valuable to me. Another thought that crossed my mind was that it was necessary for me to become a realistic landscape artist. This led to the advanced study of the great landscape painters: Jean Corot, George Inness, Albert Bierstadt, John Constable, the Dutch landscape painters, and the Impressionists, particularly Claude Monet, just to name a few. Museums where I could study the original paintings have meant a great deal to me.

When I started selling small drawings to nature and outdoors magazines, my confidence kept building. One of the editors asked me why I only drew birds. He needed drawings of animals and fish as well, so my field quickly broadened to a variety of wildlife. Artists never stop studying. The day you quit learning, you will find yourself in the doldrums and will not advance in your chosen field.

The acrylic of the woodcock in Figure 11.11 is the study for a painting. The complex pattern made it necessary to make

Figure 11.11
Woodcock.

Figure 11.12
JIM SPRANKLE
Black Duck (wood carving).
Courtesy of the Wildlife Museum of the Ward
Foundation, Salisbury, Maryland.

this study first. The beautiful wood carving by Jim Sprankle (who used to be a pitcher for the Brooklyn Dodgers and the Cincinnati Reds) is a masterpiece in this interesting phase of fine art in the wood-carving field. (See Figure 11.12.)

The painting of the red-bellied woodpecker (Figure 11.13) was one of a series that was made for a manufacturer and was used as a point of sales for one of its products. As your name becomes better known as a wildlife artist, you will probably be kept busy making drawings in your specialized field.

It is impossible to illustrate examples of all birds since the number of species is generally estimated to be over 8,500. We all have certain birds that interest us. Some like the parakeet; others may be lost in the world of the hummingbirds. Probably the greatest interest is in the game birds. In my particular field, game birds and animals are my specialty. They are the most common, particularly in the fall when thousands upon thousands of ducks and geese travel south in their yearly migration. At this time of the year, people take to the country in droves—bird clubs, hunters, photographers, and certainly wildlife artists—in order to get additional information and inspiration for their next projects.

A wildlife artist's paintings are seen by thousands of critics when his or her work is published in books, magazines, and calendars. There is a saying: "There are thousands and thousands of hunters and all of them are experts." These are your critics, those who read the nature, outdoor, and hunting and fishing magazines and books. These people know their birds and animals and they are your potential market.

Flight

There have been innumerable books written about a bird's most characteristic activity—flight. The infallible camera sees the split-second wing beats and the pinions' adjustment as the bird sets its wings for a soft or sizzling landing characteristic of ducks and swallows in particular.

Figure 11.13
Red-bellied woodpecker.

This section is not a treatise on flight but is directed more to the anatomy of the bird. Some knowledge of anatomy is necessary in order to understand the various attitudes of the wing when its function is necessary for all of the positions required for flight, such as side-slips, stalls, high forward speed, slow flights, and fast turns. One of the great reference books on flight is *Prairie Wings* by Edgar M. Queeny, illustrated by Richard E. Bishop, and published by J. B. Lippincott. You may want to add it to your library.

The aquatint etching of the flying canvasback ducks by Richard E. Bishop is authentic in every aspect of flight and should be carefully studied. (See Figure 11.14.) When you look at a painting, or in this case an etching, try to analyze the flight. In this picture the ducks are beginning to turn to the left. The wing positions of the three ducks tell you what is happening: the left wings are in the downbeat position and they are pulling the bird into a left-hand turn.

149

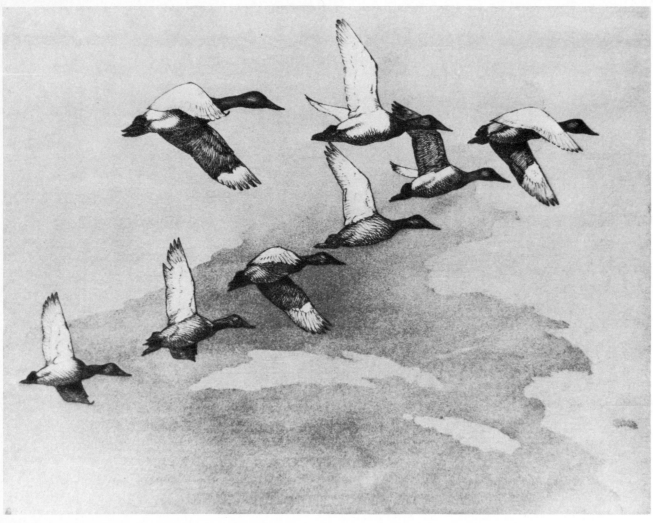

Figure 11.14
RICHARD E. BISHOP (American, 20th century)
Down from Manitoba (etching).
From the archives of and copyright Brown and Bigelow, St. Paul,
Minnesota.

Figure 11.15
FREDRIC SWENEY (American, 20th century)
Canada Geese (oil).
Courtesy of *Sports Afield* magazine.

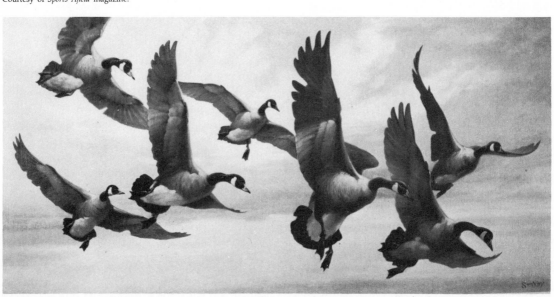

Figure 11.15 illustrates a flight of Canada geese about to land. Their feet are being lowered and a few are approaching a stall as they kill their flying speed.

Climbing flight. Figure 11.16 shows a sequence of normal climbing flight executed by a surface-feeding duck. Surface-feeding ducks, such as the mallard, vault off the surface of the water. Ducks that dive for their food, such as canvasbacks, run off the surface of the water. The legs and feet of diving ducks are further back on their bodies than on river or surface-feeding ducks.

Usually, a bird takes off heading into the wind, but there are occasions when it is necessary to take off downwind. Mallards literally fly off the water with a downward thrust of their wings against the water. They vault off the surface, heading downwind and then turn quickly, facing into the wind in order to increase their lift. This maneuver is performed in one-fifth of a second. It is so rapid that the human eye cannot see it.

Dropping-in flight. This is one of the most exciting and exhilarating aspects of flight. As the bird drops down, its wings are thrust forward and cupped in order to kill its flying speed. The bird lands just like an airplane; its body is tipped into a near vertical position, and the wings are spread into an open position and cupped. (See Figure 11.17.)

Figures 11.16 and 11.17

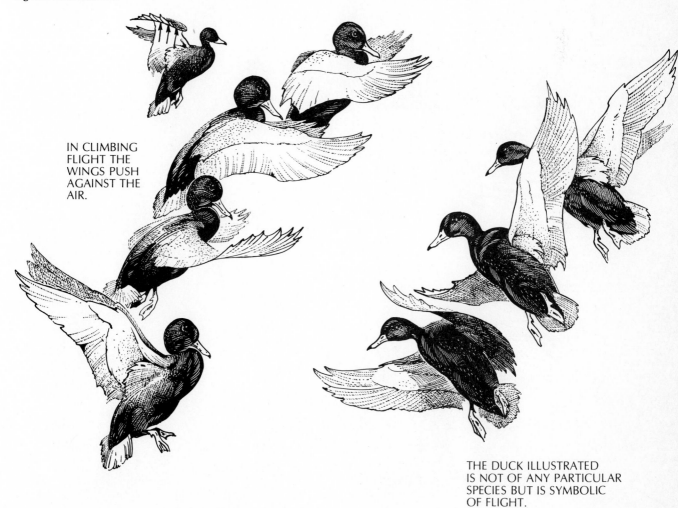

IN CLIMBING FLIGHT THE WINGS PUSH AGAINST THE AIR.

THE DUCK ILLUSTRATED IS NOT OF ANY PARTICULAR SPECIES BUT IS SYMBOLIC OF FLIGHT.

Sketches

Figures 11.18, 11.19, and 11.20 are a few of the quick, abstract sketches that I usually make when I am searching for an idea. Here is where you look for story-telling ideas and a design for the overall picture.

Use your imagination. Think back to your field trips. It is good practice not to look at clippings or pictures while composing an idea. Once you have seen other work it is very hard to be original in your own art.

After you have your idea established, make a small color sketch and use a field guide book for the general color and conformation of your birds. If at all possible, keep the values very simple at this stage. One light value, one dark, and two gray values will be sufficient now.

The quick pen sketch of the duck's landing is an example of how the birds are designed into a single unit by having their wings overlap each other. (See Figure 11.21.)

Figure 11.20

Figure 11.21

Figure 11.18

Figure 11.19

DEMONSTRATION PAINTING

A layout or sketch is to be considered a visual representation of an idea; the graphic design is the window of an artist's mind. It is the visual creation of a past experience, in this case the sketch of a flock of Canada geese preparing to land among a set of decoys. (See Figure 11.23.)

Brief thoughts cross your mind. You sort them out, discarding the ones that will not lend themselves to a pleasing and interesting composition. You think of the chilling elation of being out in the weather near the wind-whipped waters of a salt marsh, of snuggling deep into the blind to keep out of the cold wind, of your duck boat that has been pulled into a safe harbor among the reeds, of your dog and your companion if you are hunting.

As the first streaks of daylight crack the gray wall of clouds on a cold winter morning, the restless geese rise, their appetites satisfied and their craws full of the scattered grain from the harvested fields where they spent their usual moonlight feeding period.

Out over the water, near the distant shore, a thin wavering line of gabbling geese slowly drifts toward your side of the bay. A well-executed goose call quickens their flight as they come to investigate the seductive sound.

In a matter of minutes the great gray V sweeps in high over the marsh and passes over a small finger of reeds where well-placed, stiff-looking goose decoys float quietly on wind-rippled waters. The geese continue on after carefully looking over the decoys and land in the center of the bay, far away from the reedy shores.

A fast-moving north wind drives clouds over the water. The stiffening wind quickly whips the bay into wild whitecaps. As the wind strengthens, it bends the tall reeds downward. The geese grow restless and are soon airborne, their wings hammering against the driving storm. The flock wheels into an arc as they prepare to land. Their wings make a hissing sound as they brake against the wind.

This is the scene I wish to paint. Whether you use a gun or a camera, the thrill will still be the same. The most important thing to do at this time is to get the idea down on paper while it is still fresh in your mind.

Reaching for a sketch book, I began to jot down small marks and rhythmic shapes. An abstract pattern began to appear. My enthusiasm quickened as the doodles took on a semblance of forms—the placement of the abstract shapes of the reeds and grasses, the triangular pattern of the flight of geese, and the sweep of the clouds.

The sketch had now developed into a series of wavelike forms; the picture moves. This is all that we need for a sketch. (See Figure 11.23.)

The oil layout was made on illustration board that had a matte fixative spray on its surface. This ensures that the paint will not spread over the surface of the paper. The color scheme has been worked out, the studies of the geese have been made (Figure 11.22), and the next step is to enlarge the drawings and transfer them to the prepared canvas.

After the geese, decoys, and duck boat were traced into position, the outlines of the water and the reeds were added. The canvas was then sprayed with a fixative so that the pencil lines would not be destroyed by the oil paint.

My working procedure on this particular painting was to do the sky first, then the geese and landscape. Using a reasonably wide brush (bright), the sky and clouds were blocked in, working from the distant background and overlapping the edges of the paint to the foreground, thereby gaining aerial perspective. The soft edges were achieved with a combination of sable brushes, cloths, wadded paper, and the thumb.

The sky was practically completed at one sitting. (See Figure 11.24.) I did not trim around the birds at this time but brushed the paint directly across them. This preserves continuity in the sky area. The paint on the birds was scrubbed from

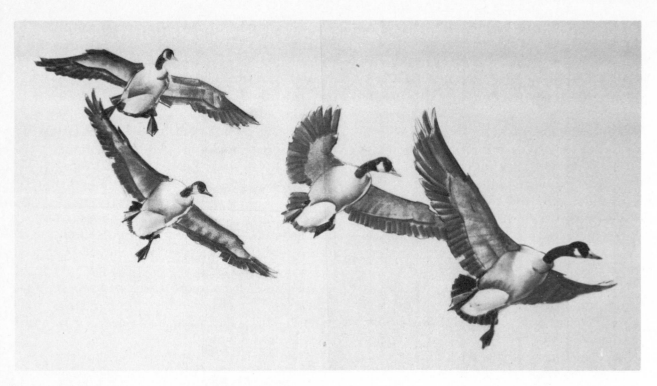

Figure 11.22
Charcoal study for the flight of geese.

Figure 11.23

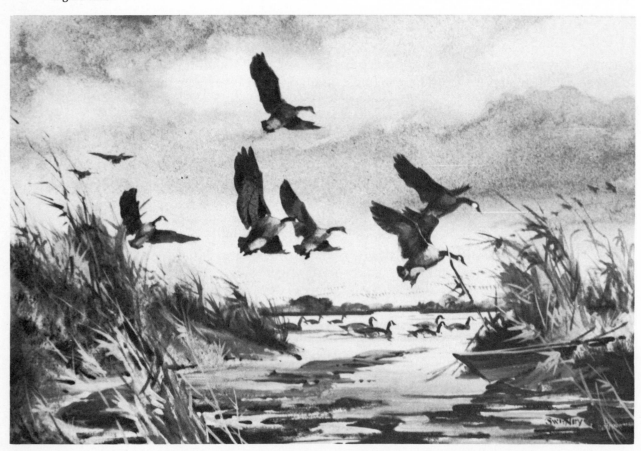

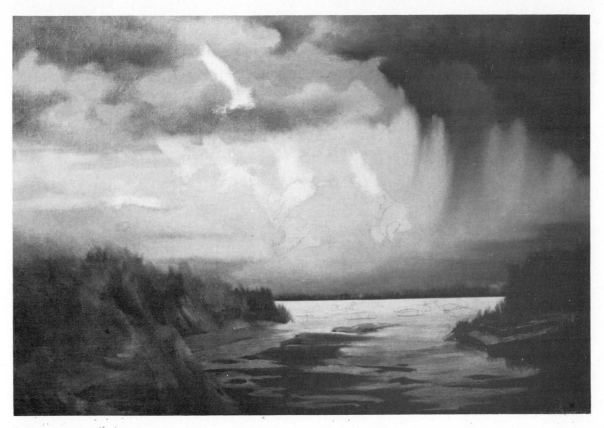

Figure 11.24

them with a round pig-bristle brush and turpentine.

The color of the reeds was painted next. No detail was added yet. The general forms of the geese were also added, working from the back bird forward to the lead bird. The palette consisted of ultramarine blue, viridian, cadmium yellow light, cadmium barium orange, cadmium red light, yellow ochre, raw umber, burnt umber, raw siena, and ivory black.

With all the major forms and values established, the painting was now beginning to take shape, and the feel of the outdoors was evident.

The sky was nearly complete except for some final adjustments to the values. These values are very critical, especially the aerial ones that separate the wings of the geese. Particular attention is also paid to the divisions of the wing and the proper feather count.

Other sections of this painting that received special attention were the edges of the wings. These were softened by dip-

ping a small sable brush into turpentine, wiping it nearly dry, and very carefully dragging it along the contours of the wing forms. This took away the undesirable hard look.

I highly recommend that you study the edges of round objects that have been painted by the Dutch painter Jan Vermeer.

I have also painted a value scale on the bodies of the geese, from light on the leading bird to a darker value on the trailing birds. These are approximately a quarter to a half in range between each goose.

Painting grass and reed stalks will make you feel liberated and free. This can be a lot of fun. Do not sketch out the individual stalks and blades. If you can draw them separately on a layout or sketch, you can do it on the finished painting. Keep in mind which way the wind is blowing.

Previously, I painted the darkest value of the reeds and grass with a reddish brown, softening the edges with a

155

brush. I also scumbled (softened or blended) some of the contours with a dry brush. Working from back to front, I casually indicated the blowing stalks and blades to show wind direction. Remember that birds land into the wind.

After finishing the shape of the reeds against the sky and also the ones on the lake side, I began painting toward the foreground. The grasses and reeds in the intermediate planes were painted with a lighter value, while changing some of the colors—some tannish, some greenish, some reddish, and so on. At this stage the palette knife was introduced in order to loosen up the art. Using the edge of the knife and the flat of the blade, a series of casual strokes were made.

The final phase was done after the painting was dry so that I could take advantage of the texture of the previous day's work and have a rougher surface to play with. Longer strokes were made with the knife, keeping in mind the size of the stalks as governed by the rules of perspective.

Now I turned my attention to the painting of the Canada goose decoys, beginning by painting the distant ones first, keeping in mind that I must darken the values of the rest of the decoys as I approach the foreground. (See Figure 11.25.) Decoys must look like wooden birds and not live ones.

The distant shoreline has some small indentations to indicate that there are little waterways winding back into the marsh. Care must be taken not to overwork this area.

The darks and lights of the waterway in the foreground are indicated by varying shades of neutralized blues and greens, keeping in mind that there is a mud flat down the center of the inlet. The inlet was painted with a generous amount of raw umber and juicy purple paint for top lighting. Blown-down stalks of reeds were indicated lying flat on the water at various angles. These were done mainly with a palette knife, and the blades of grass were indicated with a round sable brush.

The painting is now approaching the

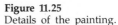

Figure 11.25
Details of the painting.

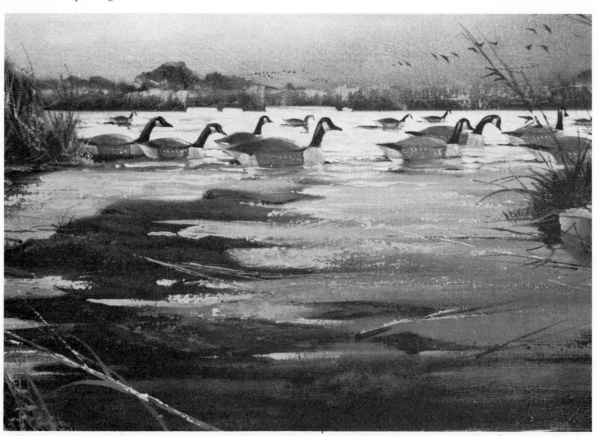

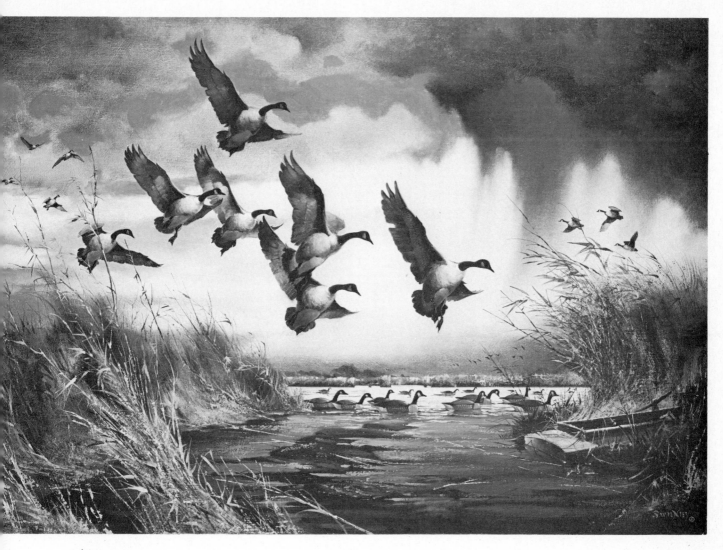

Figure 11.26
FREDRIC SWENEY (American, 20th century)
The Fall Guys (oil).
Courtesy of Mr. Robert J. Carlson.

final stages and more attention is being paid to the fine detail that a student of nature would expect. With the wings dry, I could proceed with the final glazing of colors, especially the reflected colors from the sky and water.

Whites, such as the chin strap on the head, and the light tannish grays of the body take on a blue or green reflected cast as the bird approaches the water's surface.

The broken feathers of the wing tell us that the bird has traveled a long distance, or that the feathers have been broken by the bird's flying through branches. The soft edge of the trailing feathers indicates that they are old and frayed but will be renewed during the spring moult.

With the head pointing downward, the goose is looking for a suitable landing place. The feet, which have been tucked under the tail, are now brought forward in preparation for the landing. The wing position and the tilted tail indicate that the bird is turning slightly to the left and that the body has been rolled so that the belly will show. The left foot has been dropped more than the right; this is in order to put a drag on that side to assist in the turn.

These are the things that a connoisseur of waterfowl art will search for. The final touch is the reflected color in the eye and its highlight.

PRACTICE SUBJECTS

These sketches will give you a latitude of choice in order for you to try your skill at paintings of this type. I have purposely made the sketches simple in design. You are to fill in the background that you choose to depict.

You may want to take the first one and show a pintail duck in a driving snowstorm, or it may be a spring day and late in the afternoon.

Please yourself regarding the weather, the time of day, or the season of year you wish to paint. All that I have done is to indicate some flight positions that you are free to use. The only thing you must do is design the landscape and finish the painting.

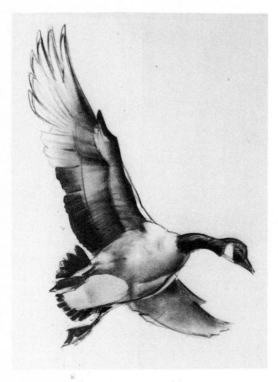

Figure 11.27
Canada goose.

Figure 11.29
Mallards.

Figure 11.28
Pintail.

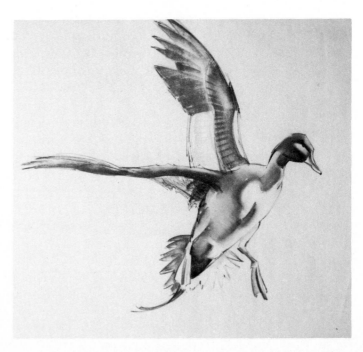

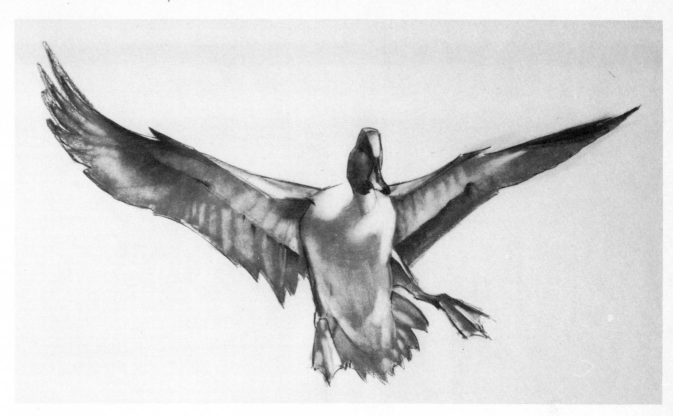

Figure 11.30
Pintail.

Figure 11.31
Mallards.

Figure 11.32
Pintails.

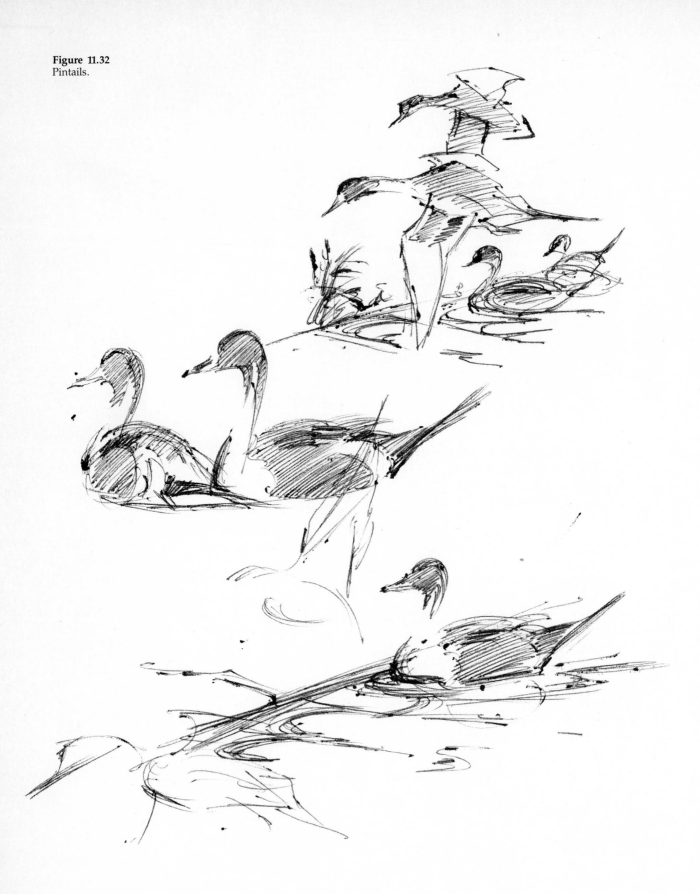

Bibliography

ADAMS, NORMAN, and JOE SINGER. *Drawing Animals*. New York: Watson-Guptill Publications, 1979.

Africa, From the Sahara to the Zambesi. Peoples of the Earth Series, vol. II. Suffern, N.Y.: The Danbury Press, 1973.

Alaska–High Road to Adventure. Washington: National Geographic Society, 1976.

AUDUBON, JOHN JAMES. *The Birds of America*. New York: Macmillan, 1941.

AYMAR, GORDON C. *Bird Flight*. New York: Dodd, Mead, 1936.

BATES, MARSTON, and the EDITORS OF LIFE. *The Land and Wildlife of South America*. Alexandria, Va.: Time-Life Books, 1964.

Birds of America. Garden City, N.Y.: Garden City Publishing, 1936.

BRIDGES, WILLIAM. *Wild Animals of the World*. Garden City, N.Y.: Garden City Publishing, 1948.

BRIDGMAN, GEORGE E. *Bridgman's Complete Guide to Drawing from Life*. New York: Sterling Publishing, 1952.

CALDERON, FRANK. *Animal Painting and Anatomy*. New York: Dover Publications, 1975.

CARRINGTON, RICHARD. *The Mammals*. Alexandria, Va.: Time-Life Books, 1963.

CONRAD, BARNABY. *La Fiesta Brava*. Boston: Houghton Mifflin, 1950.

CUTLER, MERRITT. *How to Cut Drawings on*

Scratchboard. New York: Watson-Guptill Publications, 1949.

Domestic Descendants. Alexandria, Va.: Time-Life Films, 1979.

DUPLAIX, NICOLE, and NOEL SIMON. *World Guide to Mammals.* New York: Crown, 1976.

DUPONT, JACQUES, and FRANCOIS MATHEY. *The Seventeenth Century: The New Development in Art from Caravaggio to Vermeer.* The Great Centuries of Painting Series. Skira, 1951.

EAST, BEN. *Bears.* New York: Outdoor Life Crown Publishers, 1977.

ELLENBERGER, W., H. BAUM, and H. DITTRICH. *An Atlas of Animal Anatomy for Artists.* New York: Dover Publications, 1949.

FARB, PETER, and the EDITORS OF LIFE. *Ecology.* Alexandria, Va.: Time-Life Books, 1963.

FORBIS, WILLIAM H. *The Cowboys.* Alexandria, Va.: Time-Life Books, 1973.

FOSCA, FRANCOIS. *The Eighteenth Century: Watteau to Tiepolo.* The Great Centuries of Painting Series. Skira, 1952.

HIRSH, DIANA. *The World of Turner: 1775-1851.* Alexandria, Va.: Time-Life Books, 1969.

HULTGREN, KEN. *The Art of Animal Drawing.* New York: McGraw-Hill, 1950.

KEATING, BERN. *Alaska.* Washington: National Geographic Society, 1969.

KELLER, DR. HILTGART, and DR. BODO CICHY. *20 Centuries of Great European Painting.* New York: Sterling Publishing, 1957.

KNIGHT, CHARLES R. *Animal Drawing.* New York: Dover Publications, 1947.

Know the American Quarter Horse. Farnum Horse Library, 1972.

KOLLER, LARRY. *The Treasury of Hunting.* Indianapolis, Ind.: Odyssey Press, 1965.

KUHN, BOB. *The Animal Art of Bob Kuhn.* North Light Publishers, 1973.

LAYCOCK, GEORGE. *The Deer Hunter's Bible.* New York: Doubleday, 1963.

LESLIE, CLARE WALKER. *Nature Drawing–A Tool for Learning.* Englewood Cliffs, N.J.: Prentice-Hall, 1980.

LORGUES-LAPOUGE, C. *The Old Masters: Byzantine–Gothic–Renaissance–Baroque.* New York: Crown Publishers, n.d.

LUDWIG, COY. *Maxfield Parrish.* New York: Watson-Guptill Publications, 1973.

Marvels and Mysteries of Our Animal World. White Plains, N.Y.: Readers Digest Association, 1964.

MILLER, MIKE. *Alaska–The Great Land.* New York: Sierra Club/Charles Scribner's Sons, 1975.

MITCHELL, JOHN, and the MASSACHUSETTS AUDUBON SOCIETY. *The Curious Naturalist.* Englewood Cliffs, N.J.: Prentice-Hall, 1977.

MOORE, RUTH, and the EDITORS OF LIFE. *Evolution.* Alexandria, Va.: Time-Life Books, 1962.

MORGAN, NEIL, and the EDITORS OF TIME-LIFE BOOKS. *The Pacific States–California, Oregon, Washington.* Alexandria, Va.: Time-Life Books, 1967.

MUYBRIDGE, EADWEARD. *Animals in Motion.* New York: Dover Publications, 1957.

PECK, STEPHEN ROGERS. *Atlas of Human Anatomy for the Artist.* New York: Oxford University Press, 1951.

PERARD, VICTOR. *Anatomy and Drawing.* New York: Victor Perard, 1928.

PRIDEAUX, TOM, and the EDITORS OF TIME-LIFE BOOKS. *The World of Delacroix: 1798-1863.* Alexandria, Va.: Time-Life Books, 1966.

QUEENY, EDGAR M. *Prairie Wings.* Philadelphia: J. B. Lippincott, 1947.

RUE, LEONARD LEE III. *The Deer of North America.* New York: Outdoor Life Crown Publishers, 1978.

RUE, LEONARD LEE III. *The World of the White-Tailed Deer.* Philadelphia: J. B. Lippincott, 1962.

SANDERSON, IVAN T. *Living Mammals of the World.* New York: Doubleday, 1955.

Seven Centuries of Art–Survey and Index. Editors of Time-Life Books. Alexandria, Va.: Time-Life Books, 1970.

SIMMONS, SEYMOUR III, and MARC S.A. WINER. *Drawing: The Creative Process.* Englewood Cliffs, N.J.: Prentice-Hall, 1977.

SIMON, HOWARD. *500 Years of Art in Illustration from Albrecht Durer to Rockwell Kent.* New York: World Publishing, 1942.

STONEHOUSE, BERNARD. *Animals of the Arctic–The Ecology of the Far North.* New York: Holt, Rinehart and Winston, 1971.

TANNER, OGDEN. *Bears and Other Carnivores.* Alexandria, Va.: Time-Life Films, 1976.

TYLER, RON. *The Cowboy.* New York: William Morrow, 1975.

TYNAN, KENNETH. *Bull Fever.* New York: Harper Brothers, 1955.

Wild Animals of North America. Washington: National Geographic Society, 1979.

Wild Herds. Alexandria, Va.: Time-Life Films, 1977.

WILWERDING, WALTER J. *Animal Drawing and Painting.* New York: Watson-Guptill Publications, 1946.

Index